THE ART OF ARCHIBALD J. MOTLEY, JR.

THE ART OF ARCHIBALD J. MOTLEY, JR.

BY JONTYLE THERESA ROBINSON
AND WENDY GREENHOUSE

WITH AN INTRODUCTION BY
FLOYD COLEMAN

CHICAGO HISTORICAL SOCIETY

The Art of Archibald J. Motley, Jr.
accompanies the exhibition
"The Art of Archibald J. Motley, Jr."

Exhibition organized by the
Chicago Historical Society

Exhibition Tour
Chicago Historical Society
October 23, 1991–March 17, 1992

Studio Museum of Harlem
New York City
April 5–June 10, 1992

High Museum\Georgia-Pacific Gallery
Atlanta, Georgia
June 29–September 25, 1992

Corcoran Gallery of Art
Washington, D.C.
October 10, 1992–January 3, 1993

Published in the United States of America in 1991
by the Chicago Historical Society.

Director of Publications, Chicago Historical Society: Russell Lewis.
Edited by Russell Lewis and Rosemary Adams.
Designed by Bill Van Nimwegen. Composed in Gill Sans on a
Macintosh IIci using Quark Xpress 3.0. Printed by Great Lakes
Graphics, Inc., Skokie, Illinois

Library of Congress Cataloging-in-Publication Data:
Robinson, Jontyle T, 1947–
 The art of Archibald J. Motley, Jr. / by Jontyle T. Robinson and
 Wendy Greenhouse; with an introduction by Floyd Coleman.
 p. cm.
 Accompanies an exhibition by the Chicago Historical Society.
 Includes index.
 ISBN 0-913820-15-6 : $24.95
 1. Motley, Archibald John, 1891–
 —Exhibitions I. Greenhouse, Wendy.
 II. Motley, Archibald John, 1891–.
 III. Chicago Historical Society. IV. Title
 ND237.M8524A4 1991
 759.13—dc20 91-28552
 CIP

FOR

MARY F. MOTLEY, 1870–1959

AND

IRMA JONTYLE GROVEY ROBINSON, 1921–88

Contents

THIS EXHIBITION IS SPONSORED BY: **LILA WALLACE—READER'S DIGEST FUND**

ADDITIONAL SUPPORT

HAS BEEN RECEIVED FROM: THE AT&T FOUNDATION

AON CORPORATION

NATIONAL ENDOWMENT FOR THE ARTS, A FEDERAL AGENCY

ILLINOIS ARTS COUNCIL, A STATE AGENCY

JOHN H. AND EUNICE W. JOHNSON

JOHN NUVEEN & COMPANY

REGINALD F. LEWIS FOUNDATION

The first time I saw a group of paintings by Archibald J. Motley, Jr., I was immediately drawn to them. The vitality of the images and the artist's love of his subject and his medium were evident in each canvas. The idea of organizing a retrospective exhibition of his work at the Chicago Historical Society is inseparable in my memory from my first encounter with Motley.

Archie Motley, the artist's only child and the Society's curator of archives and manuscripts, introduced me to his father's work soon after I joined the Society's staff in 1987. Perhaps because he knew that my background was in American studies and much of my professional experience in art museums, Archie began to talk to me about our common interest in twentieth-century art. After a few months he invited me to see the many paintings by his father that hang in his Evanston home. I knew that his father was a painter with a growing reputation for scenes of black nightlife, but because of Archie's modesty I was unprepared for the depth and quality of the work. I was immediately struck with Motley's sheer ability to paint, visible in the student exercises in which he seems to be solving a problem, the sensitive portraits of family members, and the vibrant Bronzeville scenes.

I was fascinated to find that he received his formal training at the School of the Art Institute of Chicago and then applied that training to the world he saw around him. Although Motley was by all accounts a reserved man, through his paintings we see him wrestling with the issues of his own identity as a black artist living in both the black and white worlds of the twentieth century. His subject matter encompasses African legends, portraits of African-Americans, the rural South, Paris in the 1920s, the pool halls and street scenes of Chicago's black community, murals of historical events and figures for the WPA, and a few works that deal with the relationship between the races.

Motley's life also offers a rich subject for examination, and one that I feel is particularly appropriate to the Chicago Historical Society at this point in its development. Not only did Motley live and work in Chicago for most of his life, but he also chose to paint the city and its people. His own identity, his feelings about Chicago, and the issue of race still confront us today as we, as an institution and a society, try to come to terms with our own identity and our relationship to Chicago's diverse populations.

Archie was receptive to the idea of the Chicago Historical Society organizing an exhibition about his father's art but pointed out that we did not have the necessary curatorial staff in place. He put me in touch with Jontyle Theresa Robinson, then assistant

professor of art history at Winthrop College, who had devoted several years to researching and locating the approximately one hundred Motley canvases known to exist. Jontyle's long-standing interest in Motley grew as she helped to organize the exhibition "Three Masters" at the Kenkeleba Gallery in New York in 1988, which represented the largest assembly of Motley works since the artist's death in 1981. Jontyle had her own dream of seeing Motley's work receive both critical consideration and wide public visibility through a major retrospective exhibition and catalogue, but did not have an institutional affiliation to make this possible. In 1987 we began exploring how a Motley exhibition could be put together.

At that same time, the Society was fortunate to hire Wendy Greenhouse, who was finishing her doctoral dissertation at Yale, as curator of paintings and sculpture. Wendy was interested in the combination of art historical analysis and social history that would allow us to put an artist such as Motley in a broad context.

Wendy and Jontyle each brought valuable and unique talents to the project. Following the successful institutional model of pairing academics with curators, we teamed them up as co-curators of "The Art of Archibald J. Motley, Jr." The three years since that partnership began have seen the birth of a daughter and a change of job for each of them, but they have continued to bring their expertise to the project. We are deeply indebted to them for bringing the works together and for this catalogue, which will be invaluable to future scholars researching Motley, Chicago, and black art. Jontyle's years of gathering information resulted in the compilation of historical data for each piece in the catalogue of the exhibition and a biographical essay that provides insights into the relationship between the artist's life and his work. Wendy's extensive research on the history of the city and particularly on other artists working during Motley's career allows us to see the artist in the context of Chicago from 1890 to 1940. Drawing upon all of the sources available as well as her own visual response to the works, Wendy also wrote the interpretations of each piece that appear as catalogue entries in this volume and as label text in the exhibition.

One of the greatest pleasures in directing this project has been watching it grow over the past four years. An ever-widening group of people became involved with all aspects from research to fund-raising. The project has been greeted with universal enthusiasm and generous support throughout the Society and has been shaped by the many talented people involved.

On behalf of Jontyle Robinson and Wendy Greenhouse, I would like to thank Donald and Tritobia Benjamin, Diedre Bibby, Margaret Burroughs, Claude L. and Nell Grovey Cole, Thomas Cole, Floyd Coleman, Tina Dunkley, Carroll Greene, James R. Grossman, Ethel Nathan Grovey, R. R. Grovey, Dana Hamilton, The Bess L. Harper Estate, Bonny Ebumbu Eboule Gabin Jacques, Bronislaus Janulis, Cecelia Jeffries, Jacob Lawrence, Marvin and Catherine Lewis, Lydia Litwin, Michael Lomax, Richard Long, Alan Mandel, Jacqueline S. Marshall, Garett McCoy, Margaret Miller, Lev Mills, E. J. Montgomery, Kelly Morris, Veronica Njoku, Susan Noble, Charles Page, Jim Parker, Susan Perry, Tamara Plummer, Deborah Bailey Poole, Richard Powell, Edsel Reid,

Freddie A. Robinson, Frederick Robinson (Salim Malik), Earl Robinson, Praylor Robinson, Prajjon Nicole Robinson, Bill Sanders, Gerald Sanders, Beth Sarantos, Rick Strilky, the Smithsonian Institution, Esther Sparks, Spelman College's Bush Foundation Grant for Faculty Development, John J. Treanor, Susan Weininger, Shirley Woodson, West Virginia State College, Winthrop College, and Faye Wrubel.

Motley's works are widely dispersed throughout public and private collections. The excitement of seeing the paintings together for the first time and the opportunity this provides to trace Motley's career would not be possible without the extraordinary generosity of the twenty-eight lenders, who are recognized earlier in this catalogue. For giving up their paintings for nearly two years, we offer them our heartfelt thanks.

Members of the Motley family made the exhibition possible, not only through their loans, but also by providing valuable information about the artist. We greatly appreciate the assistance of Mr. and Mrs. Terrence L. Bailey, Judge Norma Y. Dotson, Charlotte C. Duplessis, Deborah Gwin Hill, Sharon Y. Holland, Norma Worthington LaMonte, Denise A. LaMonte-Smith, the late Mrs. Flossie Moore, Archie Motley and Valerie Gerrard Brown, and Mrs. Frederica Westbrooke.

From the beginning of the project there has been a consensus among the Chicago Historical Society staff that this is an exhibition that should be done and done well. Virtually every member of the staff contributes to an exhibition of this size, and for their creativity, professionalism, and generosity of spirit, I am very grateful.

For the past year, a team of staff members has devoted tremendous energies to the project and deserves special recognition: Riva Feshbach, assistant curator of paintings and sculpture, for cheerfully managing the details of the exhibition on a daily basis; Russell Lewis, director of publications, and Rosemary Adams, assistant editor, for skillful conceptualization and realization of the catalogue and labels; and Andrew Leo, director of design, and Bill Van Nimwegen, graphic designer, for their elegant design.

Thanks also to the many staff members who contributed their considerable professional abilities in specific areas: Mary Janzen, assistant to the president, for her early encouragement and successful grant writing; John Alderson, photographer, and Jay Crawford, assistant photographer, for documenting the works on the road and in the studio; Carol Turchan, conservator, for her careful treatment of archival material; Lorraine Mason, curatorial secretary, for keeping us organized; Louise Brownell, registrar, for arranging the many details of the tour; Pat Kremer, public relations manager, for enthusiastically spreading the word about the exhibition; Marc Hilton, former vice-president of development, Joe Sopcich, director of development, and Barbara Reed, corporation/foundation manager, for their creative and effective fund-raising; Amina Dickerson, director of education and public programs, Lynn McRainey, associate educator, and Eva Olson, former associate educator, for planning a rich array of programs; Beth Hubbartt, museum store manager, for her creativity; Janice McNeill, librarian, and her staff for their research assistance; Ralph Pugh, assistant curator of archives and manuscripts, and Corey Seeman, archives and manuscripts assistant; Ted Gibbs, assistant designer; Myron Freedman, preparator; Judy Sponsler, publications assistant; Joyesha Bhattacharya, Felicia

McNeil, and Christina Durr, publications interns; and finally, Archie Motley for balancing his dual role as archivist and son of the artist so beautifully.

Special recognition goes, as it does for each exhibition, to Ellsworth H. Brown, president and director, for his unfailing support of the project. He recognized the potential of Motley's work to help the Society achieve its mission of reaching new audiences and interpreting the life of the city to them. To that end, he worked tirelessly with trustee Sharon Gist Gilliam and members of the development department to form a volunteer committee of community leaders to raise funds and pave the way for this exhibition. Our thanks goes to members of this illustrious committee, each of whom contributed their time, talents, and skills: Lerone Bennett, Jr., Peter C. B. Bynoe, Johnnetta B. Cole, John H. and Eunice W. Johnson, Allison S. Davis, John Hope Franklin, Daryl F. Grisham, Elzie L. Higginbottom, Mrs. Jetta Jones, Mrs. Josephine B. Minow, Mrs. Isobel Neal, Mrs. Judith Neisser, Madeline Murphy Rabb, Mrs. Sandra Rand, Mrs. Dorothy Runner, and Dempsey Travis. Johnnetta Cole, president of Spelman College, where Jontyle Robinson now teaches, has been a special friend to the project, having traveled several hundred miles to meet with the committee and offer her assistance to the staff.

We are particularly pleased that the funding of the exhibition represents a collaboration of foundation, corporate, and government support. The Lila Wallace—Reader's Digest Fund has been a generous and enthusiastic supporter of the project in the role of the exhibition's major sponsor. The AT&T Foundation helped underwrite the Chicago Historical Society's installation of the exhibition, as well as the three venues of the national tour. The Aon Corporation generously answered the Advisory Committee's request for funds. Grants from the National Endowment for the Arts, a federal agency, and the Illinois Arts Council, a state agency, have lent a strong endorsement to our first major painting exhibition in recent years. Further support for the exhibition has been provided by John H. and Eunice W. Johnson, the Reginald F. Lewis Foundation, and John Nuveen & Company.

We are pleased that "The Art of Archibald J. Motley, Jr." will be seen by thousands of people nationwide as it travels to the Studio Museum in Harlem, the Georgia Pacific Branch of the High Museum, and the Corcoran Gallery of Art. We extend our thanks to the staff of each of these museums and their sponsors for hosting the exhibition in their communities.

Susan Page Tillett
Director of Curatorial Affairs and Project Director

I n 1956, as a freshmen art major at Alabama State College (now University), I became aware of the art of Archibald J. Motley, Jr., through reproductions of *Playing Poker* and *The Liar*, works included in James A. Porter's *Modern Negro Art*. Although the paintings were presented as small black-and-white reproductions, Motley's sure composition and engaging dramatic narrative forcefully came alive. Often thereafter I returned to Porter's book because it reminded me that black artists had existed in North America for many generations.

That there were black artists other than Henry Ossawa Tanner was an amazing discovery for me, a seventeen-year-old from Alabama's Black Belt. In the black public schools of Hale County, where the sessions were split because in the spring the cotton had to be cultivated and in the fall the crops had to be harvested, there were no art courses in the curriculum. Thus, to be in college studying with an artist such as Hayward L. Oubre was a new and exciting experience. In Professor Oubre's design and painting classes we discussed and analyzed the works of Motley, Richmond Barthe, Aaron Douglas, Hale Woodruff, Lois Mailou Jones, Augusta Savage, Elizabeth Catlett, and Charles White, among others.

In 1962, I began to study more about Motley's life and work while teaching a humanities course at Clark College in Atlanta, Georgia. At this time I was able to see Motley's work in the larger context of American art and to note specifically that Motley was among the artists of the 1920s who consistently depicted African-Americans in a positive manner. He produced memorable paintings, such as *Blues* and *The Plotters*, that captured the energy and character of black urban life. Motley did not sanitize his subjects, nor did he present grotesque stereotypes. Instead he created authentic images that were compelling manifestations of the creative spirit of the African-American folk. He depicted the black community, as Jontyle Theresa Robinson so aptly maintained, "not as a critic or moralist, but as a recorder reporting with eyes and brush the diversity and universality of the Black experience."[1]

Motley's family was part of the vanguard of the Great Migration of African-Americans from the South to the North in the early twentieth century. Moving from New Orleans to Chicago, the Motley family joined the tens of thousands of African-Americans who settled in the Midwest and the Northeast and changed forever the African-American's role in American society. For the first time in the western hemisphere,

a large and diverse black urban community with a unique cultural dynamic developed, far removed from the once prevailing rural environment.

Archibald Motley's art must be considered in light of the changes that had and were taking place in cities across the United States, particularly the remarkable culmination of creative activity centered in the 1920s in New York City—the Harlem Renaissance.

The philosopher and mentor of this movement was Alain Locke, who urged black artists of that era to turn to their African heritage for inspiration. Locke believed that if young black artists learned the discipline and the technical mastery of classical African art, they would create a more original art.

While studying for my Ph.D. at the University of Georgia, I began to examine the works of black artists and their specific relationship to traditional African art and culture. Again, Archibald Motley figured prominently in this query. Motley extolled his African ancestry, calling attention to his "pygmy grandmother." He was one of the first black artists to explore such subject matter, predating his Harlem Renaissance confederates and the artist heirs to that movement. His *Kikuyu God of Fire* antedates Sargent Johnson's *Mask* (1933), Palmer Hayden's *Fetiche et Fleurs* (1933), Lois Mailou Jones's *Ascent Ethiopia* (1932) and Malvin Gray Johnson's *Self-Portrait* (1934). Only works such as Meta Warrick Fuller's *Ethiopia Awakening* (1914) and Aaron Douglas's illustrations for Alain Locke's *The New Negro* (1925), the virtual manifesto of the Harlem Renaissance, preceded Motley's treatment of African themes.

I had the privilege of meeting Archibald Motley in April, 1972, at the annual meeting of the National Conference of Artists (NCA) in Chicago. It was a rare treat to talk briefly with Motley and to share the dais with him and the other officers of the NCA. Although Motley was over eighty years old, he was still a striking figure. Without the aid of notes, he spoke eloquently to this group of mostly black artists, art educators, and art historians about art and about his life as an artist. Here, in the city that had embraced him from the time that he was a student at the School of the Art Institute, Motley was a commanding presence, confirming what I had already gleaned from images and texts: he possessed an uncommon talent and an indomitable spirit.

Floyd Coleman
Owen Duston Distinguished Professor of Art, Wabash College
Chair, Department of Art, Howard University

1. Jontyle Theresa Robinson, "Archibald John Motley, Jr.: A Notable Anniversary for a Pioneer," in *Three Masters: Eldizer Cortor, Hughie Lee Smith, Archibald J. Motley, Jr.,* (New York: Kenkeleba House, Inc., 1988), 45.

THE LIFE OF ARCHIBALD J. MOTLEY, JR.

JONTYLE THERESA ROBINSON

The life and career of Archibald J. Motley, Jr., in its bare outline encompasses themes familiar to the lives of countless other artists: academic training at a prestigious art school, a period of economic struggle and personal frustration while maturing as an artist, critical acclaim and national recognition, and finally, a fall into obscurity. But a survey of the more than one hundred extant Motley paintings reveals a rare and unusually gifted artist whose work is among the best of its time. An astute observer of the world around him, Motley eschewed grand social theories and political agendas; his goal was simply to record his world as completely and as honestly as he could. As a result, Motley's images of the familiar faces and places of his surroundings are charged with insight and verve. Incorporating into his paintings his fascination with natural and artificial light, his modernist sense of color, and his deep respect for the heritage of African-Americans, Motley's oeuvre is a compelling record of twentieth-century black urban life.

Motley was a working artist in Chicago for more than fifty years. He began his career as a portraitist in the late 1910s and 1920s, and during this time he also painted canvases that explored his African ancestry and his southern Creole heritage. After a brief stay in Paris in 1929–30 as a Guggenheim fellow, Motley returned to Chicago, where he painted some of his most memorable Bronzeville scenes and numerous works for various federally sponsored arts projects during the 1930s and 1940s. In the 1950s Motley shifted his artistic focus to Mexico, but by the 1960s, most of the few paintings he completed, again focus on familiar themes of black life in Chicago.

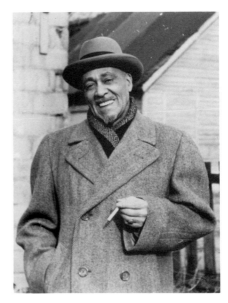

Fig. 1. Archibald J. Motley, Jr., Chicago, c. 1950. Collection of Archie Motley and Valerie Gerrard Browne.

EARLY LIFE

Louisiana's extraordinary mixture of French and African history, language, music, and people was a strong influence on Archibald J. Motley, Jr., throughout his life. Born in New Orleans on October 7, 1891, Motley lived in Louisiana for less than two years before his family settled in Chicago after brief residences in St. Louis and Buffalo. As a child Motley and his sister Flossie regularly visited Louisiana in the summer months to attend school and to renew ties with relatives. His southern kin introduced him to his family's rich Creole ancestry and instilled in him curiosity and fascination with his African heritage.[1] Motley was especially close to his maternal grandmother, Harriet Huff, who, according to family oral history, "was a Pygmy from former British East Africa, a little bit of a person, very small . . . about 4 feet 8 or 9 inches" tall, who had been a slave in Tennessee and

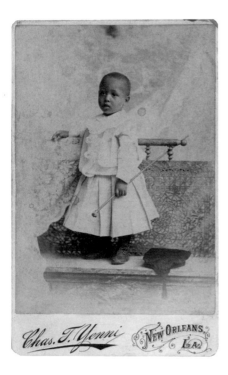

Fig. 2. Archibald J. Motley, Jr., c. 1892, New Orleans, Louisiana. Collection of Archie Motley and Valerie Gerrard Browne.

Fig. 3. Archibald. J. Motley, Jr., when he was a student at Nicholas Copernicus School, Chicago, c. 1906. Collection of Archie Motley and Valerie Gerrard Browne.

Louisiana. Throughout his career as an artist, Archibald J. Motley, Jr., revisited these cultures and his family's place in them, exploring in his paintings their meaning for twentieth-century black urban life.

Motley lived in Chicago's Englewood neighborhood on the city's South Side for most of his childhood and adult life. Originally a railroad depot with a few scattered houses along the tracks, Englewood prospered during the World's Columbian Exposition building boom, and Motley and his family experienced this development first hand.[2] Motley's parents, educated middle-class African-Americans, left the South in the 1890s for better opportunities in the North. Mary F. Motley (fig. 5) was a school teacher, and Archibald J. Motley, Sr. (fig. 4), was a Pullman Porter (one of the more prestigious jobs available to blacks), and he was an early supporter and a militant member of the Brotherhood of Sleeping Car Porters. The Motleys were one of the few black families living in the community, which was populated largely by people of German, Irish, Swedish, English, Welsh, and Dutch ancestry. Motley apparently had a normal childhood with only isolated incidents of racial discrimination.[3] All of his schoolmates and playmates were white, and Motley recalled that during his youth relations among the various ethnic groups were very congenial.[4] Raised by his parents in the Catholic faith, Motley attended the Mission Church of St. Brendan with which he had an association that spanned decades.

As early as the fifth grade, drawing held special pleasure for Motley. Recognizing his interest and talent, his teachers encouraged him to draw block forms, and colored vases, bowls, and flowers; Motley also helped classmates with their drawings. By the seventh grade, he "began using . . . textbooks as sketch pads making . . . sketches of his classmates and drawings from memory of many things [he] had seen." Motley recalled that "some of my teachers were quite lenient and allowed me to deface the textbooks so long as I knew my lessons altho some were not appreciative of my art and punished me for defacing school property."[5] Especially intrigued by the lives of black people, Motley sought them out as subjects for his sketches:

When I was in the fifth grade at school there was a pool room around the corner from school . . . Ricks . . . I used to take my lunch, go over there, sit in the pool room so I could study all those characters in there. There was nothing but colored men there. The owner was colored. I used to sit there and study them and I found they had such a peculiar and such a wonderful sense of humor and the way they said things, and the way they talked, the way that they expressed themselves you'd just die laughing. I used to make sketches even when I was a kid then.[6]

Attracted to black urban life, Motley trekked north of Englewood to the vicinity of Thirty-fifth and State streets, where he could lose himself among the throngs of African-Americans along "the Stroll," Chicago's most colorful stretch of black culture. The Stroll, a strip of State Street between Twenty-sixth and Thirty-ninth streets, featured jazz spots,

movie theaters, and dance halls. Motley reveled in the energy, colors, characters, and rhythms of the street. In the surrounding areas along Prairie Avenue and Indiana and Calumet streets, Motley found other expressions of black life in churches and sporting and gambling houses.[7] Motley was an keen observer of this world, and it inspired him to record African-Americans and their heritage and culture as no other artist had before.

Motley worked at a number of part-time jobs after he graduated from elementary school, including shining shoes, porterage for a barber shop, and a variety of tasks for the Michigan Central Railroad (probably working with his father).[8] By the time he entered high school in 1909 at the age of eighteen, he was eager to pursue a full program of artistic training. At Englewood High School he received instruction in lettering, free-hand drawing, charcoal and chalk sketching, and the fundamentals of mechanical drawing, which gave students a working knowledge of perspective. In addition to this technical coursework, Englewood teachers instilled in him an "appreciation of the things of beauty and development of a taste that discriminates between the superior and the common-place."[9] Motley no doubt studied the works of art that adorned the school's corridors. Particularly noteworthy was Lorado Taft's 125-foot-long plaster cast of the Parthenon frieze, which was installed over the main entrance of the first floor. Taft made several casts of the work, originally created for the 1893 World's Columbian Exposition, and he presented one to the school.

The arts were not Motley's only interest in high school. A talented athlete, Motley was a member of the school's football and baseball teams (fig. 6) and also played first base for the Royal Giants semipro baseball team on weekends. Motley combined his interest in art and sports in a series of posters depicting the competitive sports that were played at Englewood.[10] He and Edith Granzo, his neighbor and future wife, who was white and of German stock, dated during their years at Englewood High School. Although overt racism did not predominate in Englewood, interracial relationships were still considered taboo; Edith and Archibald courted discreetly.[11]

THE ART STUDENT

After graduating from high school in 1914, Motley enrolled in the School of the Art Institute of Chicago. He had originally been offered a full scholarship to study architecture at Chicago's Armour Institute by its president, Frank Gunsaulas, who had become acquainted with Archibald J. Motley, Sr. Even though young Motley turned down this generous offer, Gunsaulas was impressed enough with him to pay his first year's tuition at the Art Institute. Motley's thorough practical training in Englewood's art department was excellent preparation for the school's rigorous program.[12] Its four-year curriculum included drawing in charcoal, pen-and-ink work, painting in watercolor and oil, drawing nudes and portraits, a complete study of composition in black-and-white and color, the study of perspective and anatomy (which included human bone structure and muscles), still life painting, portrait painting, cast drawing, and figure sketching.

Motley's life as a student was not easy. His strong grades during his first year of study had earned him a job the following year, which paid his tuition and a weekly stipend of fif-

Fig. 4. Archibald J. Motley, Sr. Collection of Archie Motley and Valerie Gerrard Browne.

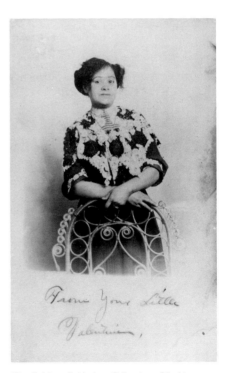

Fig. 5. Mary F. Motley. Collection of Archie Motley and Valerie Gerrard Browne.

teen dollars. During his second year, he was out of bed by 5:00 A.M. and off to school to clean and dust statuary in the galleries, his tuition job, before classes began at 9:00 A.M. He painted nudes until noon and portraits from 1:00 P.M. to 4:00 P.M. After classes he worked an hour or more at school and worked at home on assigned compositions until 2:00 A.M. or 3:00 A.M.[13]

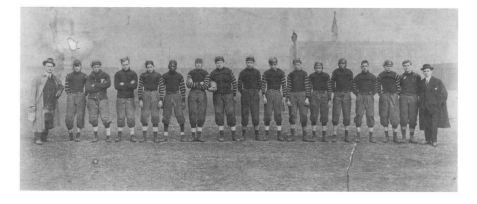

Motley enrolled in the Department of Painting and Illustration. The advanced classes were the life (figure, both costumed and nude, and head) drawing and painting courses. Although he thoroughly immersed himself in drawing and painting the human form, composition interested Motley most of all. Motley studied black-and-white composition with Albert Krehbiel (1873–1945) and color composition with George Walcott. They taught Motley to appreciate the subtleties of lighting and introduced him to techniques to achieve a wide range of effects, lessons the artist would draw upon to create some of the most exciting works of his career. Krehbiel had his students work first using only three values— white, gray, and black—and then advance to four and to five values, alternating from light to dark.[14] Under Walcott's instruction, Motley had to prepare for each oil painting with numerous sketches exploring harmony, perspective, and anatomy. Walcott then asked his students to consider the treatment of light throughout the painting. As part of his exercises, Motley had to solve various lighting problems, such as the effect of sunlight, rain, snow, or the play of cool moonlight in contrast to warm artificial light. "If your artificial light is stronger than your half-tones," Motley recalled from his Art Institute instruction, then "shadows will be warmer and the reverse if your moonlight is more prominent."[15] After his student days, Motley continued to study examples of lighting, composition, and portraiture in the Art Institute's collection, which he visited regularly. "The best example I have seen of [artificial interior] lighting is *Nighthawks* by the American painter Edward Hopper . . ."[16]

Fig. 6 (top). The 1912 Englewood High School football team. Archibald J. Motley, Jr. is fourth from the right. CHS, Prints and Photographs Collection, ICHi-22831.

Motley worked very hard to master Walcott's and Krehbiel's composition instruction, and he won honorable mention awards from the school's faculty for his work in junior composition and composition classes. But he was also a talented portrait painter who excelled under the tutelage of Karl Buehr (1866–1952), his instructor in figure and portrait painting (Motley also won an honorable mention for his work from charcoal life studies class). Buehr stressed the relationship of value, color, and tone in the play of light in a painting. In his students' paintings, he looked for a study of flesh tones, an emphasis on textures, and attention to reflections, ranging from the hard shiny surfaces of brass, silver, copper, or wood to dull surfaces, such as soft cloth. *The Chef* (c. 1916–18, cat. no. 1) and *Seated Nude* (c. 1916–18, cat. no. 2) are typical of Motley's student work. *The Chef*, an exercise in combining portrait and still life, shows the influence of Buehr in the

Fig. 7. Archibald J. Motley, Jr., 1913. Collection of Archie Motley and Valerie Gerrard Browne.

variety of reflective surfaces Motley employs. In addition to Walcott, Krehbiel, and Buehr, Motley studied with John Norton (1876–1934) whose interest in murals (he painted murals for the Daily News Building and Midway Gardens among other commissions) may have inspired Motley to work in this medium in later years.

While at the Art Institute, Motley became very close friends with two other students: Russian-born William Schwartz (1896–1977) and Czechoslovakian-born Joseph Tomanek (1889–?). Known as the "Big Three," the young art students were very supportive of each other, and they often worked together on weekends and holidays at Tomanek's studio.[17] Tomanek made frames for Motley's paintings and encouraged him to submit his *Portrait of My Mother* (1919, cat. no. 4), to the annual exhibition of Chicago area artists when Motley's own confidence in his work flagged.

Motley regularly viewed the Art Institute's collection of American painters, and he was especially fond of the work of John Sloan, Randall Davey, and George Bellows. Bellows, a member of the Ashcan School, a group of artists who pioneered the realistic portrayal of the urban scene, taught at the Art Institute for a term in 1919, and Motley returned after graduating to sit in on the class. Motley was probably familiar with two of Davey's works in the collection, *The Flower* and *Portrait of a Lady*, and he must have also seen Bellows' *Love of Winter* and *The Village Houses* during his student days. Among European works at the Art Institute, Motley was especially taken with George S. Seurat's *Sunday Afternoon on the Island of La Grande Jatte*, to which Motley later paid tribute in his *Lawn Party* (c. 1937, cat. no. 45).

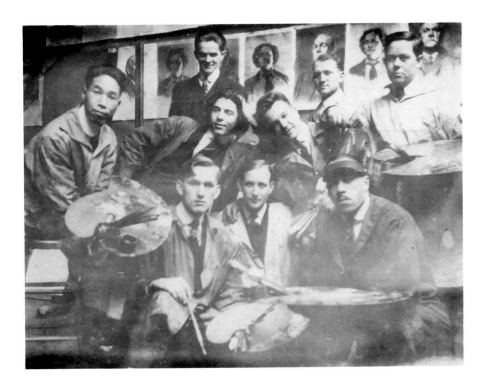

Fig. 8. Archibald J. Motley, Jr., front row, far right, with painting students at the School of the Art Institute, c. 1917. CHS, Prints and Photographs Collection.

PORTRAITURE

The years following his graduation from art school in 1918 were difficult for Motley. The relatively tolerant environment of Englewood had buffered him from experiencing widespread discrimination while he was growing up, but Motley felt the consequences of racism on two occasions soon after leaving the Art Institute. Confident that his training had prepared him for a career as an artist, Motley applied for a commercial artist job downtown. The position was offered instead to a white fellow student who was, according to Motley, much less qualified than him.[18] The 1919 Race Riot, which rocked Chicago's South Side with violence and destruction over a six-day period, frightened Motley and his family, who had never felt such inflammatory racial tensions. The Motleys sequestered themselves in their Englewood home, where white neighbors protected them and took care of their needs through the duration of the incident.[19]

Unable to find work as an artist, Motley continued to work odd jobs—steamfitter, coal heaver, plumber, and waiter—and pursue painting whenever he had time.[20] Although he had been stung several times by racial prejudice, Motley was not embittered by these experiences. Motivated by his belief that black life and culture was intrinsically interesting and by the realization that African-Americans had not been depicted honestly or with any regularity by American artists, Motley made a conscious decision during this period to paint only black subject matter. Through his art Motley hoped to break down stereotypes of blacks and to promote appreciation for and present a true perspective on the full gamut of people who considered themselves Negroes. Motley had already been moving toward this goal in art school, suggesting that the Art Institute use black models in class.[21] Writing some years later on this issue, Motley expressed the philosophy he had formed as a young student and would follow throughout his life:

> For years many artists have depicted the Negro as the ignorant southern "darky," to be portrayed on canvas as something humorous; an old southern black Negro gulping a large piece of watermelon; one with a banjo on his knee; possibly a "crap-shooter" or a cottonpicker or a chicken thief. This material is obsolete and I sincerely hope with the progress the Negro has made he is deserving to be represented in his true perspective, with dignity, honesty, integrity, intelligence and understanding. Progress is not made by going backward. The Negro is no more the lazy, happy go lucky, shiftless person he was shortly after the Civil War. Progress has changed all of this. In my paintings I have tried to paint the Negro as I have seen him and as I feel him, in myself without adding or detracting, just being frankly honest.[22]

Motley's earliest attempts to create an authentic depiction of African-Americans took the form of portraits. Between 1919 and 1931, he painted portraits of members of his family and a series of black women of mixed racial ancestry. Inexperienced and lacking an adequate portfolio to attract patrons to commission portraits, Motley turned to his family, who were available and supportive of his efforts, for his first subjects. Through family portraits Motley explored his African and Creole heritages as part of the search for racial

identity that preoccupied many black artists and intellectuals of his generation. Motley's own mixed ancestry and his fascination with the variety of skin color of black people led him to undertake what he called a "scientific"[23] inquiry into mulattoes, quadroons, and octoroons. Through these portraits Motley hoped to expand Americans' understanding of race and to help them appreciate the wide spectrum of black culture and character.

These early portraits fall into two groups: those in which the figure is set against a plain background, which focuses the viewer's attention on a subject who looks straight out of the painting; and those whose figure is placed within a domestic setting filled with representative or symbolic objects. Although these early works reflect Motley's formal training at the Art Institute and follow the conventions of American portraiture, they are particularly important because they apply these techniques to black subjects, resulting in portraits rather than stereotypes.[24]

Rita (c. 1918, cat. no. 3), the earliest portrait of this group of paintings, depicts Motley's niece, Flossie Motley's young daughter, a sickly child who died from diphtheria in 1927. The only child portrait Motley did in his career, it shows Rita's head and upper body almost filling the canvas as if the artist were trying to compensate for her small stature or the small dimensions of the canvas (this 17 1/8-by-14 1/4-inch painting is in fact Motley's smallest finished work). Rita is stopped only momentarily, focused outward with childlike intensity before disappearing in a blur of activity. Full of kinetic energy, Rita is a haunting figure who draws the viewer in close to her as if to hear her speak. Although Motley came to be an accomplished colorist, his color scheme for *Rita*, browns and blacks, reflects the limited palette of his student exercises. Only the bright red hair bow hints at what is to come.

Rita is the exception in this group of family portraits. The other portraits are quiet, almost solemn in character. Depicting their sitters as highly dignified people, these portraits convey Motley's deep respect for the elders of his family. *Portrait of My Mother* (1919) is a tightly rendered representation of Mary F. Motley that captures the artist's deep respect for his mother. The freer, more expressive form and immediacy of *Rita* are replaced by precise brushwork, a still posture, and respectful distance. The somber palette is illuminated by her glowing honey-colored skin and the red accent of the pendant she wears. The dark background and clothing sharply contrast with her light skin and focuses attention on the hands, which appear relaxed and comfortable compared to her overall stiff posture. Here and in other paintings, Motley makes hands an expressive element of the portrait.[25]

Perhaps Motley's most revealing portrait of this period is his *Self-Portrait* (c. 1920 cat. no. 6). This painting captures the young artist in transition from student to professional. Appearing dapper but self-conscious, he surrounds himself with the tools of his trade— the array of brushes and the vibrant color and impasto of the palette indicating the color and life about to burst forth.

In *Portrait of The Artist's Father* (c. 1921, cat. no. 7) Motley depicts his father as a learned man pondering a passage in the book he holds, gazing at the viewer with a stern but dignified visage. Archibald J. Motley, Sr., appears surrounded by symbols of his past.

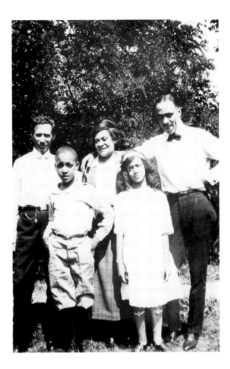

Fig. 9. *From left to right: unidentified, Willard Motley, Mary F. Motley, Rita Motley, and Archibald J. Motley, Jr. Collection of Archie Motley and Valerie Gerrard Browne.*

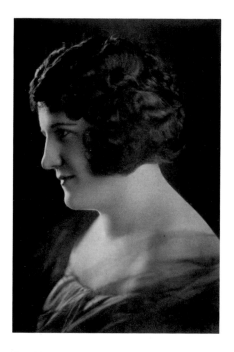

Fig. 10. *Edith Granzo. Collection of Archie Motley and Valerie Gerrard Browne.*

The painting of a farm scene in the background recalls his father's humble rural southern origins, while the books and figurine represent his solid middle-class standing and more sophisticated life in the urban North. The father's hand, holding a cigar that juts forward toward the viewer and appears exaggerated in size, appears relaxed and at ease compared to his otherwise formal appearance. Although Motley is beginning to experiment with more complex and interesting lighting in this painting, he has not yet mastered his command over all of these elements.

Motley painted two important portraits of his paternal grandmother, Emily Motley, during this early period. *Portrait of My Grandmother* (1922, cat. no. 9) is a remarkable painting and a milestone in Motley's development as an artist. As in his earlier portraits, a solemn dignity and respect for his family stands out, but here the stillness and quietness speak volumes about the life of this elderly matriarch. In her shrunken posture, her lined face, and her bony hands, Motley captures both the frailty and the beauty of age. Her gnarled and crooked hands seem awkward in repose; idle hands seem not to be part of her character. Using a patinalike gray background and full but soft lighting, Motley achieves his most successful use of the muted palette, resulting in his brightest and most vibrant painting to date.

In *Mending Socks* (1924, cat. no. 10) Motley shows a breakthrough in his ability to create a three-dimensional space in his work. Attending to the humble task of darning socks, Motley's octogenarian grandmother is busy with her hands, but she appears frailer in this portrait, perhaps because the cluttered table appears physically to overwhelm her. The cropped oval portrait in the top left corner, a feature Motley uses in many of his paintings, appears here for the first time. Motley's two portraits of his grandmother earned him critical acclaim. *Grandmother* was shown in the Art Institute's 1923 "Exhibition by Artists of Chicago and Vicinity," and *Mending Socks* was selected "best liked painting" during The Newark Museum's 1927 exhibition, "Paintings and Water Colors by Living American Artists."[26]

The success and acclaim Motley received for the portraits of his grandmother was a turning point in his career. Insecure about his future as an artist and unsure of his financial standing, Motley had postponed marriage to Edith Granzo since his student days at the School of the Art Institute. Motley's decision finally to marry (they were wed on February 14, 1924) was a reflection of his new confidence in himself. But Motley made clear to Edith that his art would come first before anything else.[27] For the nearly twenty-five years of their marriage (Edith died in December 1948) Edith remained committed to Motley and his work and provided both emotional and financial support when it was needed, working a number of different jobs, including masseuse and clerical worker, to support her family. Unable to cope with their daughter's marriage to a black man, the Granzos apparently disowned Edith; only a brother, Art, kept in contact.[28]

Motley's fascination with skin color was rooted in his own Louisiana-Creole heritage, his sensitivity as an artist to the nuances of color, and the status American society attributed to gradations in skin color. "Form is essential to me," Motley wrote, "only as a means of producing a pleasing composition; color being more important as an expres-

sion of the numerous shades and colors which exist in such great variety among Negroes."[29] His first work in a series of portraits of women of mixed racial ancestry, *Mulatress with Figurine and Dutch Seascape* (c. 1920, cat. no. 5), depicts a young woman whose race or ethnicity is not readily evident from the painting alone. Neither her expression, the figurine, nor the small Dutch seascape offer any clues. Though Motley's color scheme is not radical, it nevertheless is a bold venture away from the browns, blacks, and grays he had favored for his family portraits.

Light in skin color himself, Motley painted another mulatress[30] (1924, checklist no. 5; fig. 11) and a quadroon (c. 1927, checklist no. 13), but he devoted several canvasses to octoroons; he "was sincerely interested in pigmentation of the skin in regard to the lightest type of colored person . . . consisting of one-eighth Negro blood and seven-eighths caucasian blood."[31] Motley was clearly inspired when he painted his first octoroon portrait, *Octoroon* (1922, cat. no. 8). Captivated by her youth and her beauty, Motley adorns this graceful, willowy woman with pearls to give her an aristocratic bearing.

Motley was especially pleased with his second octoroon portrait, *The Octoroon Girl* (1925, cat. no. 12), and compared it to his painting of his grandmother. "I think outside of my grandmother's [*The Octoroon Girl*] is the best portrait I've painted."[32] Motley painted another octoroon portrait, *Aline An Octoroon* (c. 1927, checklist no. 11; fig. 11), as well as *Head of a Quadroon*[33] (c. 1927, checklist no. 17). In a discussion of *Aline, An Octoroon* Motley wrote:

> In some cases it is quite difficult to determine precisely whether or not a person is pure caucasian or octoroon. I have seen octoroons with skin as white as people from northern Europe such as the Baltic countries; with blond straight hair, blue eyes, sharp well proportioned features and extremely thin lips. The head is normal and well constructed and symmetrically balanced. The construction of the body such as an elongation of the arms, a tendency toward a weak bone construction found in many of the dark purer Negroes and large fat heels are nonexistent. In fact a very light octoroon could be compared favorably with a Swedish or Norwegian person. In this painting I have tried to show that delicate one-eighth strain of Negro blood. Therefore, I would say that this painting was not only an artistic venture but also a scientific problem.[34]

The figure in *Woman Peeling Apples* (1924, cat. no. 11) is a sharp contrast to Motley's elegant octoroons and quadroons not only in skin color but also in social class. Her clothes are no match for the au courant fashions of these sophisticated African-Americans, and one cannot imagine their long slender hands peeling apples. But Motley portrays this woman with dignity and strength. Her gaze is confident, and she takes pride in the task at hand. Motley has painted her with great sensitivity, reflecting the light off her scarf to cast a purple hue over her face that softens her features. Although Motley did not typically separate social classes from each other in his paintings (he tended to mix them together), this painting shows that Motley was not ignorant of class issues in black life.

Reception (1926, cat. no. 13), which depicts a group of upper-class white women

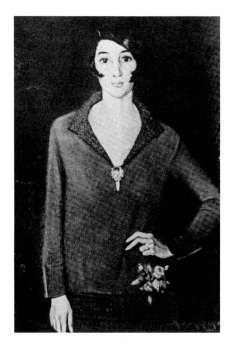

Fig. 11. Aline, An Octoroon, *(c. 1927, checklist no. 11). From* Opportunity, *September, 1926.*

9

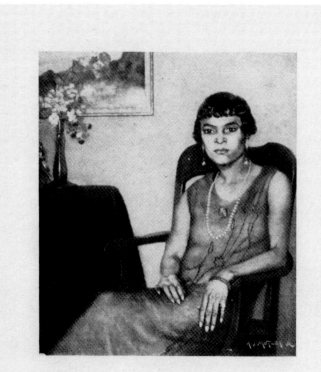

February 25th through March 10th, 1928

EXHIBITION OF PAINTINGS
BY
ARCHIBALD J. MOTLEY, JR.

The New Gallery

600 MADISON AVENUE · NEW YORK

NOTE: The first one-man exhibition in a New York art gallery of the work of a negro artist is, no doubt, an event of decided interest in the annals of the American school of painting. It seems, however, worth while to record the fact that the invitation to Mr. Motley to show his paintings at The New Gallery was extended prior to any personal knowledge concerning him or his lineage and solely because of his distinction as an artist.

Fig. 12. Cover of the catalogue for Motley one-person exhibition at the New Gallery, 1928. CHS, Archives and Manuscripts Collection.

being served by a black servant, is one of Motley's earliest paintings that comments on black-white relations. It is especially noteworthy for its play of interior lighting on the setting and Motley's use of color. The orange lampshade, the purple window frame and shadow on the rug, and the red light emitting from the fireplace across the rug all anticipate the vibrantly colored compositions still to come. Although paintings of interior settings gave Motley the opportunity to experiment with light and color, financial return may also have been one of Motley's motivations for turning to paintings of everyday life. Comparing portraiture and genre composition, Motley stated that, with the latter, "I felt that I could build up more saleable things than I could with portraits.[35]

By the mid-1920s, Motley's exhibited paintings earned him local and national recognition as well as students for his private art lessons, which he began offering in 1926. He showed his paintings in several of the Art Institute's annual "Chicago and Vicinity" exhibitions, he participated in two exhibitions staged by the No-Jury Society of Artists, he was included in the prestigious "Paintings and Water Colors by Living American Artists" exhibition at The Newark Museum, and he showed work in several other exhibitions in Illinois and in New York. His widest exposure and acclaim came in 1928, however, when the New Gallery of New York City organized a one-person show of his work. Robert B. Harshe (1879–1938), director of The Art Institute of Chicago, took a special interest in Motley's progress as a student.[36] Harshe, a painter, had often called Motley out of class to visit with him in his private office, where he gave advice and information to the young student. On a personal trip to New York in 1927, Harshe contacted two galleries about organizing a one-person show of Motley's works, and both expressed interest.[37] Motley decided that George Hellman, president of the New Gallery at 600 Madison Avenue, offered him the best terms, and he began working to complete paintings for the exhibition. Motley exhibited twenty-six paintings at the New Gallery for two weeks, from February 25 to March 10, 1928.[38] The exhibition included five new works that focused on African themes, ten portraits, three works relating to black music and dance, and eight genre scenes.

Motley undertook the African paintings at the urging of Hellman, who wrote: "My general suggestion to you would be . . . [to] paint some pictures showing various phases of negro life in its more dramatic aspects—scenes, perhaps, in which the voo-doo element as well as the cabaret element—but especially the latter—enter."[39] Hellman clearly recognized the sales potential of Motley's work and directed the artist accordingly to take advantage of the growing interest in African-Americans and the art that represented them during the era popularly known as the Harlem Renaissance. During the Jazz Age, whites joined black artists, writers, musicians, and intellectuals in celebrating the exuberant freedom of "Negritude" and its African roots. Being black during the Jazz Age was fashionable, as historian Nathan Irvin Huggins suggests:

> The Jazz Age meant new behavior, new styles, new morals, and white
> Americans were all to eager to break constraints of rural, puritan America.
> Harlem had become the white folk's playground and most blacks loved it.
> Musicians and dancers got work at such places as the Cotton Club and

Connie's Inn (neither of which catered to black folks) and Small's. Fun-seeking whites brought money uptown and that was good. It was also fun for blacks to watch them act "colored." No white visitor to New York would consider his stay complete without an evening in Harlem.[40]

Although African themes were a new direction in Motley's work, they were not inconsistent with his earlier work. Inspired by the many stories his grandmother Harriet Huff passed on to him about life in East Africa, Motley drew on his African ancestry for a series of paintings on the theme of Vodun (voo-doo) to satisfy Hellman's request.

Waganda [Uganda] Woman's Dream (1927, checklist no. 10), *Waganda [Uganda] Charm-Makers* (1927, checklist no. 26; fig. 13), *Kikuyu God of Fire* (1927, cat. no. 14), *Devil-Devils* (c. 1927, checklist no. 16) and *Spell of the Voodoo* (c. 1927, checklist no. 25).

Kikuyu God of Fire portrays a deity who carries men into the air and is typical of these paintings. Motley's fire-god is an enormous, lithe, sexless, steer-horned, and bat-eared creature with flaring nostrils, electric green fingernails, and a half-open mouth from which sparks rain down on the diminutive Kikuyu warriors and women, whose spears and cloaks cannot shield them. Their metal weapons, gold anklets, and bracelets glint in the light of the fire as they try to flee into the forest of feathery palm and darker trees. It is as if Motley had caught the essence of the human condition: frozen in flight from a terrifying yet shimmering evil, which like fire is illuminating, the figures flee toward a safe place they will never quite reach. Meanwhile, the awesome deity, in an ecstasy of anticipation, is forever on the verge of capturing his prey.[41]

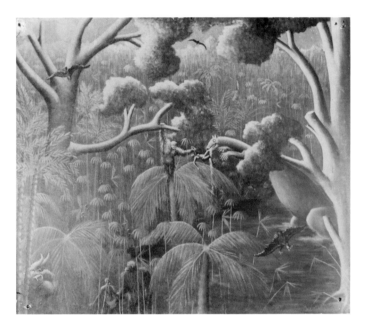

Fig. 13. Waganda [Uganda] Woman's Dream, *(1927, checklist no. 10). From* The New York Times Magazine, *March 25, 1928.*

Motley's African paintings were the most controversial works in the exhibition, and the *New Yorker* magazine questioned the validity of the work: "For the subjective things, boys' imaginings of Voodooland, we do not care at all. Such things, to be real primitives, could hardly be executed by the young man who painted the sophisticated *Octoroon* and *Black and Tan Cabaret*."[42] Marya Mannes was especially critical of this series in her review of the exhibition in the April 10, 1928, issue of *Creative Art*: "In some of his portraits and cabaret scenes he shows considerable character and technical proficiency; in his African voodoo fantasies and garden party idylls he suggests the cheapest, most blatant ten-twent-thirt illustrations, brightly glazed."[43] Only Edward Alden Jewell seemed to understand and appreciate Motley's attempt to connect the New Negro Movement to its ancestral roots:

Here are steaming jungles that drip and sigh and ooze, dank in the impenetrable gloom of palm and woven tropical verdure, or ablaze with light where the sun breaks fiercely in. Here are moons that rise, yellow and round, quizzical and portentous, aureoled with a pallor or sorcery;

crescent moons with secrets cryptically packed in the shining scimitar, and moons that wane and die with a shudder of spent prophecy. There are mummified heads of enemies rudely cased in clay, embellished with gaudy colors. There are devil-devils watching in the night or poised to swoop on hapless human prey. There are thunders and lightnings with reverberation imprisoned in their heart of death. There are charms, simple unsearchable, to lure a smile or to ravage with the hate of vampires.

Glistening dusky bodies, stamping or gliding, shouting or silent, are silhouetted against hot ritual fires. Myriad age-old racial memories drift up from Africa and glowing islands of the sea to color more recent ghostly memories of plantation days when black was black and slaves were slaves; and, these memories sift, finally, through Negro life in Northern cities of the present, leaving everywhere their imprint and merging with a rich blur of tribal echoes.[44]

The exhibition was a commercial and professional success; twenty-two of the twenty-six paintings sold. *The New York Times Magazine* incorrectly reported in a special boxed article on the front page of its February 25, 1928, issue that Motley's exhibition was the first one-person exhibition of a black artist in American history. In fact, Henry Ossawa Tanner (1859–1937) had a one-person exhibition at the American Art Gallery in 1908. But the *Times* report demonstrated the importance of Motley's exhibition.

Even though Motley had paid a gallery commission and rental fees and helped to defray the cost of publishing the catalogue of the exhibition, he must have cleared between five and seven thousand dollars, a large sum in 1928. The exhibition's success was due in part to the network the artist and the gallery owner had put together. A number of collectors interested in black artists and black subject matter purchased the majority of the paintings. Hellman presumably contacted the members of this East Coast group, which included: Mrs. T. Morris Murrray, Ralph Pultizer, Carl Hamilton, and John E. Nail.[45] Nail, a black real estate developer of considerable means, lived in Harlem. In a letter to the artist after the exhibition had opened, Nail discussed his views on the collecting of art:

> As to your hope that this purchase may prove an inspiration to colored people to develop an appreciation for colored artists, I think this will come in time, but hardly in your generation or mine. I believe the acquisition of art objects on the part of our people is not cultivated because they are things that are not sufficiently showy for their capital to be invested in like automobiles or fine clothes or fine houses, but after they have sufficiently evolved and developed a real culture, the Negro artist who has arrived will undoubtedly be supported. I do not think you should think so much about any particular racial group being interested in your work. Seriously pursue your art, and the world will be your market.[46]

Harshe, intensely interested in Motley's progress, had written personal letters without the artist's knowledge to five of Chicago's wealthiest African-Americans, explaining who Motley was and why he deserved their support. The responses, which Harshe

reluctantly showed to Motley, were insulting, shocking, and distasteful, stating in effect that because he was a white man, Harshe should "mind his own business"; the five men said they did not require his assistance to help them spend their money.[47] Patronage from the African-American community was to be a passionate cause for Motley. He later wrote bitterly:

> As a Race, the present American Negroes are educated, they are *literate,* they are ambitious, they are trustworthy and they are noble. But this group is lacking that one essential qualification, that one most important, most vital thing, (Culture). A man may be educated and still lack culture, in the true sense and a man may be cultured and still lack education. Therefore, why not encourage Negro Art by appreciating it, *by buying it*. If the Negro artist has no market for his products; if that market is to be limited only to a few sympathetic, philanthropic and kind gentlemen of the other group, it means discouragement and lack of confidence in the heart of the struggling Negro artist. Instead of literally littering our walls and our homes; and we have many homes that compare favorably with the best in America, smearing them with buck eyes, cheap chromos, poor copies and purchasing works from (inferior artists) . . . why not search out those painters of the group who are finished and capable artists and purchase their works.[48]

Although Motley's concern for patronage was to be born out by later experience, his New York show was a critical and popular success, and African-Americans flocked to the gallery. The exhibition was a great event, recalled Edward Morrow, then an undergraduate at Yale University and an adopted nephew of Bessie Bearden, the mother of artist Romare Bearden (1914–88). Bessie Bearden had become a powerful New York socialite, public relations figure, and newspaper reporter. At the time of the New Gallery exhibition she was the New York correspondent for the *Defender,* Chicago's black daily newspaper. Like other black writers, she wrote a positive review of Motley's exhibition. She also frequently promoted black artists, and in Motley's honor, she planned an elaborate black tie gathering intended to give his career an additional boost.[49]

In addition to Motley, Beardon had invited artists who were affiliated with the Harlem Renaissance: sculptor Augusta Savage (1892 or 1900–62) and painters Aaron Douglas (1899–1979), O. Richard Reid (b. 1898), Richard Bruce (Nugent) (b. 1906), and Charles Alston (1909–79). Motley, however, did not attend the reception. Perhaps he felt some competitive hostility from the other artists, or he may not have wanted to be associated with the movement, no matter how innocent such a gathering might be. According to Edward Morrow, Motley did not appear because he did not have proper formal clothes.[50] Whatever the reason, Motley had formed his own ideas about the importance of black artists depicting African-Americans and black life in their paintings independently of the New Negro Movement and the Harlem Renaissance artists. About this time, Motley complained about the lack of vision among contemporary black painters and the need for them to portray their own lives and people:

There exists entirely too much imitation and not enough originality . . .
Our artists are entirely too much interested and influenced by the modern
school of French painting. In practically all exhibitions of our group, I have
"seen" Renoir, Matisse, Corot, and many other Frenchmen imitated and
poorly copied. Occasionally, I noticed here and there a futile attempt at the
portrayal or depiction of our vibrant and rapidly progressing Negro Race.
And this field is such a broad one, such an extremely interesting and
important part of our American civilization. What a pity so many of our
artists go in for pretty landscapes and pictures which have no bearing what-
soever on our group. The Negro poet portrays our group in poems, the
Negro musician portrays our group in jazz, the Negro actor portrays our
group generally with a touch of hilarity, comedy dancing and song. And
now he is grasping for and is succeeding with that which is more serious in
the theatre; the drama. All of these aforementioned portrayals are serious,
original interpretations of the Negro. There is nothing borrowed, nothing
copied, just an unraveling of the Negro soul. So why should the Negro
painter, the Negro sculptor mimic that which the white man is doing,
when he has such an enormous colossal field practically all his own; por-
traying his people, historically, dramatically, hilariously, but honestly. And
who knows the Negro Race, the Negro Soul, the Negro Heart, better
than himself?[51]

Looking back on his New Gallery exhibition some years after the event, Motley
spoke with some bitterness about the little support he received from fellow black artists
and their reluctance to embrace a position on race he had long advocated. He felt his
exhibition ". . . was very daring. I had the guts and the ambition to carry it through. So
many colored artists discouraged me . . . Now you take the average Negro, if they'd get
out of that way of thinking that 'Oh, I can't send that [paintings with black subject matter]
in there because the white folks they're not going to have that....' They told me that
when I was younger, when I sent in paintings like *Mending Socks*. They said 'they're not
going to have that.' White artists, friends of mine, disagreed with them entirely."[52]

While in New York, Motley apparently found his kindred spirit not in fellow black
artists but in Mexican artist Miguel Covarrubias, who had a one-person show at the
Valentine Gallery at 43 East Fifty-seventh Street. Covarrubias came to see Motley's exhi-
bition, the two artists had lunch together, and then went to see Covarrubias's exhibition.
Covarrubias, who had visited Africa, dealt with Caribbean, African, and Harlem themes
in his works on exhibit. Works from his 1927 publication *Negro Drawings* show singers,
shake dancers, bands, and cabarets, all subjects that would occupy Motley. Covarrubias's
style borders on caricature; it is lively, brazen, and rambunctious like some of the seven-
teenth-century Flemish and Dutch artists Motley admired. There was obviously a meet-
ing of the minds and artistic styles between Covarrubias and Motley, who brought his
own special brand of vibrancy and gusto to his paintings about music and life in
Bronzeville.

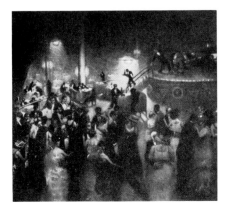

Fig. 14. Syncopation, *(1924, checklist no. 4).*
From Revue du Vrai and du Beau, *July 10, 1925.*

Although Motley disassociated himself from the Harlem Renaissance artists, he found a strong supporter in W. E. B. DuBois, a major figure in the New Negro movement, who closely followed the artist's career. DuBois, editor of *The Crisis,* the magazine of the National Association for the Advancement of Colored People, encouraged black achievement, culture, and self-awareness during the 1920s and was among those to whom Motley sent copies of articles on his work by Comte Chabrier that appeared in the French publication, *Revue du Vrai et du Beau.*[53] DuBois publicized Motley's work in several issues of *The Crisis,*[54] and listed Motley as a credit to the race in the credit and debit section of his column, "Opinion of W. E. B. DuBois," which appeared in the January 1926 issue. Later in 1952, when DuBois was indicted as a "foreign agent" and branded a communist, he wrote Motley from New York asking him to find some means of expressing his support for the repeal of the Smith Act. DuBois addressed his form letter "To Leaders of the American Negro People." It is not known in what way Motley responded.

Motley had already turned to the depiction of life in Bronzeville in three paintings that date to the early to mid-1920s. In *Stomp* (1927, checklist no. 8), *Syncopation* (1924, checklist no. 4; fig. 14), and *Black and Tan Cabaret* (c. 1921, checklist no. 3), Motley captures the unmistakable energy and rhythm of the Jazz Age. The clubs Motley featured in these paintings, unlike Harlem's Cotton Club, were black-and-tan clubs operated specifically for a mixed audience of African-Americans and whites; these establishments were the spawning ground for great bands, such as the Duke Ellington Band, the Fletcher Henderson Band, and King Joe Oliver's Creole Jazz Band.[55] The interior of the club depicted in *Stomp* recalls the nightclub setting of boxer Jack Johnson's Chicago club, the Café du Champion, which opened in 1912 at 42 West Thirty-first Street; the Chicago Hot Five, Louis Armstrong's band, may have been the model for the four-piece band and singer-shake dancer depicted. *Stomp* also includes among its many characters the first appearance of the short, fat, bald-headed figure (who or what this enigmatic figure represents is not clear), who is found in many of Motley's paintings.

During the summer following his one-person exhibition in New York, Motley traveled to Pine Bluff, Arkansas, to visit relatives and to paint. As an adult, Archibald Motley continued to travel south; his decision to go to Pine Bluff in the summer of 1928 was motivated in part by his desire to see his elderly uncle, Robert White, and to paint his portrait. Going south also gave him the opportunity to paint subjects unavailable to him in an urban setting. Traveling with two unidentified Chicago artists, Motley must have found this painting trip welcome rest after his hectic winter and spring.[56]

Motley painted several landscapes that summer: *Barn and Silo* (1928, cat. no. 15), *Boat and Houses by the River* (1928, cat. no. 16), *Landscape* (1928, cat. no. 17), and *Landscape—Arkansas* (1928, cat. no. 18). Although painting in nature allowed Motley to pursue his ever present curiosity about natural light, these landscapes reveal a deeper chord in the artist. They also presented him with another opportunity to explore his southern origins. Working in earth tones, he depicted a rural setting that recalled home to many transplanted blacks in Chicago.

Motley executed two portraits while he was in Arkansas. Both *Uncle Bob* (1928, cat.

no. 20) and *The Snuff Dipper* (1928, cat. no. 19) depict people of the soil. Motley's uncle, who must have been about ninety years old when the portrait was painted, is shown on the front porch of his Pine Bluff home. Once again, Motley paints a member of his family with great sensitivity to his age. Uncle Bob was a hardworking man, and Motley captured this in his depiction of the hands of a man who has worked the land—large, hard, farmer's hands.

The Snuff Dipper records a local custom of dipping tobacco using a twig from a special tree. A snuff dipper would chew on one end of the twig until it softened, then shape the end into a scoop or spoon. Motley depicts the figure in similar fashion to earlier portraits. She could easily pass for one of his city dwellers; the twig in her mouth is the only element that distinguishes her as a rural person.

In *Tongues* (1929, cat. no. 25) Motley captures the moment when the members of a sanctified or Pentecostal church are touched by the Holy Spirit; they move, they shout, and they dance, seemingly out of control. As a practicing Catholic, Motley may not have personally experienced this style of worship, but most likely he visited such a church during his stay in Arkansas. Similar swaying figures like the minister and the woman in the white dress appear in later works, such as *Saturday Night* (1935, cat. no. 35). Motley's use of artificial light, which casts dark, dramatic shadows, and the symbolic reference to the Holy Trinity in his depiction of three lights and three windows, unifies the composition and conveys the spiritual excitement of the moment.

When Motley returned to Chicago after his trip to Arkansas he brought his cousin Fannie to live in Chicago with his family. He also had come down with a case of malaria, and his family nursed him back to health in preparation for his trip to France.

PARIS

On July 18, 1929, Archibald Motley, with his wife Edith, sailed out of New York Harbor on the steamer *Rochambeau* bound for France to begin a year of study as a Guggenheim fellow. In the study plan he submitted with his fellowship application, Motley cited further development of technique as his primary goal, explaining that he would "specialize in the study of masterpieces in the Louvre, as to color composition, drawing and technique, laying most stress on a serious study of the relationship of cold and warm light."[57] But Motley may also have been drawn abroad to discover something more about his own French roots and to learn firsthand about race relations in another country. Indeed, Motley made clear his intentions not to immerse himself completely in European culture, but to continue to confront the same issues that had been of critical importance to him in his art thus far. "I would visit the Louvre every morning," he wrote,

> and do creative painting afternoons, or vice versa. I would paint composi-
> tions and genre-pictures, paintings depicting the the various phases of
> Negro life. I would like to paint about twenty or thirty pictures . . . where
> the play of cool and warm light would be an important factor. To me it
> seems that pictures portraying the suffering, sorrow, and at times the child-
> like abandon of the Negro; the dance, the song, the hilarious moments

17

when a bit of Jazz predominates, would do much to bring about better relations, a better understanding between the races, white and colored.[58]

For more than two months the Motleys lived at the Istria Hotel at 29 Rue Campagne Première, a very popular hotel for artists (Josephine Baker stayed in the same hotel in 1925 when she was part of Le Revue Nègre). Motley and sculptor Benjamin Greenstein (1901–?)[59], who became friends in Paris, acquired studios at 16 Rue Simon Dereure, not far from the Sacré-Coeur in Montmartre, where many artists worked. Motley's space—a bedroom, kitchen, bathroom, and a fifteen-by-nineteen-foot studio—was on the second floor (Altelier 48), and Greenstein was directly below on the first floor.

Motley completed fifteen paintings while in Paris: six portraits, five paintings about black life, one canvas devoted to black life in Paris, and three genre paintings about Parisian life.[60] Several of the paintings show Motley's interest in recording the range of cultures represented by black people. *Martinique Dancer* (c. 1929–30, checklist no. 30)

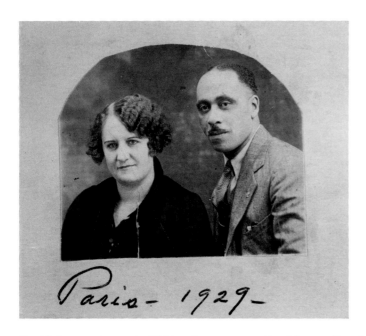

Fig. 15. Passport photograph of Edith and Archibald J. Motley, Jr., 1929. Collection of Archie Motley and Valerie Gerrard Browne.

and *Martinique Youth* (c. 1929–30, checklist no. 31) represent the Creole heritage that was a part of Motley's life as well as that for vast numbers of people in the West Indies. Although he had alluded to these roots in earlier paintings, in Paris he found plentiful examples of this fusion of French and African cultures. In *Senegalese*[61] (c. 1929–30, checklist no. 33) Motley depicts a young African man dressed in European clothes. The composition, which the artist considered one of his most successful, uses the stark whiteness of the shirt to highlight the rich, dark skin tones of the model.

Although Motley had tried in some of his paintings to inspire African-Americans to appreciate their African heritage, in Paris, ironically, Motley found Africans embracing American culture through its jazz and blues. *Blues* (1929, cat. no. 21), Motley's masterpiece about the fusion of Africa and America in Paris, depicts the Petite Café, a popular jazz club whose patrons included Senegalese, Libyans, Martiniquais, and other French-speaking African and West Indian people.[62] In style and subject matter it is a continuation of his exploration of music and black life. But In Blues, jazz is celebrated not only as one of the most popular black cultural innovations, but also as one of the few bridges across cultural boundaries that united people of different nationalities and races in a common bond.

Motley painted three paintings of family members during his Paris stay. *Portrait of My Mother* (c. 1930, checklist no. 36) was completed while Motley's mother visited the artist and his wife in France,[63] and Edith Motley was the subject for both *Nude* (1930, cat. no. 26) and *Portrait of Mrs. A. J. Motley, Jr.* (1930 cat. no. 27). In the latter, the artist's wife is elegantly dressed in garments and jewelry purchased in Paris and appears somewhat hardened.[64] The fox fur practically engulfs her and echoes her own dark eyes and red

hair, while the dark background exaggerates the whiteness of her skin. Literally stripped of all of theses accoutrements in *Nude*, Edith seems vulnerable by contrast. At the same time he was painting portraits, Motley was also working on other compositions, including *The Flight* (c. 1929, checklist no. 29), *Sharks* (c. 1929–30, checklist no. 34), *Refugees* (c. 1929–30, checklist no. 32), and *Spirituals* (c. 1929–30, checklist no. 35).

The paintings *Dans la Rue, Paris* (1929, cat. no. 23), *Cafe, Paris*[65] (1929, cat. no. 22), and *Jockey Club* (1929, cat. no. 24) chronicle life in Paris in much the same way that countless other artists' street and cafe scenes have captured the charm of the city. Motley clearly reveled in the recording of daily urban life in the French capital, and in the streets, cafes, and clubs he found something reminiscent of Chicago. Although his palette is very light in *Dans La Rue, Paris* compared to previous works, this painting is a prototype for Motley's 1930s and 1940s Bronzeville street scenes in which he combined buildings and vignettes from many different streets to achieve an exciting composition. *Jockey Club*, a night scene where Motley once again explores the mix of natural and artificial light (including headlights) on the street, is also a statement about French racism and the politics of exclusion. The black doorman, although at the center of the composition, remains outside of the activity of the scene.

The Guggenheim Foundation offered Motley a six-month extension of his fellowship if he would make reports and send photographs of his progress. Although he had enjoyed his stay in Paris, he declined the offer, saying that he missed Chicago and wanted to go home.[66]

BRONZEVILLE

The period following Motley's stay in Paris was clearly a pivotal point in his career. After returning to America, Motley painted in a fresh and vibrant manner, committing himself to the portrayal of the black experience in genre scenes of Chicago's Black Belt. He also struck out in new directions, notably mural painting under the auspices of the Works Progress Administration (WPA). Motley conceived and executed several works in a series on black history in the 1930s and 1940s, and he showed his work in a number of national and international exhibitions.

Motley's last portraits from this period are particularly important: *Portrait of a Woman on a Wicker Settee* (1931, cat. no. 29), *Brown Girl After the Bath* (1931, cat. no. 28), and *Self-Portrait* (1933, cat. no. 31). *Portrait of a Woman on a Wicker Settee* (possibly the artist's mother) includes in the left corner a reproduction of *Baldassare Castiglione* by Raphael, which Motley must have seen at the Louvre. In this portrait, Motley's depiction of space is more successful than in previous works. As a result, the setting, though still academic in execution, is more dynamic, and the figure seems more at home in her environment. Symbolism becomes less important than composition and the attempt to depict an accurate portrait in a believable space.

Motley develops this combination of portraiture and composition even further in *Brown Girl After the Bath*. Painted in dark, sensuous tones, *Brown Girl After the Bath* is an arresting work. The figure, looking at her reflection after having just completed her bath,

19

Fig. 16. Archibald J. Motley, Jr. with one of his paintings, possibly Portrait of My Mother, *c. 1930. From the Chicago* Defender, *September 21, 1933.*

stares back at the viewer in the mirror. This double portrait is a complex composition, but Motley handles it superbly, creating an engaging illusion of space that focuses our attention on the girl, who appears relaxed and natural, poised in a moment of reflection.

In his 1933 *Self-Portrait*, Motley holds the same palette that appears in his earlier *Self-Portrait*, but the artist and his environment are quite different.[67] In this more relaxed and revealing portrait, Motley has given up his formal suit for a more practical smock and beret (a reference to his recent Paris visit) and appears as a striking figure who exudes confidence. Clearly at ease with the tools of his trade, Motley places himself in his sunlit studio at work on a painting of a nude instead of the dark opaque background of his first self-portrait. Like *Woman on a Wicker Settee* and *Brown Girl After the Bath*, this self-portrait is a more sophisticated painting in its combination of revealing portrait within a three-dimensional space.

At about the same time, Motley began his long series of paintings depicting Black Belt leisure and street life. *Black Belt* (1934, cat. no. 32) is typical of Motley's paintings of Bronzeville, the South Side community where more than 90 percent of Chicago's African-Americans lived in the 1930s.[68] Motley composed this work so that in the foreground flat silhouetted figures, almost abstract shapes, are presented in a friezelike manner across the picture plane. In the middle ground, figures with their backs turned move away from the viewer toward the background. The artist ingeniously overlaps areas of color to link the different planes of the painting, moving the viewer through the scene.[69] As in *Jockey Club*, another outdoor night scene, the artist is exploring the play of artificial and natural light in the city street.

The *Plotters* (1933, cat. no. 30), *The Boys in the Back Room* (c. 1934, cat. no. 34), and *The Liar* (1936, cat. no. 38) all provide glimpses inside Bronzeville's bars and pool halls. In *The Liar*, the viewer is brought into a back room where events are unfolding dramatically among several men clustered around a table. The man in spats first appears in *The Plotters*, his elbow on the table as he listens intently to the details of a plan outlined on a piece of paper before him. The painting of boxers on the wall records the special role that boxing matches, especially interracial contests, had in the Black Belt as important social and political events. A poker game is in progress in *The Boys in the Back Room*. These hangouts and the characters who frequented them were one aspect of black male life that had intrigued Motley ever since he visited South Side pool halls as a child.

Carnival (1937, cat. no. 43), most likely a portrayal of the black traveling carnivals that moved around the country in the early part of this century, once again reveals Motley's interest in night scenes and his ability to effectively mix natural and artificial light effects. In an innovative use of color, Motley creates a "day-glow" effect by contrasting complementary colors, such as the silhouetted woman in blue at the right who is outlined in a strong orange.[70] *Saturday Night* (1935, cat. no. 36), like *Stomp*, *Syncopation*, and *Black and Tan Cabaret*, evokes the dizzy energy of Bronzeville night life. But here Motley relies more on the orchestrated movement of his figures, rather than color, to create the mood and to recreate the pulsating rhythms.

The artist's rewarding association with the Works Progress Administration's Illinois

Art Project (IAP) began in 1935, the year it was founded. Motley completed a number of mural projects and easel paintings, including *The Liar*, *Marijuana Joint* (c. 1935–36, checklist no. 47), *Surprise in Store* (c. 1934, checklist no. 43), *Progressive America* (c. 1935, cat. no. 37), *The Picnic* (1936, cat. no. 38), *The Jazz Singers* (c. 1937, cat. no. 44), and *In A Garden* (c. 1938, checklist no. 36). He also painted a mural for the Treasury Relief Art Project (TRAP) as well as a number of easel paintings. Motley's paintings were placed in buildings in Chicago, including the Hall Branch Library, Humboldt Park Field House, The Municipal Tuberculosis Sanitarium, and the Juvenile Court.

Motley endeavored to choose appropriate iconography based on the site where the work would be placed. A soothing outdoor scene, *In A Garden*, for example, was created specifically for the State Sanitarium in Evansville, Indiana.[71] Motley's murals were more than enlarged easel paintings; their creation was carefully detailed and designed. Extensive measurements, site visits, and innumerable preliminary drawings were made prior to beginning a project. Concerned with the integration of mural and architecture, Motley would note in some instances the color of the exterior bricks and the interior wall coloring. Motley may have developed his understanding of mural techniques from his Art Institute teacher John Norton, but he appears to have been the only black WPA artist in Chicago interested in murals.[72]

Motley received a number of mural commissions during this period. *Negro Children* (c. 1939, checklist no. 52), *Band Playing* (c. 1936, checklist no. 50), and *Dance Scene* (c. 1936, checklist no. 51) were painted on the walls of the music room of the Nicholas Elementary School in Evanston, Ilinois, and *Recreation* (c. 1940, checklist no. 60), for which *Playground* (c. 1940, cat. no. 49) may be a study, was created for the back of the auditorium stage at the Doolittle School in Chicago. Perhaps Motley's most important mural project was completed outside of Illinois. In 1935, Motley received a TRAP commission to execute a mural in the entrance lobby of one of two new buildings on the Howard University campus in Washington, D.C. Motley chose Douglass Memorial Hall and was given until June 30, 1936, to complete the project. President Johnson of Howard University and Art Department Chair James V. Herring made Motley's stay in Washington easier by covering the cost of his room and board and appointing him a visiting instructor at the university. The subject of the mural for Douglass Memorial Hall (c. 1935–36, checklist no. 46) was, appropriately, the abolitionist Frederick Douglass. Unfortunately, the mural has been painted over. The easel painting entitled *Frederick Douglass* (c. 1935, checklist no. 44) was most likely a study for the Howard University mural.[73]

In 1934 Motley had apparently planned an entire mural and painting series on black history for the WPA entitled "The Evolution of the Negro." He eventually produced fifteen works for this series, including *Africa* (1937, cat. no. 42), *Negroes Captured in Africa* (c. 1938, checklist no. 58), *Picking Cotton* (c. 1933, checklist no. 38), and *Negro Slaves at Work* (c. 1934, checklist no. 41), as well as an oil sketch, *Arrival at Chickasaw Bayou of the Slaves of Jefferson Davis* (c. 1938, cat. no. 47). Although Motley may have created this cycle as a continuous narrative, he probably never expected these works always to be

exhibited together. Motley also painted or created preliminary sketches for other historical works during the WPA period, including *Progressive American* (c. 1935, cat. no. 37), *LaSalle and Tonty Meet the Illini, Lincoln Riding Through Richmond, April 9, 1865* (c. 1940, checklist no. 63), and *Peter Stuyvesant, Governor of New Amsterdam*.

In 1935 Motley entered a competition to execute a canvas for the Wood River, Illinois, post office. His lengthy proposal described in detail how the work would be a historical narrative depicting the early American transportation of passengers, baggage, and mail by stagecoach. In his proposal, Motley tried to capture the commitment of these postal employees to getting the mail safely over long dangerous roads in horrendous weather with the threat of violence:

> We can hear the creaking of the old coach as the straining horses struggle
> to get its great weight to the summit of the unmerciful height and the Inn
> there. On the tree which the coach is passing a poster is visible advertising
> a reward for the capture, dead or alive, of a particularly notorious and successful stage coach bandit.[74]

On July 15, 1935, Motley received official word that his proposal had been accepted; he would be paid $240 for the six-by-four-foot stretched canvas. For the final work *United States Mail* (1936, cat. nos. 40, 41) Motley decided to show the travelers just prior to their arrival at the inn, when the desire to get there safely is the most intense. His cropping of the coach, horses, the tree, and the guide increases the tension and focuses the energy in the central area of the mural.

While *Barbecue* (c. 1935, cat. no. 39) and *Saturday Night* (1935) relate to the iconography of Motley's Chicago paintings, they were probably inspired by scenes in Washington, D.C., when Motley was an instructor at Howard University.[75] *Barbecue*, an outdoor scene illuminated by artificial light and stars, is a fairly calm tableau compared to other works.[76] The waiters in the background move the viewer across the canvas, but the diners in the foreground are immobile. *Saturday Night* is a more lively and engaging rendering of a similar scene. Again Motley uses waiters in the background to move the eye across the painting, but the figures in the foreground are equally animated. The painting virtually rocks with the movement of the dancer, the beat of the band, and the swaying of the diners.

During the 1930s Motley participated in many important exhibitions, including traveling exhibitions of black art sponsored by the Harmon Foundation that were seen throughout the United States. The artist's work was also included in "Udstilling af Amerikansk Kunst," an important retrospective of three centuries of American art, which was shown in Sweden and Denmark. In 1933 the Chicago Woman's Club sponsored a one-person exhibition of Motley's work in their Tudor Gallery, and the artist participated in both of two exhibitions held at The Art Institute of Chicago in conjunction with the A Century of Progress International Exposition in 1933 and 1934.

Despite his success, Motley was denied participation in some exhibitions because he was black. Although his work had been regularly exhibited at the Art Institute's annual juried art shows, appearing at least eleven times between 1921 and 1935, after Daniel

Catton Rich became director of the Art Institute in 1938, Motley's work was accepted for exhibition only once, in 1949. Rich had even attempted to prevent Motley from receiving the Wood River Post Office commission because the artist was black.[77]

Motley continued his association with the WPA in the 1940s. In *Lawd, Mah Man's Leavin'* (1940, cat. no. 48) Motley returns to rural America to depict the tearful farewell of a black woman to her husband, who is perhaps heading north in search of a job. Filled with tension and stylized emotion in contrast to the charm and serenity of his Arkansas series of 1928–29, this painting captures a poignant moment that thousands of African-American families had experienced. Motley completed paintings of historical scenes, including *Lincoln Riding Through Richmond, April 9, 1865*, and he proposed works such as *Lakeside General Station* (c. 1940, checklist no. 62) and *Subway Constructions* (c. 1940, checklist no. 64) but whether these projects were murals or even executed is not clear.[78] Motley was also associated with another WPA project, the founding of the federally funded South Side Community Art Center at 3831 South Michigan Avenue—and he exhibited in its inaugural show, *Paintings by Negro Artists of the Illinois Art Project*. The opening of the center took on great significance for the Illinois Art Project, especially in light of the closing of the Harlem Art Center in New York City. In a letter to Florence Kerr, Assistant Commissioner of the WPA, Peter Pollack, director of the South Side Community Art Center, wrote that "now that the Harlem Art Center has closed its doors, this Center stands as the only progressive organization for free education in the arts and crafts."[79] During its first two months of operation some 6,500 people visited the institution for classes, to view exhibitions, and to hear lectures.

Motley painted several genre scenes during this period, including *The Argument* (c. 1940, checklist no. 59), *Sunday in the Park* (1941, cat. no. 50), *Night Life* (1943, cat. no. 50), *Extra Paper* (1946, cat. no. 53), and the charming *Playground* (c. 1940). Three paintings from the 1940s, *Casey and Mae in the Street* (1948, cat. no. 54), *Gettin' Religion* (1948, cat. no. 55), and *Christmas Eve* (c. 1945, cat. no. 52) are strikingly similar street scenes. All three feature Motley's favorite color, a deep, rich cobalt blue that the artist began to favor during this period and used throughout the 1960s, and each is a night scene lit by artificial and natural illumination. Motley also places his Englewood home in each street scene (it appears slanted in *Casey and Mae*). The scenes pulsate with the electricity of city life and are choreographed with such vitality that one expects the paintings to burst forth with city sounds. *Gettin' Religion* is a particularly successful composition with its strong diagonals unifying the vertical and horizontal elements. Although Casey and his chicken, Mae West, are ostensibly the main focus of the painting, the composition first leads the viewer's eye to Motley's enigmatic bald-headed fat man standing next to a street light. Only then does the viewer pick the eccentric Casey Jones out of the crowd. Eldzier Cortor, an artist who trained at the South Side Community Art Center, remembers that the street hustler had few teeth, talked like the comedienne Jackie "Moms" Mabley, sold hot tamales for five cents, and mesmerized his chickens to perform with him as he sang and danced.[80] *Christmas Eve*, the brightest of the three scenes because of the light reflecting off the snow, is also the most subdued. A Santa Claus stands in the

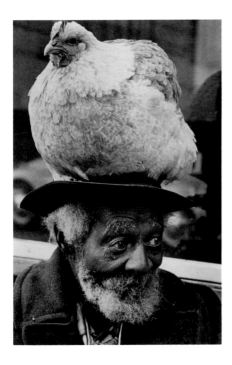

Fig. 17. Casey Jones and his trained chicken, Mae West, Chicago, 1973. Collection of Judge Norma Y. Dotson. Photograph by Ted Gray.

middle of the painting ringing his bell, but the figures moving in the foreground disregard him as they make their way along the street, perhaps on last minute shopping errands.

MEXICO

The 1950s were a period of dramatic change for Motley. Motley, his wife, and young son moved to 3518 South Wentworth Avenue in 1942 and in 1947 they moved back to 350 West Sixtieth Street. When Edith died on December 17, 1948, the artist had to discontinue his painting in order to support his mother and son. Motley found a job with Styletone, Inc., manufacturer of hand-painted shower curtains and worked there for eight years. He was laid off in 1957 but found work with Artistic, Inc., painting shower curtains for about a year. In 1957, at the age of sixty-six, the artist applied for his social security benefits.[81]

Almost all of Motley's œuvre from the 1950s is devoted to Mexican themes.[82] His two Mexican notebooks suggest that the artist was in Mexico from 1953 to 1954 and perhaps in 1957 after he left Styletone. Letters and notes among his personal papers suggest even earlier dates for his visits with his nephew, Willard, an acclaimed novelist, in Cuernavaca—from December 25, 1952 to June 1953. While in Mexico, Motley continued to paint portraits, landscapes, and genre scenes, including cabarets, street scenes, and funerals (some are so large they could pass for murals), and his palette lightened considerably in response to the Mexican light, climate, and environment. Gone at least for the moment are the rich blues of *Gettin' Religion*.

Motley appears to have resided in two areas while in Mexico with Willard: Guanajuato state, northwest of Mexico City and Cuernevaca, just south of Mexico City. Motley most likely visited Diego Rivera's murals in the Palace of Cortes in Cuernavaca while he was there. Petate wall decorations by native artisans introduced him to working in oil on petate mats, which were made from woven palm leaf strips.[83]

Cabaret at Puebla (1953, checklist no. 68), a painting on petate, is an energetic depiction of the interior of a club where many Mexican people are gathered. Like his earlier club paintings of Bronzeville, this scene pulsates with the feeling of Mexican music and its staccato rhythms. Even in the preliminary drawing for this work, Motley has captured the rhythms of Mexico.

The long horizontal format of the petate mat works well for the funeral procession *Another Mexican Baby* (c. 1953–54, cat. no. 59), a commentary on the high incidence of infant death in Mexico. Family and friends on their way to the cemetery are presented in a frieze-like arrangement in the shallow space in front of what may be the cemetery wall. Although strong vertical figures sharply contrast with the horizontal format of the mat, stalks of gladeola flowers and other objects held diagonally help to move the viewer across the painting.

Seri Indian Woman (1953, checklist no. 70) and *José with a Serape* (1953, cat. no. 58) are two portraits from Motley's 1953 visit to Mexico. The Seri Indian woman, who came from the Tiburon Islands on Mexico's west coast, is painted with a Mexican landscape as a background. The landscape with portrait, a new device for Motley, is a logical progres-

sion in his integration of portraits into more illusionary space. But here the portrait and landscape are not well integrated. The painting, flat like a petate mat, has a folk or naive quality. José, who worked for Willard Motley, is rendered in a flat style against a pale yellow background, and the painting is virtually devoid of light and shadow.

Motley's paintings from his second trip to Mexico in 1957–58 are largely genre scenes. *Guanajuato, Mexico* (cat. no. 61), *Calle del Padre* (cat. no. 62), *Callejon de Beso* (cat. no. 63) and *Market Scene, Mexico* (cat. no. 64), are all from 1957; *San Miguel de Allende* (cat. no. 65) and *Near San Miguel de Allende, Mexico* (cat. no. 66) are dated 1958. Motley captures the tropical climate and culture in his soft pastel colors. Unlike earlier works where figures with strong, even exaggerated features, are the dynamic force in his paintings, the figures here are faceless. The men wear sombreros pulled down over their faces, and the women have no features at all. Motley seems more interested in the setting than the people, who appear perhaps only for scale.

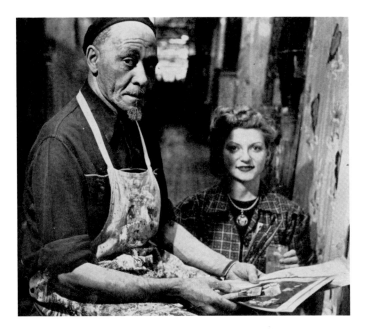

Fig. 18. Archibald J. Motley, Jr., and artist Josephine Franklin study shower curtain designs at work for Styletone, Inc., a manufacturer of hand-painted shower curtains, 1953. From Ebony, February 1953. Photograph by David Jackson.

LATE WORKS

During the 1960s and 1970s, Motley executed only a few paintings, experimenting with new styles and subjects but also returning to his familiar images of black Chicago. In *After Revelry, Meditation* (c. 1960, checklist no. 72), Motley creates an almost surreal image of a Mexican outdoor cabaret after the patrons and the musicians have gone home. Motley conveys a sense of sorrow here in sharp contrast to the usual festive and energetic flavor of his nightlife scenes. The revelry returns in *Barbecue* (1960, cat. no. 67) and in *Hot Rhythm* (1961, cat. no. 68), both scenes that take us back to Bronzeville. In *Hot Rhythm* Motley boldly shifts the band and dancers to the foreground to create a more frenzied mood. Unlike the musicians and dancer in *Saturday Night*, where the musicians had a subordinate role, these performers need no audience; they are caught up in the ecstacy of the moment and the trumpet player beckons the viewer to join in. *Barbecue* is one of Motley's most challenging explorations of natural and artificial light, and he creates a masterful and subtle mix of starlight with the soft glow from Chinese lanterns to cast blue, red, and green light over the scene in a rich interplay of color.

Motley's painting, *The First One Hundred Years: He Amongst You Who Is Without Sin Shall Cast the First Stone; Forgive Them Father For They Know Not What They Do* (1963–72, cat. no. 69), is his most overtly political work and seemingly his most puzzling. Nearly a decade in the making, the work is painted in the style of a religious apocalyptic vision; however, it draws attention not to the future, which is typical of such views, but to the past century. Combining religious imagery with historical figures and symbols from African-American life and culture, Motley assaults the viewer with a horrific record of past injustices against blacks. Although the painting is rich with many layers of meaning, the

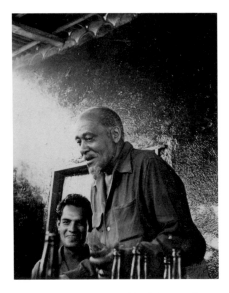

Fig. 19. Mexico, c. 1953–57. Collection of Archie Motley and Valerie Gerrard Browne.

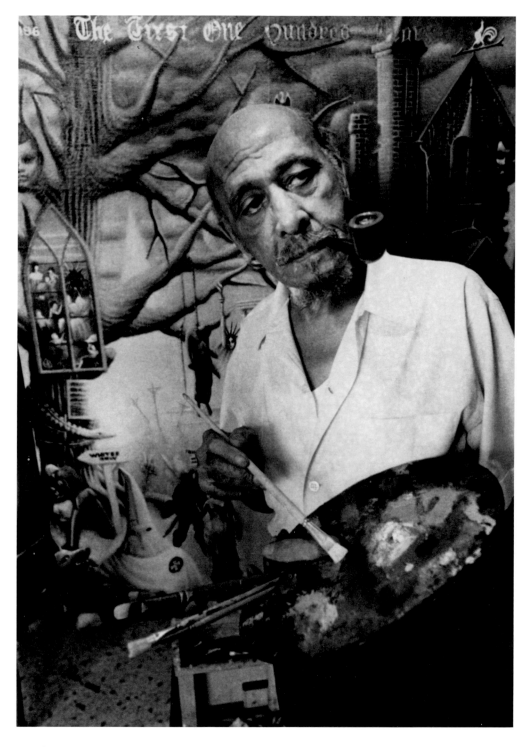

Fig. 20. *Archibald J. Motley, Jr., with his last painting,* The First One Hundred Years: He Amongst You Who is Without Sin Shall Cast the First Stone: Forgive Them Father For They Know Not What They Do, *1963–72. Collection of Archie Motley and Valerie Gerrard Browne.*

powerful juxtaposition of the lynched black man and the Statue of Liberty is the central, riveting image in the painting.[84] But the painting appears to represent a catharsis for the artist rather than a mournful cry of despair. Although Motley makes no clear reference to progress here, the words "1961 The First One Hundred Years" painted at the top of the canvas imply the beginning of a new century of struggle for freedom and equality, not the end of the fight in defeat. Painted not as a warning of some terrible future but as a reminder of a past that must be overcome, the painting ultimately speaks of hope for a better time.

For some African-Americans, the responsibility of representing their race artistically has been a terrible burden. Writing in the first decade of this century, W. E. B. DuBois alluded to this problem in his discussion of his own two warring souls: "an American, a Negro: two souls, two thoughts, two unreconciled strivings, two warring ideals in one dark body whose dogged strength alone keeps it from being torn asunder."[85] More recently, Henry Louis Gates, Jr., identified the issue in a wider historical context:

> For a people who seem to care so much about their public image, you
> would think blacks would spend more energy creating the conditions for
> the sort of theatre and art they want rather than worrying about how they
> are perceived by the larger society. Many black people still . . . feel that
> their precarious political and social condition within American society war-
> rants a guarded attitude toward the way images of their culture are pro-
> jected . . . Given the burdensome role of black art, it was inevitable that
> debates about the nature of that art—about what today we call its "political
> correctness"—would be heated in black artistic circles. These debates
> have proved to be rancorous, from the 20's renaissance through the bat-
> tles between realism and symbolism in the 30's to the militant black arts
> movement in the 60's . . . The burden of representing "the race" in accor-
> dance with explicitly political programs can have a devastating impact on
> black creativity.[86]

Although Motley shared Gates's concern with "creating the conditions for the sort of theatre and art" African-Americans wanted, he appears not to have been burdened by this responsibility. Indeed, his artistic output during his career is testimony to the energy and singlemindedness with which he pursued his personal goal of painting black culture and life. "In my paintings I have tried to paint the Negro as I have seen him and as I feel him, in myself without adding or detracting, just being frankly honest."[87] Unencumbered by political agendas, Motley concentrated on what he loved and knew best—painting. Although he depicted a broader selection of black life than any of his contemporaries, anyone looking for a historical record or a social document of his times will be disap-pointed. But as an artist Motley captured what facts alone cannot—the rhythms, the sounds, the blur of activity, indeed the essence of life itself. An innovative artist who used light and color to create compelling portraits and imaginative composition, Motley's paintings present a remarkable vision of black Chicagoans and their lives.

Fig. 21. *Motley with José, Willard Motley's gard-ner, Mexico, c. 1953–57. Collection of Archie Motley and Valerie Gerrard Browne.*

27

NOTES

1. Interview with Archibald J. Motley, Jr., by Dennis Barrie, January 23, 1978, Archives of American Art, Smithsonian Institution, Washington. D. C.; copy of transcript in Archibald J. Motley, Jr., Papers, Archives and Manuscripts Collection, Chicago Historical Society, ?. Louisiana, one of the last states to bring slaves directly from Africa, was America's largest importer of African slaves. To work the fields of cotton and sugarcane introduced from the West Indies, the Louisiana French imported Africans from the Bantu Cultures of the Lower Congo. By 1600 Creoles—French-speaking people of both French and African heritage—and their slaves numbered about forty thousand people. Their homes were concentrated along the banks of the lower Mississippi River, where Mary F. Huff and Archibald John Motley, Sr., were born. Harriet Huff, maternal grandmother of Archibald J. Motley, Jr., was probably a descendant of the Dorobo (Ndorobo) or one of the related ethnic groups from the Rift Valley Province between Lakes Victoria, Albert, and Nyansa and the Indian Ocean on Africa's east coast. The Dorobo, who live in Kenya and northern Tanzania, are small in stature and are possibly related to the pygmies. Harriet Huff married Henri Breause a French Caucasian. Emily Motley, the artist's paternal grandmother, a mulatress, was from Louisiana and later Arkansas. The artist's mother, Mary F. Motley, was born in Plaquemine, Louisiana, on April 3, 1870 and married Archibald John Motley, Sr., of Napoleonville, Louisiana, on January 14, 1891.

2. "Autobiography" by Archibald J. Motley, Jr., n.d., Archibald J. Motley, Jr., Papers, Archives and Manuscripts Collection, Chicago Historical Society, notes?. Motley was about six years old when his family moved to a two-story flat at 5544 South Morgan Street in Chicago. The Motleys lived at two more Englewood addresses before purchasing a home at 350 West Sixtieth Street in 1907, where Archibald J. Motley, Jr., resided for many decades. For an overview of the development of the Englewood neighborhood see Gerald E. Sullivan, ed., *The Story of Englewood*

1835–1923, (Chicago: Foster & McDonnell, 1924).

3. Motley, "Autobiography," 3–4. When Motley was about twelve or thirteen years old he was accosted by two brothers, eighteen-year-old Max Herder and his sixteen-year-old brother Eric. They picked up Motley and threw him in a large wooden breadbox outside of Kliengenschmit's Grocery store at the corner of West Sixty-sixth and Morgan streets. The brothers sat on the box for fifteen to twenty minutes while Motley kicked and screamed in vain for help. Finally, the brothers let him out, "gave [Motley] a kick in the pants and said, 'Go home Nigger.'" Motley, "Autobiography," 3. See Elaine Woodall, "Archibald J. Motley, Jr.: American Artist of the Afro-American People, 1891–1928" (Master's thesis, Pennsylvania State University, 1977), 9.

4. Motley, "Autobiography," 1–2. Motley attended three elementary schools in the Englewood community. He and his sister Flossie were the only black children enrolled in the Perkins Bass School, located at Sixty-sixth and May streets, and they attended the Beale School at Sixty-first and Peoria streets with seven other black children. The Motley children graduated from the Nicholas Copernicus School at Sixtieth and Throop streets. Motley, "Autobiography," 2.

5. Motley, "Autobiography," 6.

6. Barrie, Interview, [9].

7. Barrie, Interview, [9–10].

8. Woodall, 14. Motley may have taken time off from school to work fulltime, which would explain his late start in high school.

9. Laura Bergquist et al., *History of Englewood High 1874–1935* (Chicago: The Students of Englewood High, 1935), 63. Motley studied mechanical drawing for eighty weeks, earning a grade of 82; free-hand drawing for one hundred and twenty weeks, receiving a grade of 90; and he earned a grade of 90 for his one hundred-week crafts class. Archibald J. Motley, Jr., Application for the John Simon Guggenheim Fellowship, 1929–30, John Simon Guggenheim Foundation, New York City; copy in Archibald J. Motley, Jr., Papers, Archives and Manuscripts Collection, Chicago Historical Society.

10. Englewood High School Certificate of Recommendation. Archibald J. Motley, Jr., Papers, Archives and Manuscripts Collection, Chicago Historical Society.

11. Videotape interview with the Motley family by the author, summer 1990, Archibald J. Motley, Jr., Papers, Archives and Manuscripts Collection, Chicago Historical Society. Motley's sister Mae Flossie Motley Moore remembers Edith and Archibald flirting with each other from their respective basements across the street. Motley family interview. New evidence suggests the houses were located at opposite ends of the street. Census information provided by Ralph Pugh, Chicago Historical Society.

12. Motley remained attached to Englewood High School during his Art Institute years. He stayed in contact with principal James Elder Armstrong, teacher Josephine Allini, and especially his art teacher, Elizabeth D. Troeger, to whom he sent exhibition invitations and publications highlighting his achievements throughout his career. "Long Notebook," Archibald J. Motley, Jr., Archibald J. Motley, Jr., Papers, Archives and Manuscripts Collection, Chicago Historical Society, 171–72.

13. Woodall, 15.

14. Motley, "Autobiography," 10.

15. Motley, "Autobiography," 11.

16. Motley, "Autobiography," 11.

17. Barrie, Interview, [20]. Schwartz emigrated to America from Smogen, Russia, when he was seventeen years old, having completed four years of study at the Vilna Art School in what was then Russian-occupied Poland. An accomplished singer, Schwartz was strongly influenced by music and created a series of abstract paintings titled "Symphonic Forms," which tried to express the relationship between music and painting.

18. Woodall, 29.

19. Woodall, 29–30.

20. Woodall, 29–30. Motley carried his sketchbook with him to work and drew whenever he could.

21. Barrie, Interview, [18].

22. "How I Solve My Painting Problems," by Archibald Motley, Jr., n.d., Harmon Foundation Papers, Library of Congress, Washington, D. C.; copy in Archibald J. Motley, Jr., Papers, Archives and Manuscripts Collection, Chicago Historical Society, 5.

23. Motley, "How I Solve My Painting Problems," 5.

24. Barrie, Interview, [19, 22]. Karl Buehr, who taught him figure and portrait painting, asked him never to change his style, believing that Motley had "stated on something very interesting" and that it would do him good to continue working in this mode. Motley took the suggestion to heart and as a result, he remained steadfastly academic in his portrait style throughout the twenties.

25. Motley told his sister that painting hands was one his most difficult tasks. Motley family interview.

26. "In Native Colors," The Survey 58 (August 1, 1927), 56.

27. Woodall, 93.

28. Personal communication with Archie Motley.

29. Woodall, 93.

30. Motley wrote of the model: "[She] was the possessor of an extremely fiery temper, a very temperamental person. I have tried to express her personality in the physiognomy of the face and the personality and relation of the hands to the face. I have also tried to express the true mulattress. I think the very strong fiery red dress adds much to the personality of the subject. The accessories in this painting are added for the purpose of balance of spaces and color and a certain tranquility which exists in the painting hanging in the background and the vase of flowers on the table and a slightly humorous note, of the Chinese flowers. These objects are a balancing note and reduce to a certain extent the fiery appearance of the figure. Motley, "How I Solve My Painting Problems," 4.

31. Motley, "How I Solve My Painting Problems," 5.

32. Barrie, Interview [25].

33. "This painting was built first on the round or oval shape, the stem shape, the triangular shape and finally the square or oblong shape. It was a study in skin pigmentation. A quadroon is a person having one-fourth Negro blood and three-fourths caucasian blood. This painting was a portrait of a doctor's wife who was the possessor of a gracious personality and a very symmetrical face with a true feminine loveliness. This type of colored person falls in a category between the mulatto and the octoroon. There is possibly more variance in their features, color and hair than any other Negro type. But I do think this painting depicts the true quadroon." Motley, "How I Solve My Painting Problems," 7.

34. Motley, "How I Solve My Painting Problems," 5.

35. Barrie, Interview, [26]. According to Woodall, "Motley always considered portraiture to be his specialty, but he turned to compositional pieces more and more as he realized the limited economic advantage of rare portraiture." Woodall, 43.

36. Motley, Autobiography, 8.

37. While in New York City, Harshe also served on the panel that awarded Motley a John Guggenheim Foundation fellowship to study in Paris. Barrie, Interview.

38. There were other exhibitions of black art in New York at the same time. The Harmon Foundation, which offered grants to black writers and artists and sponsored annual art exhibitions, held its first exhibition in 1928 at the Art Center in midtown Manhattan. Also, in February, the portraitist O. Richard Reid had an exhibition of his work at the 135th Street branch of the New York Public Library. In May 1988, the Kenkeleba Gallery in New York City celebrated the sixtieth anniversary, almost to the date, of this historic one-person show at the New Gallery with a showing of Motley works. See Jontyle Theresa Robinson, "Archibald John Motley, Jr.: A Notable Anniversary for a Pioneer,: in Three Masters: Eldzier Cortor, Hughie Lee Smith, Archibald John Motley, Jr. (exh. cat.) (New York: Kenkeleba Gallery, 1988).

39. George S. Hellman to Archibald J. Motley, Jr., May 9, 1927, Archibald J. Motley, Jr., Papers, Archives and Manuscripts Collection, Chicago Historical Society.

40. Nathan Irvin Huggins, "Introduction," in Alan Schoener (ed.), Harlem On My Mind: Cultural Capital of

Black America 1900–1978 (New York: Dell Publishing, 1979), 14.

41. Rosalyn Cambridge, who has done extensive investigations of Peter Minshall and contemporary masquerade in Trinidad and Tobago, believes there may be some correlation between this floating figure in Motley's *Kikuyu God of Fire* and the many Mardi Gras figures that Motley must have witnessed during his periodic returns to New Orleans (Motley kept Mardi Gras souvenirs from these visits). *Kikuyu God of Fire*, therefore, may represent a merging of Motley's African ancestry and his New Orleans roots.

42. "The Art Galleries," *The New Yorker* 4 (March 1928), 79.

43. Marya Mannes, "Gallery Notes," *Creative Art* 16 (April 10, 1928), 16.

44. Edward Alden Jewell, "A Negro Artist Plumbs the Negro Soul," *The New York Times Magazine*, March 25, 1928, sec. H, 8. Motley felt that Jewell described what he was trying to say, and he included portions of the essay in "How I Solve My Painting Problems."

45. John Nail paid $400 for his painting; Carl Hamilton purchased six paintings (*Waganda [Uganda] Charm Makers*, *Omen*, *Octoroon Girl*, *A Mulattress*, *Mending Socks*, and *Picnic at the Grove*) for $2,650; Mrs. T. Morris Murray of Boston purchased *Head of a Quadroon* for $300; Ralph Pulitzer paid $600 for *Aline, An Octoroon*; an anonymous collector bought *Blaine, A Convalescent* for $400. New Gallery to Archibald J. Motley, Jr., May 1, 1928; George S. Hellman to Archibald J. Motley, Jr., March 12, 1928; New Gallery to Archibald J. Motley, Jr., March 14, 1928; New Gallery to Archibald J. Motley, Jr., March 15, 1928; Archibald J. Motley, Jr., Papers, Archives and Manuscript Collection, Chicago Historical Society.

46. John E. Nail to Archibald J. Motley, Jr., April 9, 1928, Archibald J. Motley, Jr., Papers, Archives and Manuscripts Collection, Chicago Historical Society.

47. Motley, "Autobiography," 7–9.

48. Archibald J. Motley, Jr., "The Negro In Art," n.d., Collection of Archie Motley; copy in Archibald J.

Motley, Jr., Papers, Archives and Manuscripts Collection, Chicago Historical Society.

49. The day following the closing of his exhibition, Motley received the following invitation from Edward Cherry: "This is just a note to say that we will expect you on Monday evening about ten o' clock at the home of Mrs. Bessie Bearden, 173 W. 140 Street to meet especially Aaron Douglas, Augusta Savage, Richard Reid, Richard Bruce and Charles Alston. These young people are all interested in the plastic arts. Some of the others present will be poets, story writers and leading stage actors. Looking forward with a great deal of pleasure to seeing you." Edward Cherry to Archibald J. Motley, Jr., March 11, 1928, Archibald J. Motley, Jr., Papers, Archives and Manuscripts Collection, Chicago Historical Society

50. Edward Morrrow quoted in Robinson, "Motley," 42–43.

51. Motley, "The Negro In Art."

52. Barrie, Interview, [42]. Asked later in life what he thought of the artists recognized as part of the Harlem Renaissance and of the period in general, Motley stated: "There was no Renaissance. I think it was quite an advancement over the work that they had been putting out. But the work did not reflect a Renaissance." Barrie, Interview, [42].

53. Comte Chabrier, "Expositions de l'Art Institute de Chicago, du No Jury Expositions et du Cincinnati Museum," *Revue du Vrai et du Beau* 4 (February 10, 1925) 14-20; Comte Chabrier and G. Serac, "Expositions d'Amerique," 4 (July 10, 1925) 26–30, 28–29.

54. In the February 1918 issue of *The Crisis* DuBois mentioned what is perhaps Motley's earliest group exhibition. On December 21, 1917, the Art and Letters Society of Chicago opened its first exhibition of Chicago's Negro artists, which, in addition to Motley, included the work of F. L. Holmes, William A. Harper, W. M. Farrow, Jesse Stubbs, Edward Knox, R. M. Williams, and Charles C. Dawson. In 1923 DuBois reproduced *Portrait of My Grandmother* in *The Crisis* and informed readers that Motley's two paintings,

Grandmother and *Octoroon*, were on view in the "Twenty-seventh Annual Exhibition by Artists of Chicago and Vicinity" at The Art Institute of Chicago. A photograph of Motley appeared in the July 1925 issue of *The Crisis* after the artist had won the Frank G. Logan Medal for *Syncopation* and the Joseph N. Eisendrath prize for *Mulattress*, which were exhibited in the "Twenty-ninth Annual Exhibition by Artists of Chicago and Vicinity."

55. Jazz followed the Mississippi River from Louisiana to Chicago and then spread to New York City. With the help of King Joe Oliver and his Creole Jazz Band, musicians such as Louis Armstrong were able to spread the jazz sounds of New Orleans to the north, where it was embraced and transformed into a unique kind of music. When Oliver moved to Chicago, he sent for Armstrong to join him. After arriving in Chicago, Armstrong began to merge his New Orleans blues and jazz sound with northern urban jazz.

56. Motley wrote of one excursion: " . . . after a hike of some distance through a thick forest of pines, lugging painting paraphenalia we finally arrived at a clearing near a stream of water. It was early afternoon that we set up our easels and decided to paint the landscape . . . diligently working for approximately an hour . . ." Archibald J. Motley, Jr., "Six Pairs of Stockings," 1928, Archibald J. Motley, Jr., Papers, Archives and Manuscripts Collection, Chicago Historical Society, 1.

57. Motley, Application.

58. Motley, Application.

59. Greenstein received his education at the Ferrer School, where he studied with Robert Henri and George Bellows, two artists Motley admired.

60. Motley's Paris diary describes his work schedule. He worked with live models in the morning, preferably on sunny days (Motley wrote constantly about the weather in his diary), for about three hours at a time; he worked on one painting at a time and never talked while painting. After 1:00 P.M. he worked on compositions. Paris Diary, January–February, 1930, Collection of Archie Motley and Valerie Gerrard Browne; copy in Archibald J. Motley, Jr., Papers, Archives and Manuscripts Collection, Chicago Historical Society.

61. Ms. Zaida, a Haitian woman, was the model for Martinique Dancer. Motley used two models for Senegalese: Mr. Diara from Senegal, and Mr. Maurice, who replaced the first model when he became ill. Archibald J. Motley, Jr., Diary, Collection of Archie Motley and Valerie Gerrard Browne, February 17, 1929; February 25, 1929; May 19, 1930; May 28, 1930.

62. See Richard J. Powell, *The Blues Aesthetic: Black Culture and Modernism* (exh. cat.) (Washington, D. C.: Washington Project for the Art, 1989) 26–27.

63. In letters written to his niece, Motley recounted that on the night of his mother's arrival his wife Edith drank too much celebrating her mother-in-law's visit to Paris, and he included a humorous drawing of Edith in an inebriated condition. In another letter he included a delightful drawing showing his mother enjoying her stay in Paris, especially the wine. Archibald J. Motley, Jr. to Norma Worthington LaMonte, Collection of Norma Worthington LaMonte.

64. Edith returned to the United States on November 6, 1929 due to illness and came back to Paris on March 1, 1930. These are probably articles Motley purchased to welcome her back to Paris after her hiatus in America.

65. Motley made sketches for *Dans La Rue, Paris* and *Cafe, Paris*, but also found among his papers are four postcards from the area where Motley lived and worked, which may have helped him remember a sense of place or mood in Paris. Some aspects of the settings he depicted in these two works can be seen in the postcards. In his Paris diary, Motley mentions the Cosmos and the Cafe Reve, two of the cafes that he frequented.

66. Barrie, Interview, [49]. Motley's report of his activities as a fellow does not mention any dramatic changes in the artist's approach, but merely lists where he traveled and which European artist inspired him most. Motley reported that he had visited the Louvre, Luxemburg, Cluny, Versailles, St. Germain, and many exhibitions in Parisian galleries. Motley was especially struck by the work of David, Ingres, Delacroix,

Courbet, and Hals. Motley did not submit any of his work to the exhibitions in Paris, preferring instead to wait and exhibit in the United States. Archibald J. Motley to Henry Allen Moe, September 3, 1930, Guggenheim Foundation, New York City; copy in Archibald J. Motley, Jr., Papers, Archives and Manuscripts Collection, Chicago Historical Society.

67. For this painting, however, he may be holding the palette in his hand for dramatic effect. Family members suggest that he almost always worked with the palette, which is approximately two feet in length, on the table. Motley family interview.

68. Mary Elaine Ogden, "A Chicago Negro Community: A Statistical Description," Report of Official Project 165-54-6999, Works Progress Administration, December 1930, Chicago, Illinois, 3.

69. On a preliminary drawing of this work, the artist noted "Painting for Myself" and "Negro Policeman." In Black Belt the artist may be remembering Richard Havelock, a man who had a great influence on the artist as a young child. Motley's father met Havelock in 1900 as a passenger on one of his return train trips from New York to Chicago. An educated and well-traveled man (he had been to Africa and Europe) Havelock came to live with the Motleys and stayed with them for three or four years. He was exceedingly kind to Motley and his sister, helping them with their homework and diction. But he always told Motley's mother that someday he would leave for work and never return and that is precisely what he did. Two years later the artist and his mother were ". . . shopping downtown and crossed the street at Madison and State and in the center of the street . . . directing the automobiles and people in his immaculate white gloves . . . was Mr. Havelock." Motley, "Autobiography," 5.

70. Interview with Floyd Coleman by the author, March 12, 1988, Washington, D. C.

71. Motley received thirty-four dollars for the two oil paintings (destroyed by fire in 1943) created for the Evansville State Hospital, Evansville, Indiana.

72. In a letter from George G. Thorp, State Director of the Federal Art Project, to Thomas C. Parker, Assistant

Director of the Federal Art Project, WPA, Thorp discusses Motley and his ability to execute murals and recommends the artist for a mural commission in North Carolina: "Mr. Motley designed and executed a mural at the Nicholas Elementary School in Evanston. The room is completely decorated, the last two panels being done under the supervision of the Federal Art Project. It is unquestionably a mural of merit. Although we have a number of very talented negro artists in the Easel division, none so far have been interested in doing murals." George G. Thorp to Thomas C. Parker, February 27, 1939, Archibald J. Motley, Jr., Papers, Archives of American Art, Smithsonian Institution.

73. "Colored Artist Painting Murals," *The Evening Star* (Washington, D. C.), October 18, 1935. Motley worked in Washington for seventy-six dollars a month (one hundred and twenty hours maximum) and was able to hire an assistant. Olin Downs to Archibald J. Motley, Jr., September 4, 1935, Archibald J. Motley, Jr., Papers, Archives and Manuscripts Collection, Chicago Historical Society. The mural sketch for the Douglass Memorial Hall project, executed between 1935 and 1936, appears on a January 1943 allocation list for the Cook County Board of Education. The sketch, now lost, probably hung in a Chicago Public School. Motley must have enjoyed his residency at Howard University because he tried to secure another mural commission there in 1936. Again, Olin Downs, chief of the Treasury Relief Project, wrote Motley about the sketches the artist had sent him, praising *Funeral Scene* as interesting and dynamic, but advising him that the chances of him doing other murals on the campus were slim based on his conversations with James Herring and President Johnson. Olin Downs to Archibald J. Motley, Jr., May 11, 1936, Archibald J. Motley, Jr., Papers, Archives and Manuscripts Collection, Chicago Historical Society.

74. Archibald J. Motley, Jr to Administrators, Fine Arts Section, 1935, Papers of Archibald J. Motley, Jr., Archives and Manuscripts Collection, Chicago Historical Society. The artist also chose to paint about stagecoaches because they traveled near Wood River stopping at

the Three-Mile House at Edwardsville.

75. An examination of the original frames indicates that they were purchased and perhaps manufactured in Washington, D.C.

76. Motley was exploring nighttime illumination during this period, and he often painted in the dark using only candles for light in an attempt to understand the effects of dark and light from natural and artificial sources.

77. Edward B. Rowan, the superintendent of the Treasury Department's Section of Painting and Sculpture had to overrule the Chicago committee's decision to grant the award to another artist from Chicago. Rich, who was chair of the committee, wrote Rowan to explain to him that Motley was a "negro" and therefore did not deserve the commission, but Rowan felt that Motley's design was "the best possible mural decoration . . ." Edward B. Rowan to Daniel Catton Rich, July 2, 1935, Archibald J. Motley, Jr., Papers, Archives and Manuscripts Collection, Chicago Historical Society.

78. Allocation Files for Buildings in Chicago, Works Progress Administration Federal Art Project, Chicago, Illinois, Archives of American Art, Smithsonain Institution, Washington, D. C.

79. Peter J. Pollack to Florence Kerr, January 19, 1941, Archives of American Art, Smithsonian Institution, Washington, D.C.

80. Interview with Eldzier Cortor by the author, April 23, 1988.

81. Archibald J. Motley Jr., "A General Summation," n.d., Archibald J. Motley, Jr., Papers, Archives and Manuscripts Collection, Chicago Historical Society.

82. In *Nude*, Motley paints a figure within an abstract composition, an extremely unusual combination for the artist.

83. "Negro Artist Exhibits at Public Library," *Chicago Tribune*, October 25, 1953. These works are now very fragile because the artist used no primer to stabilize the paint, which he applied directly onto the palm leaf.

84. Motley may have modeled his figure after a photograph of a lynched man on the cover of the July 1930

edition of *Detective*, which he acquired in Paris in 1929–30.

85. W. E. B. DuBois, *Souls of Black Folk: Essays and Sketches* (New York: Dodd, Mead & Company, 1961) 30.

86. Henry Louis Gates, Jr., "Why the 'Mule Bone' Debate Goes On," *The New York Times Magazine* February 10, 1991, sec. H, 5.

87. Motley, "How I Solve My Painting Problems," 5–6.

MOTLEY'S CHICAGO CONTEXT, 1890–1940

WENDY GREENHOUSE

Subject matter plays a most important part in my art," declared Archibald Motley, Jr., in 1933, as he approached the midpoint of an already remarkable career. "It is my earnest desire and ambition to express the American Negro honestly and sincerely, neither to add nor detract, and to bring about a more sincere and brotherly feeling, a better understanding, between him and his white brethren.[1]"

With few exceptions Motley pursued his goal singlemindedly, choosing as his perennial subject the black community of his hometown, Chicago, where he lived for virtually his entire career. In portraits and genre scenes he surveyed the rich variety of life in the area of Chicago known as the Black Belt,[2] from its elegant night spots to the private interiors of its middle class to the lively social kaleidoscope of its street life. In a sense this was his subject even when Motley portrayed other locales. His views of the people and landscape of Arkansas, for instance, touched on black Chicago's collective memory of its origins in the South; his Paris images, from street scenes to a Senegalese youth, spoke to African-Americans' dream of a distant metropolis where they could find a welcoming sanctuary and encounter their ancestral roots. Only in his Mexican work did Motley temporarily depart from his accustomed subject matter. But in works such as *Another Mexican Baby* (cat. no. 57) Motley pictures Mexican peasants with a sympathy born of a shared experience of exclusion and oppression.

Not every aspect of daily existence in the Black Belt appears in Motley's art. His largely upbeat paintings, often infused with affectionate humor, show a world in which work, politics, and public issues are absent. The artist's personal experience of racial bigotry is likewise invisible.[3] Motley treated relations between the races rarely, and then obliquely: in *Jockey Club* (1929, cat. no. 24) and *Sunday in the Park* (1941, cat. no. 50), for instance, black figures are quietly marginalized in a world of whites. In his final work, *The First One Hundred Years* (c. 1963–72, cat. no. 69), Motley finally tackled head-on the subject of black-white relations, but to do so he abandoned his usual vehicle, the "slice of life" genre scene, for highly-charged political allegory. In most of his work, however, Motley carefully limited the framework within which he met his ambition "to express the Negro honestly and sincerely."[4] In deciding in the early twenties to paint "pictures that people will buy regardless of race, color or creed,"[5] he necessarily respected his contemporaries' preferred view of African-Americans as content in the world they created for themselves within the limits imposed by white society. The optimism of the paintings

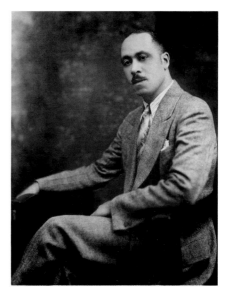

Fig. 22. Archibald J. Motley, Jr., 1929. Chicago Historical Society, ICHi-16136.

Fig. 23. Henry O. Tanner. The Banjo Lesson, 1893. Oil on canvas, 49 x 35 1/2 (124.5 x 90.2 cm). Hampton University Museum.

Fig. 24. Wayman Adams. New Orleans Mammy, c. 1920s. Oil on canvas, 39 1/2 x 29 1/2 in. (100.3 x 74.9 cm). Morris Museum of Art, Augusta, Georgia.

Motley produced throughout his career marks him as an artist who matured during the Jazz Age, in contrast to the next generation of artists, social realists who emerged in the era of the Great Depression to tackle in their art weighty themes of social injustice and individual despair.

In another sense, however, Motley's very selectivity served his mission. He chose for depiction settings and situations least conditioned by white rules and influence. From his introspective portraits to his panoramas of Bronzeville's nighttime street scene, Motley presents black life at its most relaxed and unselfconscious. The subjects of his portraits, from his aged grandmother (1922, cat. no. 9; 1924, cat. no. 10) to elegant octoroons (1922, cat. no. 8; 1925, cat. no. 12), are dignified and self-possessed, at home in their surroundings. And the figures in his genre scenes are typically too busy with their own pleasures or concerns to even notice the viewer. They appear self-sufficient in a world they have defined in their own terms, while the viewer, in turn, is marginalized, unimportant and forgotten. Yet simultaneously Motley lures us into the lively world he pictures through optical "pathways" such as the arbitrary cropping of pictorial space in *Blues* (1929, cat. no. 21) and the abandoned cigarette that juts beyond the picture plane in *Saturday Night* (1935, cat. no. 36). The artist thus invites us to share personally two aspects of the black experience in American society: denigration and exclusion in relation to the white majority, and the independent and richly vital social culture that African-Americans created for themselves within those conditions.

In several important respects Motley himself was something of an outsider in the world he portrayed. Light-skinned, middle-class, and Roman Catholic, he belonged to a small minority in Chicago's black population. He grew up not in the Black Belt but in an adjacent white neighborhood, where he and his sister were the only black children attending the local public elementary school, and he eventually married a white woman. Motley's decision to pursue a career in fine art (and his family's support of that decision) was even more exceptional. His study at The Art Institute of Chicago, where he immersed himself in European academic tradition, and the exposure and recognition he found in the artistic establishment, further separated the artist from his community. Yet Motley consistently applied his training and talents to bridging the gulf between fine art and everyday black life by celebrating the latter in his paintings. As a child with a passion for sketching he went to Black Belt poolrooms, churches, and other gathering places where he could study what he called "characters."[6] "The thing I was trying to do," he stated at the end of his life,

> was trying to get their [African-Americans'] interest in culture, in art. I planned that by putting them in the paintings themselves, making them part of my own work so that they could see themselves as they are I've always wanted to paint my people just they way they are.[7]

To the extent that he realized this goal Motley single-handedly achieved a major breakthrough in the long history of portraying the African-American in the visual arts.[8] Departing from the nineteenth-century sentimental tradition exemplified by *The Banjo Lesson* (fig. 23) by Henry Ossawa Tanner (1859–1937),[9] the most important black artist at

the turn of the century, Motley was arguably the first artist of any color to portray black Americans realistically in their modern, urban setting. As early as 1921, in *Black and Tan Cabaret* (c. 1921, checklist no. 3), and in typical works of the twenties like *Stomp* (1927, checklist no. 8), Motley applied the mode of the celebratory "slice-of-life" to this unprecedented subject matter. To do so he redefined the academic approach he so thoroughly assimilated at the Art Institute and realized with admirable facility in his portraits. For his genre scenes, Motley formulated a wholly original style that blended a deliberate naiveté in conception of form and perspective with a modernist feeling for the frenetic tempos of contemporary urban life.

Both personally and artistically, Motley was a conscious independent who acknowledged few influences from contemporary artists.[10] His work bears suggestive similarities to that of several, notably, as an early critic pointed out, Guy Pene du Bois (1884–1958) (fig. 25), who was in Paris when Motley worked there in 1929–30.[11] Motley did proclaim his admiration for George Bellows (1882–1925), with whom he studied briefly at the Art Institute in 1919.[12] Bellows may have conditioned Motley's broad manner of handling paint and the rather raking light that animates his portraits of the twenties such as *Octoroon* (1922, cat. no. 8). More importantly, Bellows offered a link to the ideals and subject matter of the circle of painters known as the Ashcan School, champions of artistic individualism (if not stylistic radicalism) who portrayed the social and physical landscape of New York City's working class with an affectionate but unsparing vision. *Cliff Dwellers* (1913, Los Angeles County Museum of Art), Bellows' view of bustling Lower East Side tenement life, points the way toward Motley's teeming street scenes of the thirties.

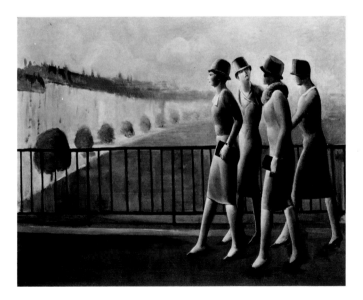

The artistic forerunners for Motley's modern, urban black subject matter were also white artists. Bellows's *Both Members of This Club* (fig. 26), for instance, his powerful rendering of a black boxer getting the upper hand with a white opponent, presented the African-American with a kind of heroic modern realism. Late in his career Motley also cited the influence of another white painter, Wayman Adams (1883–1959), who had moved from sentimental portrayal of southern black types, such as the Mammy (fig. 24), to sensitive individual portraits, according to Howard University scholar and esthete Alain Locke.[13] But Motley felt ultimately that only a black artist could fully communicate the "the soul and the very heart of colored people,"[14] and he bemoaned the reluctance of black visual artists to follow the example of black poets, musicians, and actors in reclaiming the imaging of African-Americans from the hands of white interpreters.[15] Locally, Motley may well have been referring here to such talented black artists as William McKnight Farrow (1885–1967), a landscapist and student of Tanner who eschewed even the latter's tentative artistic acknowledgement of his racial identity.[16]

Fig. 25. Guy Pene du Bois. Americans in Paris, 1927. Oil on canvas, 28 3/4 x 36 3/8 in. (73 x 92.4 cm). The Museum of Modern Art, New York. Given anonymously.

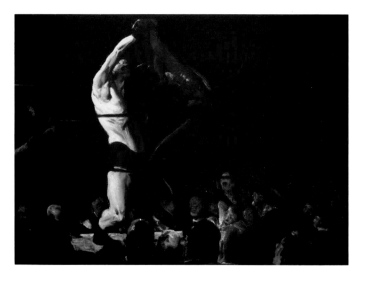

Fig. 26. *George Wesley Bellows*. Both Members of this Club, *1909. Oil on canvas, 45 1/4 x 63 1/8 in. (115 x 160.3 cm). National Gallery of Art, Washington, D.C., Chester Dale Collection.*

Motley's dedication to artistic excellence conditioned his promotion of black subject matter. He wanted to be judged not as an artist of color, but simply as an artist.[17] Motley's strong self-identity as a fine artist dated back to his school years, when he had "just felt that [art] was the only thing I could do,"[18] an outlook reinforced by the opportunity to train at the Art Institute, the Midwest's most prestigious art academy. In 1918, as an ambitious young graduate hoping to receive portrait commissions from clients of any race, Motley argued that artistic excellence, rather than black subject matter, should guide the development of a black art. "If all Negro artists painted simply Negro types, how long would our Negro art exist?" he asked rhetorically, as he praised the religious paintings of Henry O. Tanner for their universality.[19] But even after he embraced black subject matter himself a few years later, Motley continued to forge an individual path informed by a thorough respect for sound formal technique and a desire to make his subjects, however local or sociologically specific, a means of communication among all races.[20] He criticized his fellow black artists not only for avoiding black subjects in their art, but for their technical incompetence and stylistic derivativeness.[21] Although he participated in black art shows with a national scope, such as the Harmon Foundation exhibitions of 1929 and 1931, he held aloof from the activities of local black art groups (despite much criticism) because he felt that they promoted mediocre work.[22] His decision to portray contemporary black urban life in turn alienated him from Chicago's black artists. William McKnight Farrow tried to discourage Motley from submitting *Syncopation* (1924, checklist no. 4; fig. 8), along with *Mending Socks* (1924, cat. no. 10) and *A Mulatress* (1924, checklist no. 5), to the Art Institute's 1925 annual exhibition of work by local artists.[23] The exhibition marked the first time that a black artist had shown black subjects at the Art Institute, according to Motley,[24] and the paintings created an appropriate stir, while garnering two awards for the young painter.[25]

Although Motley, as a black artist embracing his racial identity, found himself somewhat isolated in Chicago, his concerns found wider echoes. In his dedication to interpreting black life through his art, his concern for artistic quality, and his idea that art should interpret the black experience as a vital component of American culture and society as a whole, Motley can be seen as an important figure in the new cultural consciousness sweeping the black American intelligentsia from the end of the Great War through the Great Depression.[26] The New Negro Movement (one of its several names) attended the period's demographic upheavals, as black America largely exchanged its rural, agrarian, southern milieu for the industrial North. The unprecedented if selective prosperity of urbanized African-Americans, as well as the racial conflicts that followed the return of white soldiers from the war, catalyzed an urgent search for black cultural identity. The result was a flowering of black artistic and literary achievement under the banner of an exuberant celebration, by African-Americans and their white admirers alike, of what

David Driskell has termed "Negritude."[27]

The movement's most influential manifesto was *The New Negro* of 1925, a remarkable collection of poetry, stories, essays, and images gathered by Alain Locke. Locke hoped that the publication would show "the Negro in his essential traits, in the full perspective of his achievement and possibilities," both affirming his racial identity and claiming an equal place in American culture and society.[28] Like the book, the movement itself was riddled with unresolvable contradictions and tensions: between the essentially elitist outlook of its leaders and the down-home reality of America's black masses; between stylistic realism or academicism and a back-to-Africa primitivism; between separatists and integrationists struggling to define the African-American's role in and relationship to American society; between an art in service to Truth, and an art devoted to uplifting the race.[29] Nonetheless, it nurtured a black consciousness in the visual arts that has continued to flower to the present.[30]

The New Negro Movement is most familiar in its New York manifestation. Harlem, the movement's self-appointed spiritual home, lent its name and captured the popular imagination. The Harlem Renaissance still conjures up glittering images: Ellington at the Cotton Club, Bessie Smith belting out the blues, poets Langston Hughes and Countee Cullen, a host of talented performers, literati, artists, and thinkers—all passionately lionized by tuxedoed high society, black and white.[31] The image of the Harlem Renaissance, as captured in the polished photographs of James Van Der Zee (1886–1983), has permanently enriched our common American perception of the Jazz Age.

There can be little question that New York was the literary and intellectual, as well as social, capital of the New Negro Movement. But scholars have long disagreed in their assessments of the visual art of the Harlem Renaissance.[32] The work of such figures as Aaron Douglas (1899–1979), Palmer Hayden (1890–1973), Meta Warrick Fuller (1877–1968), and William H. Johnson (1901–70) has been labeled as derivative and uninspired.[33] While this judgment now seems irrelevant, an examination of Motley's career and work puts the achievement of these "Harlem Renaissance artists" into perspective. In comparison to the works with which Motley made an independent breakthrough in subject matter and style in the early twenties, Fuller's sculpture seems mired in academic convention and racial stereotypes,[34] while Douglas's murals and illustrations and the paintings of Hayden and Johnson expressing the New Negro Movement's racial consciousness are, at the least, behindhand. Douglas emerged around 1925 with a unique symbolic and decorative style at least superficially influenced by indigenous African arts, but it was not until the following decade that Hayden and Johnson found their artistic voices as interpreters of black subjects.[35] By then, Motley had long since claimed his unique vision of Chicago's Bronzeville both in sensitive if stylistically conventional portraits of its women and in original, exuberant images of its cabaret scene.

Motley's achievement seems particularly remarkable in light of his detachment from Harlem's artistic scene. He may well have traveled to New York when, during his early adult years, he accompanied his father, a Pullman car porter, on the latter's travels.[36] But he recorded no contacts made there until Art Institute president Robert B. Harshe pro-

Fig. 27. Aaron Douglas. The Creation, 1935. *Oil on masonite, 48 x 36 in. (121 x 91.4 cm). Permanent Collection, Howard University Gallery of Art, Washington, D.C.*

moted his work (without revealing the painter's racial identity) to George S. Hellman, the director of New York's New Gallery, where Motley's one-man exhibition was held early in 1928. Late in life the artist spoke of the jealousy that his exhibition's enormous commercial and critical success inspired among the New York artists.[37] He, in turn, maintained his distance. When influential Harlemite Bessie Bearden invited the artist to a formal reception in his honor, Motley declined,[38] and he chose to have little contact with the black visitors he encountered in his exhibition.[39] He seems to have been unimpressed by the art of black New Yorkers: "There was no Renaissance," he later stated bluntly.[40]

Motley's sense of separateness from the New York art scene was the obverse of his conscious commitment to his hometown.[41] He was acutely aware of the rivalry between the two cities, attributing to his New York counterparts resentment that they "have to send all the way to Chicago to send a Chicago artist here to have a one-man show in New York."[42] But his affection for his city was independent of his experience in New York. "I can't find any place like Chicago," he once said, "You know, I love this place."[43] Homesickness brought him back from Paris within a year, despite his enjoyment of his stay in France and the Guggenheim Foundation's offer to extend his fellowship there for another six months.[44] While Europe provided a nurturing second home to numerous black artists following the example of the expatriate Tanner and New York proved an irresistible magnet for Chicago's creative talent, black as well as white, Motley rarely left his hometown. Chicago was not only the artist's residence in a personal sense; it was central to his art.

Motley's rootedness in Chicago, in fact, may have encouraged more than hampered his artistic breakthrough in the portrayal of urban black subject matter. Chicago's vitality as the quintessential "Black Metropolis" during the era of the New Negro Movement offered him inspiration and subject matter from the birth of his artistic ambitions until the very end of his career. The city's artistic life and traditions, from the Art Institute to the independent art circles with which he associated, fostered and conditioned the development of Motley's individual artistic outlook. These two aspects of Motley's Chicago setting bear particular examination for their role in his art.

In *The New Negro*, Alain Locke acknowledged that Harlem was only one (if the most important) of a series of "awakened centers" of the affirmative new racial culture called the New Negro Movement.[45] If New York was the movement's acknowledged capital, its closest rival "in symbolic power to seize the imagination"[46] was undoubtedly Chicago, home to one of the largest, most prosperous, and politically powerful urban black communities in the nation. Even Bronzeville's boosters did not pretend that it could challenge Harlem's artistic preeminence: the midwestern metropolis, as black sociologist E. Franklin Frazier admitted bluntly, "has no intelligentsia."[47] Rather, as Carroll Binder argued, "Chicago's pre-eminence lies in the business and professional attainments of its people,"[48] from the Victory Life Insurance Company to the *Defender*, the first truly national black newspaper. Frazier described Chicago affirmatively as "a cross-section of Negro life": precisely because it lacked New York's cosmopolitan character, Chicago represented "more nearly the pattern of Negro life at large in America."[49] By implication, the

city offered a richer, truer fund of experience and subjects for the black artist, without the self-conscious cultural posturing of its more sophisticated rival metropolis. In a sense, then, Chicago presented a more complete realization of ideals of the New Negro Movement than Harlem—in its economic successes, its self-contained social life and its striving for racial solidarity and self-sufficient community.

As the object of close scrutiny by the pioneering sociologists at the nearby University of Chicago, Bronzeville emerged by the thirties as a symbol of the modern "black metropolis" to the nation as a whole.[50] Motley's views of everyday life there affirmed this positive image of his hometown as a place where modern black popular culture and social life were at their most natural and fully realized. It was for the audience of his New York exhibition, on the other hand, that he treated African religious myths in paintings like *Kikuyu God of Fire* (1927, cat. no. 14). While such works (painted, it should be noted, at the urging of the gallery director) reflect the popularity of African tribal arts as a source of inspiration in the forging of a black American cultural identity,[51] they seem a digression in Motley's work. Back in Chicago, and even in Paris, he continued to characterize the black experience through familiar images of contemporary urban life, "in order to make my people really feel they are taking part and are a part of these paintings."[52] Despite his voodoo paintings, then, Motley disagreed with Alain Locke's argument that black American artists (like European avant-garde artists) should draw their inspiration from African tribal arts—an argument heeded by artists as diverse as Meta Warwick Fuller in her *Ethiopia Awakening* and Aaron Douglas in his hierarchically stylized murals and book illustrations.

Motley's growing-up in Chicago coincided with the city's evolution into the "Black Metropolis," the transformation of its black population from a small, geographically scattered, and quietly overlooked minority into a cohesive community, segregated into a large Black Belt on the city's South Side but recognized as a major player in the city's varied and sometimes volatile sociological and political mix. To understand the nature of that community, and Motley's picturing of it, a brief outline of Bronzeville's history and social organization is necessary.

BRONZEVILLE

When the Motley family arrived in Chicago in the winter of 1893–94, Chicago was city of immigrants, among whom the once-negligible black population was growing rapidly. By 1890 there were about fourteen thousand African-Americans in the city, double the number of a mere decade before, and by century's end the black population had doubled again to more than thirty thousand. But this number was dwarfed by the increase that occurred during the Great Migration of 1916–20, a mass exodus of black southerners to northern cities to fill labor shortages brought about by World War I. Between the war and the depression half a million African-Americans moved north, and by 1930 almost a quarter of a million of them counted Chicago as their home.[53] These people and their neighborhoods would become an inexhaustible fund of subjects and inspiration for Archibald J. Motley, Jr.

Whereas earlier black migrants to Chicago had included a significant proportion of midwesterners,[54] the 1890s saw a rising tide of arrivals from the South. This exodus of what has been referred to—with some exaggeration—as the black South's "talented tenth" involved a population that was disproportionately urban, literate, and from the upper South and the border states of Tennessee, Kentucky, and Missouri.[55] Among them were prominent leaders, such as activist Ida B. Wells and the influential pastor Archibald J. Carey, as well as unknown but enterprising individuals who would establish themselves as bastions of Chicago's black elite. After the turn of the century, however, the city's black immigrants tended to be natives of the Deep South, notably Mississippi, Alabama, Georgia, and Louisiana.[56] Typically rural and deprived of economic and educational opportunities, they also bore the legacy of slavery. For them, migration to a northern, industrial metropolis was a dramatic change.

Expanded opportunities in the North coupled with deteriorating economic and social conditions in the South encouraged thousands of black southerners to move North at the outbreak of World War I. The war stimulated basic industry in cities like Chicago at the same time that it cut off the supply of cheap European immigrant labor on which that industry depended. To fill the gap, labor agents from Chicago came south to recruit black workers. Few needed much encouragement to jettison their low wages, precarious employment, and substandard housing. The mass exodus known as the Great Migration was on.

Chicago held particular appeal for many black southerners. The Illinois Central Railroad, which Archibald Motley, Sr., rode as a Pullman car porter, connected Chicago to a network of southern terminuses from Savannah, Georgia, to New Orleans. For northbound travelers Chicago was the gateway to the Midwest and a new life.[57] Its reputation as one of the nation's largest industrial centers held out the promise of mass employment for the unskilled, while its thriving black community was well known. Residents of even the remotest backwater of the Deep South knew of Chicago as the source of the Sears, Roebuck and Company catalog, the epitome of urban modernity. Chicago was the home of the famed World's Columbian Exposition; of the American Giants, a black baseball team that toured the South; and of the widely read black newspaper the *Defender*, which spread nationwide the message of opportunity in Chicago. As black southerners arrived there they wrote home encouraging friends and relations to join them. Whole hamlets, extended families, and church congregations heeded the message, often forming "migration clubs" to pool the expenses and cushion the shock of the journey.[58]

Black migrants to Chicago quickly discovered that the North offered barriers of its own to equal treatment and opportunity. New arrivals encountered the first barrier in their search for housing. Although the city's few African-Americans of several decades earlier had lived in several neighborhoods in the city, by the 1890s blacks were increasingly segregated on Chicago's Near South Side, and in a smaller enclave on the West Side. The South Side Black Belt, as it became known, was anchored on the north by the Illinois Central Depot at Michigan Avenue and Twelfth Street (now Roosevelt Road),

where the migrants alighted at journey's end. Nearby Chicago's main vice district was one of the few neighborhoods in the city where rental housing and employment were relatively unrestricted by color. From Twelfth Street the Black Belt ran south in a narrow strip with State Street as its backbone. As Chicago's black population exploded with the Great Migration, the area slowly expanded its boundaries, while the concentration of black, relative to white, residents rose rapidly. The Black Belt expanded eastward into what had been prosperous native-born white neighborhoods near the lakeshore, where former mansions of the elite were subdivided into cheap rental flats, and pressed into working-class Irish enclaves to the west. The commercial heart of Bronzeville drifted south, from Thirty-fifth and State streets in the teens and twenties, to Forty-seventh Street and South Parkway (now Martin Luther King, Jr., Drive) by the World War II era. The Black Belt accounted for at least 90 percent of Chicago's black residents; the remainder lived scattered throughout the city, mainly in South Side neighborhoods such as Woodlawn, Hyde Park, and Morgan Park, and on the West Side in an area roughly bounded by California and Ashland avenues and Madison and Kinzie streets. When Archibald J. Motley, Sr., moved his family to 6544 South Morgan Street, in the largely German, Swedish, and Irish district of Englewood, around 1897, "We were the only colored family in the block," the artist recalled.[59] By 1920, however, nearly two thousand black residents lived in the neighborhood, now only a few blocks west of the expanding Black Belt.[60]

Increasing pressure for housing in the relatively confined area of the Black Belt created friction with neighboring areas as African-Americans sought to escape crowded, deteriorating tenements and the hazards of the vice industries. To the south and west in particular, they often encountered stiff resistance. Before the Great Migration, one middle-class black family, like the Motleys, was accepted,[61] but the larger numbers pressing the boundaries of the Black Belt in the late teens and twenties provoked hostility or flight. In some areas, notably Hyde Park and Kenwood, white property owners formed restrictive organizations to discourage black infiltration in the belief that it would lower property values. In fact, landlords found they could charge significantly higher rents to black tenants, who had few alternatives or avenues of protest.[62] Whites also resisted the encroachment of African-Americans by violence. In disputed neighborhoods bombings of properties rented or purchased by African-Americans and the offices and homes of real estate agents and owners, both black and white, who rented or sold to African-Americans occurred almost monthly in Chicago between 1917 and 1921.[63]

Conflict between the races was highly localized, however, and only serves to underscore the extent to which African-Americans, unlike any other ethnic population in the city, were segregated geographically. Restrictions on employment further ensured the invisibility of African-Americans, who constituted little more than 4 percent of Chicago's residents even after the height of the Great Migration, in 1920. Despite legal provisions for equal access, municipal services, public facilities, and integrated schools were effectively closed to African-Americans. Streets and streetcars were the only places where African-Americans and whites mingled on an equal footing.[64] For recent migrants from

the South, this in itself represented unimagined freedoms. One recalled:

> When I got here and got on the street cars and saw colored people sitting by white people all over the car I just held my breath, for I thought any minute they would start something, then I saw nobody noticed it, and I just thought this was a real place for colored people.[65]

In public places like restaurants and bars, white proprietors discouraged the patronage of African-Americans by subtle means—ignoring them, for instance, rather than actually refusing to serve them.[66] This "shifting line of color," a set of unwritten rules that were a shadow of the South's Jim Crow laws, governed black life in northern white society. Infringement—even unintentional—invited swift reprisal. In the summer of 1919, a black youth who had strayed into white territory at a Chicago city beach was stoned to death, sparking a major race riot that left thirty-eight people dead, many injured, and almost one thousand African-Americans homeless after five days of mob violence.[67]

Although Chicago segregated its African-American population as a single mass, that community itself was stratified by class, money, education, and color. Until the first decade of the new century its elite was dominated by "Old Settlers" whose Chicago roots extended back as much as a half-century before the Great Migration. By the turn of the century their leaders were largely professionals: lawyers, doctors, and clergymen. Later, a new elite of self-made businessmen moved into positions of influence in the Black Belt. Jesse Binga, for instance, made a fortune in real estate and founded the Binga Bank in 1908; real estate man Oscar De Priest became Chicago's first black alderman and the first African-American from the North to be elected to the United States Congress; and Robert S. Abbott, who trained as an attorney, founded the enormously influential black newspaper the *Defender* in 1905 with capital of twenty-five cents.[68]

By the time of the Great Migration, these men and their families defined South Side society. They were tireless founders and supporters of organizations and institutions designed to give Chicago's African-Americans the services and amenities denied them by whites, from financial credit to medical training, from rental housing to social activities. While an earlier generation had struggled to eradicate barriers to black participation in mainstream American life, the leaders who emerged after the turn of the century advocated a self-help philosophy molded by the example of Booker T. Washington.[69] Provident Hospital, the Wabash Avenue YMCA, the Negro Business League, the Chicago Urban League, the *Defender*, the Chicago branch of the National Association for the Advancement of Colored People, the Negro Fellowship League, and countless black social clubs, churches, civic and cultural organizations, and businesses all contributed to the autonomy of Chicago's black community.

Chicago's small black upper and middle classes were acutely conscious of the tenuous position they had carved out for their community in the city as a whole. While welcoming the migrants as a potential source of political and economic clout, they feared that the newcomers, with their "down-home" tastes and demeanor and their ignorance of the unwritten rules governing racial relations in the North, would derail hard-won progress toward racial equality and respect.[70] On streets and streetcars, the dress and

demeanor of recent migrants from the Deep South fed whites' stereotypes and attracted strenuous reform efforts by the black establishment. The Urban League, the *Defender*, the YMCA, and other organizations sought to indoctrinate "correct" behavior. In pamphlets, advertisements, and lectures they exhorted black citizens to watch their language, wash their hands, attend church, and dress appropriately for public places. Above all, they were reminded that "IF YOU DO WELL YOU WILL SERVE NOT ONLY YOURSELF BUT THE ENTIRE RACE."[71]

With or without the guidance or approval of these arbiters of proper behavior, the migrants permanently altered the face of Chicago's Black Belt. Often excluded from the social life of the black elite and uncomfortable in their relatively staid churches and clubs, they shaped the landscape of the Black Belt to accommodate their own needs and tastes. South State Street sprouted new storefront churches, music halls, chicken shacks, and perennial street-corner gatherings, a "Bohemia of the Colored Folks," in the vivid description of the black newspaper Chicago *Whip*.[72] From social style to food, music to religion, the culture of the rural Deep South was transported wholesale to the pavement of Chicago's Black Belt. Motley's street scenes include evidence of the vitality of southern culture in the urban north, from the fundamentalist street preacher in *Gettin' Religion* (1948, cat. no. 55), to restaurant signs offering southern specialties (including the fish and shrimp of the Motley family's native Louisiana) in *Casey and Mae in the Street* (1948, cat. no. 54) and *Chicken Shack* (c. 1936, checklist no. 53). As these works suggest, the relative rigidity of black class structure[73] did not extend to the use of public spaces. In the Black Belt's lively commercial streets upper class met working class, "Old Settlers" mingled with newly arrived "Home Folks," and "shadies" from the criminal world rubbed elbows with churchgoing "respectables" and fashionable, social-climbing "dicties." *Chicken Shack*, for instance, includes a range of types, from businessmen in hats and suits to a man sitting on the curb eating and two men tippling under the streetlight; the foreground contrasts a well-dressed family group with a pair of stylishly attired lovers.

Motley paid particular attention to one special factor in Bronzeville's social differentiation: skin color. Black society was stratified by skin tone, a reflection of the white world's discrimination in favor of relative lightness in African-Americans.[74] Some Black Belt clubs consistently chose fair-skinned individuals for its members, and socially ambitious men were said to favor "white-looking" women as wives.[75] The Motley family's Creole heritage and light coloring helped to place them solidly in Chicago's black middle class. Motley remained acutely conscious of skin color, which became a central motif in his art. As a portraitist in the twenties he addressed the special status that black Chicago accorded to lightness by seeking out women of mixed racial ancestry as models and drawing attention to their racial makeup with titles like *The Octoroon* (1922, cat. no. 8) and *The Quadroon* (1927, checklist no. 17).[76] Later, in genre paintings such as *The Picnic* (1936, cat. no. 39), he portrayed a range of skin colors, showing stylish young women in light tones and their male companions as dark-skinned. "I was trying to fill what they call the full gamut, or the race as a whole," he remarked late in life.

[I]n all my paintings where you see a group of people you'll notice that they're

43

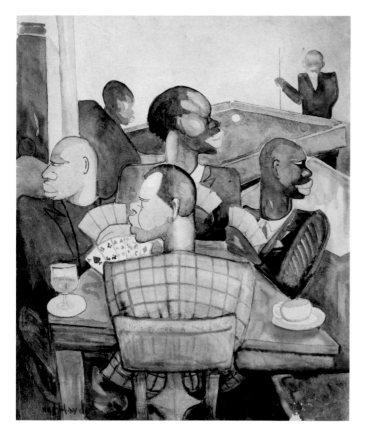

Fig. 28. Palmer Hayden. Nous Quatre a Paris, *c. 1935. Watercolor on paper. The Metropolitan Museum of Art, Purchase, 1975. Joseph H. Hazen Foundation Inc. Gift Fund.*

all a little different color. They're not all the same color, they're not all black, they're not, as they used to say years ago, high yellow, they're not all brown. I try to give each of them character as individuals.[77]

But for Motley skin color was more than a sociological fact to record. The numerous shades of coloration he found among African-Americans influenced his preference for color over form in the creation of his paintings, he noted,[78] and he used skin tone as an independent element of formal composition. In *Blues*, for instance, bronze skin plays against rich dark brown to complement the contrapuntal rhythm established by the arrangement of the shapes of heads, backs, arms, and other forms. Motley's concern for skin color is most apparent in comparison to two other portrayers of black life, Palmer Hayden (1893–1973) (fig. 28) and Jacob Lawrence (b. 1917) (fig. 29), who render generic African-Americans as uniformly brown or literally black.

Educational level also divided Chicago's black social classes. Academic credentials bestowed a dignity and status that occupation, circumscribed as it was by the white world, might not.[79] Aspiring to better educational opportunities, black migrants from the South found that Chicago's public schools, like the neighborhoods they served, were overcrowded and increasingly seg-regated. Teachers and administrators, most of whom were white, were determined to make schools the instruments of rigorous socialization for recent migrants, who found their clothes, speech, and habits subject to ridicule from both white adults and the children of the Old Settlers. Nonetheless, northern schools did offer higher standards and the promise of social mobility. Although the educational level of black Chicagoans remained relatively low and illiteracy rates were high, the high school diploma was a coveted status symbol for upwardly mobile families.[80]

White Chicago's restriction of the employment opportunities open to black Chicagoans may partly explain Motley's indifference to the theme of work in his paintings. The Black Belt's small elite included men in business and the professions, who created a separate but parallel economy in their community. Those who fulfilled aspirations for racial autonomy and solidarity by leading black institutions and providing jobs and services in the Black Belt were respected as "race leaders." Black businessmen had to be particularly resourceful in order to find capital in their circumscribed and relatively impov-erished community. While in some fields, like retailing, they faced stiff competition from white businesses that operated in the Black Belt, a few black entrepreneurs scored notable success in insurance, banking, newspaper publishing, and other areas where white concerns refused to serve black needs.[81]

However, most working African-Americans were forced to adjust to the strictures

of the white workplace. Middle-class, educated individuals often found modest niches in the white economy. As hotel waiters, Pullman porters, or servants in well-to-do white households, they at least dressed well and worked in a relatively clean, safe environment. But migrants who had been schoolteachers, a profession that carried considerable status in the South, were barred from teaching in Chicago by the disparity in educational requirements.[82]

The mass of lower-class blacks encountered formidable barriers to employment in Chicago's economy. Many migrants had worked in agriculture in the South or in industries with no equivalent in Chicago,[83] while even those with skills appropriate to the urban, industrial workplace found themselves excluded by restrictive standards or blatant racial discrimination.[84] Under these constraints, many black men turned to unskilled occupations such as factory workers, laborers, and janitors.[85] Black workers had in the past often been hired as strikebreakers.[86] Until the 1930s mutual hostility effectively kept them out of many industrial and trade unions, and they were restricted to the lowest-paying and most hazardous jobs in industry.[87] For women, there were even fewer opportunities; domestic service was the mainstay even among the educated.[88] Geographical segregation brought added inconvenience and hardship: unlike most of Chicago's migrants, who settled in neighborhoods near factories and other sites of mass employment, black workers faced a daily commute to the workplace.[89]

The extensive segregation of black Chicago stopped short of the ballot box. In 1929 E. Franklin Frazier noted that Chicago "has long been known as the political paradise of the Negro"[90]—particularly compared to the experience of migrants from the South. White politicians, such as Republican William Hale Thompson, who capitalized on traditional black allegiance to the party of Abraham Lincoln, actively courted the black vote.[91] The Black Belt's considerable electoral clout, however, did not translate into improved conditions for the majority of its inhabitants. During the depression they began to trade Republican loyalty for reform. The welfare programs of the era attracted black support to the Democratic party. Many African-Americans even briefly threw their allegiance to the communist and socialist parties, which championed working-class solidarity and resisted the evictions of unemployed renters in the Black Belt.[92]

Far more central to the everyday life of Chicago's African-Americans was the church. The Black Belt's class structure manifested itself in affiliation with particular denominations and congregations. The upper and middle classes flocked to various branches of the Baptist and Methodist churches, with much smaller numbers identifying with the Presbyterian, Congregational, Episcopal, and Roman Catholic churches. The larger black congregations bought up church buildings and synagogues from fleeing white congregations. These churches grew enormously during the Great Migration. The largest, Olivet Baptist Church at Dearborn and Twenty-seventh streets, for instance, blossomed from a membership of about four thousand in 1915 to more than nine thousand in 1920.[93]

Olivet and other big churches supported social services fueled by energetic fundraising, but the activities of civic organizations, social clubs, and the YMCA made

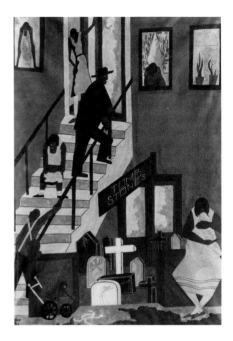

Fig. 29. *Jacob Lawrence. Tombstones, 1942. Gouache on paper. 28 3/4 x 20 1/2 in. (73 x 52.1 cm). Collection of the Whitney Museum of American Art, New York.*

never been examined in the context of Chicago's art history, a history which itself largely remains to be written.[108]

CHICAGO'S ART SCENE

By the World War I era, when Motley was a student at The Art Institute of Chicago, the city was the artistic capital of the Midwest and a formidable rival to New York and other established East Coast art centers. It boasted important private art collections, a fine art museum, regular exhibitions of contemporary art, and art clubs, schools, periodicals, critics, and suppliers.[109] Chicago's emergence as an artistic center, however, was remarkably recent. Before the Great Fire of 1871 the city, culturally speaking, was a mere frontier outpost, looking eastward for artistic direction. Local tastes ran to pedestrian portraiture and idealized views of distinctly non-local landscapes. The Great Fire of 1871 gave birth to a new and expanded moneyed elite, an explosion of architectural creativity, and a new era in Chicago's artistic life, signaled by the founding of the Chicago Academy of Fine Arts, later The Art Institute of Chicago, in 1879. From the first it was both an art school and a museum, offering regular art exhibitions that stimulated collecting among the city's wealthy citizens.[110] A host of art clubs, notably the Chicago Society of Artists, sprang up to provide a supportive network and sympathetic exposure for the city's painters and sculptors.[111] The Athenaeum, the Tree Studio Building, and the Fine Arts Building were the sites of fashionable studio gatherings and offered artistic meccas equivalent to New York City's Tenth Street Studio Building. Fledgling sculptors flocked to Lorado Taft's Midway Studio on the South Side; and artists established rustic summer retreats at the Eagle's Nest at Oregon, Illinois, and elsewhere.[112] By the time it hosted the World's Columbian Exposition in 1893, Chicago had become an art center in its own right.

Chicago's artistic tastes were conservative, typified by collector Martin A. Ryerson and Art Institute director Charles L. Hutchinson.[113] Civic leaders with roots in New England and a tradition of public philanthropy, they looked to Europe, the academy, and the past for their aesthetic standards, and collected according to their firm conviction in the power of art as a tool for civic reform. Old Master pictures and Barbizon landscapes, along with a few modern portraits, graced the drawing rooms of the city's wealthy residents. Even Chicago's enthusiasm for French impressionist painting (following Boston's lead) confirmed her elite's penchant for art that offered an escape from urban realities. Ironically, while the Art Institute offered pioneering annual exhibitions of art by contemporary American and local artists, Chicago collectors showed little interest in their work—except in the realm of conventional portraiture.[114] A generation later, even the city's pioneering collectors of modern art, like Arthur Jerome Eddy, frankly ignored the local art scene.[115]

Nothing more perfectly characterized Chicago's artistic outlook than the World's Columbian Exposition of 1893. In the reverent homage to Beaux Arts classicism expressed in its architecture, murals, sculptures, and fountains, the White City announced Chicago's cultural arrival by trumpeting her respect for European tradition. Its enormous art exhibition brought the latest in European painting to the American audi-

ence, demonstrated by comparison the conservatism of American artists, and virtually excluded local talent. For Chicagoans such as sculptor Lorado Taft, the fair fueled a fervent but unfounded hope that their city was ready to assume the leadership of American art centers. Instead, the spectacle of 1893 affirmed Chicago's conservative artistic temperament and her role as a nursery for creative talent flowing toward the irresistible magnet of New York.[116] By the turn of the century Chicago's artistic atmosphere, as Neil Harris has argued, was characterized by provincial conservatism mingled with the diffidence of its "second-city" mentality.[117] As late as 1921, Daniel Burnham's 1909 *Plan for Chicago*, a pioneering project in urban design, rather than a great work of painting or sculpture, was held up as "the city's outstanding esthetic achievement" even by the director of the Art Institute.[118]

The School of the Art Institute, where Archibald Motley began his studies in 1914, played a key role in Chicago's artistic conservatism.[119] Instruction was modeled on the French academic plan, in which student work was subjected to constant review and public criticism by instructors.[120] Students progressed from drawing to painting, from working in black-and-white to color, from studying basic geometric forms and anatomical models to copying from casts of ancient and Italian Renaissance sculpture before working from the live figure. Motley, well trained in draftsmanship at Englewood High School, placed in the antique class (just below the life class) on his entrance to the four-year course of instruction. He was well prepared to assimilate the teachings of a program shaped by the likes of Paris-trained painter John Vanderpoel (?–1911), who had made the naturalistic rendering of the human figure the cornerstone of the school's approach.[121]

Motley's stay at the Art Institute coincided with a period of upheaval for its school. John Norton, under whom Motley studied, heralded an era of more progressive teachers who questioned its traditional educational program. The Chicago presentation of the exhibition of European avant-garde art known as the Armory Show in 1913 created a virtual panic throughout Chicago's art community and inspired a handful of young artists, like Rudolph Weisenborn (1881–1973), with the iconoclasm of modernism.[122] The year after the Armory Show stirred Chicago, the death of Art Institute director William R. French, a staunch supporter of the school, ushered in a period of administrative instability in which the school's position relative to the museum was opened to question.[123] During these years, too, the electrifying presence of young Polish artist Stanislaus Szukalski (1895–1984), whose visionary, tormented images were featured in two separate one-person shows at the Art Institute, gave voice to the pent-up demands for greater self-expression among Chicago's more progressive artists.[124]

Despite these changes, however, the school remained a fundamentally conservative institution. It reinforced Chicago's mainstream aesthetic, the tone of which was essentially decorous and decorative, expressed in an emphasis on the anatomically correct human form and the harmonious color, pleasing subjects, and brilliant light effects of American impressionism. The year after the Armory Show was seen in Chicago, a student publication decried the "starved alien minds" of the modernists and championed the Midwest, with Chicago as its capital, as the source of a characteristically "sincere" national art.[125] The

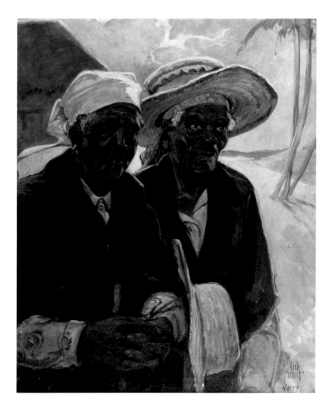

Fig.30. *William E. Scott.* Blind Sister Mary, *c. 1930. Oil on canvas, 29.75 x 24 in. (75.6 x 61 cm). Photograph by Frank Steward. Art & Artifacts Division, Schomburg Center for Research in Black Culture, The New York Public Library, Astor, Lenox and Tilden Foundations.*

institution's relative conservatism may be measured by the impact of George Bellows, whose brief visit in 1919 brought the just-graduated Motley back to the school. The Ashcan School, whose ideals Bellows represented, had long since been overshadowed by the modernists featured in the Armory Show. But Chicagoans admired his illustrational style and the "rich unadulterated strain of good sound middle-western Americanism" in his portrayals of modern life.[126] Motley's own admiration for Bellows has already been noted, and he otherwise agreed with the Art Institute's conservatism. Representational art, if not stylistic naturalism, was necessary to his populist artistic mission: "you can't start out with somebody who knows practically nothing about art and start with modern art. . . . You've got to start out with that conservative thing because every layman leads a very realistic life."[127] Motley had little use for the abstract modern art presented in the Armory Show, and the event made little apparent impact on him.[128]

The changes that the School of the Art Institute underwent in the late teens, when Motley was a student there, are reflected in the teachers he cited as the most influential in his artistic education.[129] Karl A. Buehr (1866–1952), who taught nude and portrait painting, was typical of the painters who dominated Chicago's art scene into the twenties, executing pleasantly colored, light-filled views of women in interiors and leisure life out-of-doors (fig. 31).[130] Albert Krehbiel (1873–1945), Motley's instructor in drawing and composition, was best known for impressionist landscapes and city views, as well as allegorical murals in the Beaux Arts tradition.[131] These teachers gave Motley a solid technical foundation, and set him on the path toward portraiture, if not the portrayal of urban realities.[132] Only John Norton (1876-1934) showed an interest in the latter. His 1924 painting *Light and Shadow* (1924; Art Institute of Chicago), possibly a study for a mural, shows an urban industrial landscape peopled with the working poor.[133]

Motley found the school a congenial environment, where his teachers encouraged him with no regard for race.[134] The school had also nurtured most of the other figures who comprised Chicago's tiny number of black artists. The short-lived landscape painter William A. Harper (1873–1910) studied there at the turn of the century before departing for Europe, where he worked with Henry O. Tanner.[135] William Edouard Scott (1884–1964) also worked with Tanner in Paris after he received his diploma from the school in 1908. Like Tanner, Scott gravitated toward European landscapes and images of rural, southern black life; later, after a visit to Haiti in 1931, he painted a number of rather sentimental character portraits of African-Americans (fig. 30).[136] A more permanent fixture of Chicago's art scene during Motley's early years was William McKnight Farrow, the artist who tried to dissuade Motley from exhibiting *Syncopation* in 1925. Farrow began his studies at the school in 1908 but remained until 1917, three years after Motley's arrival there.[137] An accomplished etcher and watercolorist as well as painter, Farrow favored romantic landscapes and still lifes; his illustrative style and romantic subjects were easily

adapted to the greeting cards he designed and published. In contrast to Motley's embrace of modern black American life, Farrow subscribed to Alain Locke's argument that African art was the best source for the art of the New Negro, occasionally painting in an "African" style that, like Fuller's *Ethiopia Awakening*, drew on Egyptian motifs.[138]

Another contemporary of Motley's at the Art Institute was Charles Clarence Dawson (1889–1981), who studied there from 1913 to 1917. A native of Georgia who studied at New York's Art Students' League before moving to Chicago, Dawson's ambition was to do "for the Negroes what Millet did for the French peasants."[139] His best-known works are technically brilliant though conventional watercolor illustrations, probably executed in the thirties, that bring sly humor as well as sympathy to the world of black Americans at work and play (fig. 32). Several younger black artists, notably sculptor Richmond Barthe (1901–89) (who studied briefly with Motley[140]), illustrator and portraitist Robert Savon Pious (1908–83), and painter Ellis Wilson (1900–77), began their careers at Chicago's premier art school before moving to New York.

Despite the Art Institute's receptiveness to African-American talent, these artists encountered considerable barriers in pursuing their careers in Chicago. This was particularly true in the years following the Great Migration, when the dramatic growth of Chicago's black population along with postwar competition for jobs increased racial tensions in the city. It was during this period that Motley found himself rejected for employment as a commercial artist by a white firm in favor of another recent Art Institute graduate who was far less accomplished but white.[141] The situation did not improve over the years. In the mid-thirties, for instance, Charles White was denied admission to two commercial Chicago art schools that had already awarded him scholarships when the schools realized that he was black.[142] The artistic fortunes of Motley and other black Chicago artists took a further downturn in 1938, when Daniel Catton Rich, who was openly hostile to them, succeeded the sympathetic Robert Harshe at the Art Institute's helm.[143]

The experience of exclusion rather than a single artistic outlook gave Chicago's black artists an identity as a distinct group. In 1917 the city's first exhibition of work by black artists, at the Arts and Letters Society, a black arts club, featured such established figures as Farrow, Harper, and Dawson as well as Motley, then still a student.[144] Five years later the Chicago Art League, a black artists' club, was founded at the Wabash Avenue YMCA.[145] In addition to the League's exhibitions, Chicago's leading black artists found exposure for their work in the Harmon Foundation's influential traveling exhibitions, which appeared annually from 1928 through 1933.[146] And in 1927, the black Chicago Woman's Club sponsored "Negro in Art Week," the highlight of which was an exhibition of work by black artists, held jointly at the Art Institute and the club's premises.[147] Motley, as already noted, held aloof from such activities. He participated only reluctantly in the activities of the Chicago Art League, and refused to exhibit in the "Negro in Art Week" exhibition "because Negroes were putting out such poor work."[148] Thus although Chicago had a small community of black artists, Motley remained somewhat detached from it.

Motley's closest friends during and immediately after his years at the Art Institute were white artists, notably Josef Tomanek (1889–?) and William S. Schwartz

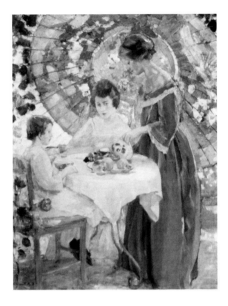

Fig. 31. Karl Buehr. Under the Parasol. *Oil on canvas, 35 x 27 in. (88.9 x 66.6 cm). Fairweather Hardin Galleries.*

Fig. 32. Charles Clarence Dawson. The Bill Poster. *Watercolor on paper, 35 x 27 in. (88.9 x 68.6 cm). The DuSable Museum of African American History.*

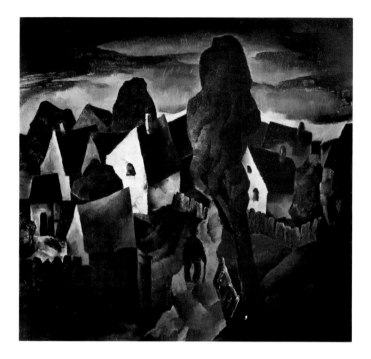

Fig. 33. *William S. Schwartz. A Countryside,
c. 1936. Oil on canvas. Hirschl & Adler
Galleries, Inc., New York.*

(1896–1977).[149] Both recent immigrants from Europe, they were, in a sense, outsiders like Motley. Their work testifies to the diversity of styles prevalent on the Chicago art scene in the period. Tomanek's painting, of which little survives, consisted of academic figure pieces; conservative critics admired his soft pastel-colored images—"like a soft piping on flutes"—as an antidote to the "insane asylum art" of the modernists.[150] While Tomanek's romantic fantasies of luscious seminudes in sunlight could not have been farther from Motley's lively Black Belt views, he was nonetheless an important source of moral support for Motley in the difficult early days of his career.[151] William S. Schwartz, an accomplished singer as well as painter, muralist, and printmaker, was a modernist who experimented with fragmented forms and intense color.[152] In the twenties he painted a series of abstract works he called "symphonic forms," but in his work of the next decade Schwartz created Chicago city scenes and images that exalt rural life (fig. 33). His work in the thirties reflects the powerful influence of the regionalist movement, an artistic and literary reaction against the perceived elitism and European orientation of modernism, fueled by depression-era nostalgia for life in America's heartland.

Schwartz and Tomanek represent two radically different artistic approaches, whose Chicago adherents engaged in a lively debate during the twenties. The traditionalists had close ties with the school and annual exhibitions of the Art Institute and gathered at clubs like the Palette and Chisel Academy. They painted portraits in the fluid, facile manner long since perfected by John Singer Sargent and William Merritt Chase, and landscapes—typically not of Chicago—in the impressionist mode. For portraitists like Louis Betts (1873–1961), figure painters like Adam Emory Albright (1862–1957), and landscapists like Frank C. Peyraud (1858–1948) the conventional union of Truth and Beauty was above question; the function of art in modern life was to elevate taste, if not the human soul, above the quotidian grittiness of urban reality. The group of aspiring modernists who challenged their assumptions included several who had been contemporaries of Motley's at the Art Institute, like Anthony Angarola (1893–1929). From the cubist Rudolph Weisenborn, to the expressionist Emil Armin (1883–1971), to Ramon Shiva (1893–1963), who abstracted the urban landscape into a vision of intense color, these artists worked in a variety of styles. Angarola brought a hard-edged realism to the imaging of urban life, while Raymond Jonson (1891–1982) painted both fantastic landscapes of the imagination and precise, iconic portraits. What they shared was a dedication to experimentation and self-expression in art, an openness to the new ideas stirring avant-garde art circles like Alfred Stieglitz's Gallery 291 in New York, as well as an impatience with the rigid jury system governing the conventional exhibition venues.

In their rebellion against the traditional organization of the city's artistic life,

Chicago's modernists created their own, mostly short-lived but dynamic clubs.[153] Among them was the Chicago No-Jury Society of Artists, founded in 1922 to provide an alternative venue for artistic radicals whose works were rejected for the Art Institute's exhibitions. Despite his suspicion of radical modernism, Motley joined the organization in 1926, exhibiting *Syncopation*, and he was quickly asked to serve as the society's director.[154] He lent his support to the advocates of artistic freedom again in 1935, when he contributed a recent self-portrait (1933, cat. no. 31) to the Salon des Refusés at the Davis Store Gallery, an exhibition organized in protest against the Thirty-Ninth Annual Chicago and Vicinity show at the Art Institute.

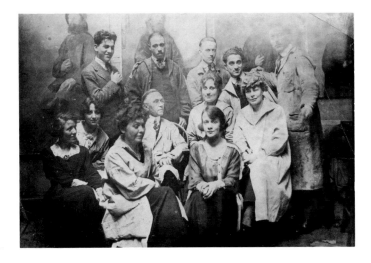

Fig. 34. Karl Buehr's Art Institute class, 1917. *Motley stands in the back row, second from left, behind Buehr. Collection of Archie Motley and Valerie Gerrard Browne.*

The independent Motley perhaps shared the spirit of individualism that informed these endeavors more than he approved of the results of some of its participants' artistic experimentations. In 1918 he had denounced Stanislaus Szukalski, the idol of Chicago's artistic radicals, as an artist "who knows absolutely nothing about painting,"[155] and late in life he condemned abstraction.[156] Although he was included in J. Z. Jacobson's catalogue of Chicago modernists in 1933, Motley remained wedded to the solid technical foundation instilled at the Art Institute, and to its traditional ideal of art as a universal means of expression, of necessity objectively representational.[157] Throughout this period of debate and upheaval in Chicago's artistic life Motley's paintings were welcomed at both the Art Institute annual exhibitions and the rebels' shows. He maintained a delicate but workable balance between the traditional and radical camps, finding stylistic and philosophic points of sympathy with each. This position reflects the synthetic nature of Motley's individual artistic vision, in which he reconciled his academic background and thoroughly modern subject matter.

Motley's decision to portray modern black life was far more of a break with other black artists, especially with Chicago's conservative black painters like Harper, Scott, and Farrow, than it was with Chicago art in general. His early aspiration to be a portraitist was thoroughly in line with Chicago's strong artistic tradition of figurative art, a tradition epitomized in the work of his Art Institute teachers. Though often discouraged in their loftier endeavors by a lack of patronage, the city's painters and sculptors had always found a market for portraiture. The portrait as a means of exploring the individual persona attracted both Chicago's artistic establishment and artists associated with modernism, notably Weisenborn and Jonson. This Chicago tradition was a natural means for Motley to legitimize black subjects in art.

In turning his art to the documentation of urban life in genre scenes, Motley allied himself with current trends in local as well as national art. The portrayal of the city had always been problematical for Chicago painters, with their conservative notions of Beauty.[158] Not until the turn of the century did Chicago's professional landscapists begin to come to terms with the city as a subject for artistic treatment, and then painters like Alson Skinner Clark (1876–1949) and George Demont Otis (1879–1962) framed it in a

romantic haze of soft impressionist color. In the twenties and thirties, however, a number of Chicago's progressive artists brought a more up-to-date vision to the portrayal of the modern metropolis. While artists like Jean Crawford Adams (1890–1971) and William S. Schwartz abstracted and redefined the material reality and physical energy of the built environment, others focused on the everyday human tragicomedy. Motley was in good company as he turned to Bronzeville's dance halls and street corners for his subjects. Gustaf Dalstrom (1893–1971), William Jacobs (1897–1953), Todros Geller (1887/9–1949), Emil Armin (1883–1972), Frances Strain (1898–1962), and others brought their individual visions to the sympathetic picturing of the lives of Chicago's ordinary people. In particular, the work of Strain is reminiscent of Motley's in both subject matter and style. Her painting *Cabaret* appeared alongside his *Syncopation* in the 1926 No-Jury Society exhibition, while *Crowd* recalls Motley's street scenes in its strong, friezelike composition based on contrasting diagonals and its rushing figures pressed up against the picture plane.

This direction in Chicago painting in the twenties and thirties testifies to the long-lived influence of the Ashcan School, with its democratic celebration of the urban social scene.[159] It also was a manifestation of the regionalist outlook, with its often xenophobic nationalism and firm commitment to representationalism. Grant Wood's stark *American Gothic* (1930) and Doris Lee's innocuous *Thanksgiving* (c. 1935), which both enraged and delighted Chicago audiences, pictured "a God-fearing, white-picket-fence America"— white, native born, and rural.[160] At the same time, Chicago artists were applying ethnic influences to the interest in social realism of the era. Jacobs, Geller, and Armin, for instance, drew on their Jewish roots, depicting the Maxwell Street enclave or working in a style influenced by the naivete of folk art. Modern Mexican art also exerted a powerful influence in Chicago. Although the great Mexican muralists Rivera, Orozco, and Siqueiros did not bring their talents to Chicago as they had to New York and other United States cities, the Pan-American Union's extensive touring exhibition surveying Mexican visual arts sparked great enthusiasm when it arrived at the Art Institute in 1932.[161] Chicago artists such as Laura Van Pappelendam (d. 1974) and Mitchell Siporin (1910–1976) were already responding to the Mexican influence.[162] Although Mexican social realist painting's relative humorlessness contrasts with Motley's general outlook, its sculptural, volumetric rendering of forms, if not its heroization of the underclass, may have inspired Motley's work in the thirties. He admired the Mexican artist Miguel Covarrubias, an illustrator of Harlem Renaissance books and periodicals, and later briefly worked in Mexico.[163]

During the thirties, in this environment of eclecticism and social consciousness, a new generation of black artists emerged in Chicago. In an article in the black magazine *Opportunity* in 1940 writer Willard Motley, the artist's nephew, surveyed their struggles for subsistence, inspiration, and recognition in "garages and top floor tenement house studios."[164] They included Charles Davis (1912–?), Bernard Goss (1913–1966), Eldzier Cortor (b. 1915), Charles White (1918–79), Ramon Gabriel, Charles Sebree (1914–85), William Carter (b. 1909), Henry Avery (1906–?), and Walter Ellison (1900–?), among others. Many did not remain in Chicago but began their careers in the city. Motley and

other black artists of his generation had paved the way for them in pioneering art both by and about blacks. But the depression and the social consciousness of the era shaped a new sense of mission for the black artist, who now sought to express the inner soul of his people with reference to their historical and contemporary struggles, failures, and triumphs. Though generally figurative and social in content, black art of the thirties ranged widely in style, from Cortor's gracefully ponderous sculptural forms to White's sinuous, graphic surfaces (fig. 35). The new generation's inevitable inclination toward stylistic realism coincided with the reaction against modernism and abstraction, while the temper of the times made the African-American a sympathetic subject in the art of such regionalist masters as Thomas Hart Benton (1889–1975), John Steuart Curry (1897–1946), and Reginald Marsh (1898–1954).[165]

Fig. 35. *Charles White.* Fatigue, *1940. Oil on canvas. From James A. Porter,* Modern Negro Art. *(New York: Arno Press, 1969).*

Despite increasing recognition of black artistic talent in the thirties and forties, black artists faced considerable barriers. A series of important publications and exhibitions, including "Art of the American Negro, 1851–1940" held at the Art Institute in 1940, drew attention to the achievements of black artists, but few commercial galleries would give them exposure.[166] Thanks to the presence of such sympathetic teachers as Kathleen Blackshear (1897–1988), Chicago's School of the Art Institute offered a tolerant environment where young and old, conservative and progressive talents could mingle, but most black artists could not afford to attend. African-Americans found themselves on the front line in the economic privations and social dislocation of the depression. Black artists supported themselves on the fringes of the economy with menial jobs, and only the federal art projects of the New Deal gave some a chance to pursue their art at least part-time.[167]

These trying conditions gave birth to the Arts and Crafts Guild, an informal group clustered about the inspiring presence of painter and intellectual George Neal (1906–38).[168] Carter, White, and Cortor, along with Margaret Taylor Goss Burroughs (b. 1917), Davis, and Joe Kersey (1908–?), are among the distinguished artists who credited Neal with encouraging their early efforts. Burroughs recalled that Neal, a student at the Art Institute, would pass along what he had learned there to those who could not afford to attend, in adult education classes and at informal gatherings in his coach house studio at Michigan Avenue and Thirty-third Street.[169] A fire destroyed the contents of Neal's studio two years before his premature death, and little of his work survives. But Locke attributed to Neal the "emancipation of the young Negro artist from academic technics [sic] and conservatism, and from the traditional sentimental modes of the Negro subject."[170] The talent Neal nurtured went on to make an important contribution to the New Deal art programs operating in Illinois.

Chicago was regional headquarters of the various federal building and improvement

projects known collectively as the Works Progress Administration (WPA), and dominated its arts projects in the state.[171] Over seven hundred Illinois artists participated, including many of Chicago's most important artists of the era. The art projects, which the federal government sponsored from 1935 to 1943, supported sculpture, easel painting, printmaking and graphic design, and crafts, in addition to the WPA's best-known products: murals created to decorate public buildings. The "American Scene" was the required subject of the majority of the artwork commissioned by the WPA, which encouraged the production of art that was representational and accessible to all.[172] To this end the programs also promoted art instruction and sponsored art exhibitions, notably the Art Institute's "Art for the Public" show in 1938.

Nearly all of Chicago's serious artists were involved in some aspect of the WPA art projects. The program provided more than just a paying opportunity to pursue creative work. It came close to realizing the era's populist ideal, charging artists with the mission of addressing issues of social justice while simultaneously bringing art down from its elitist pedestal and to the people in their post offices, courthouses, schools, and community centers. The artists worked cooperatively, in a spirit of fellowship that lingered long after their products had been forgotten or destroyed.[173]

The WPA was just one arena for the democratic spirit of Chicago's progressive artistic community in the thirties and forties. Organizations such as Artists' Equity Society of America and the Artists' Union worked to give artists the status, benefits, and occupational solidarity that labor unions were providing for workers in conventional trades. The No-Jury movement continued, finding a complement in the outdoor art fairs that blossomed in Grant Park in the early thirties. During the second such fair, for instance, the

Fig. 36. Motley (back row, holding umbrella) and others at a gathering in what may be Josef Tomaneck's studio, 1921. Collection of Archie Motley and Valerie Gerrard Browne.

young artist Gertrude Abercrombie met "all kinds of people, classes, colors, creeds, everything . . . which I hadn't known before."[174] Some of the artists she met there and through her work for the WPA became part of the lively circle of artists, writers, and jazz musicians that gathered in her Hyde Park home in the forties and fifties. The group included Motley, Charles Sebree, painters Tom Kempf (1895–?) and Karl Priebe, as well as author Thornton Wilder, musician Dizzy Gillespie, and singer Sarah Vaughan. Abercrombie was an eccentric figure whose primitive-symbolist paintings may have been an inspiration for the slightly surreal quality in some of Motley's late works, such as *After Revelry, Meditation* (c. 1960, checklist no. 72).

At first, African-Americans were not welcomed into the federal art projects, partly because of the prejudices of the Illinois Art Project's first director, Increase Robinson.[175] Motley was admitted to the program as early as 1935, perhaps in recognition of his established place in Chicago's art scene. But painter William Carter, a younger artist, had a more typical experience: he was assigned to work in a mattress factory and at the construction site of a park swimming pool, among other jobs, while awaiting a position in the easel division.[176] Eventually, however, the WPA provided employment to many among Chicago's black art community: Avery, Carter, Cortor, Davis, Ellison, Gabriel, Goss, Fred Hollingsworth, Kersey, Frank Neal (b. 1915), Gordon Parks (b. 1912), Sebree, and White, as well as Motley.[177] Most of the painters were employed in the easel division, but some, like Motley, Avery, and White, also produced murals. The WPA gave these artists opportunities to compete for mural commissions, produce easel paintings in cooperative project studios and show their work in the WPA's Chicago art gallery. African-Americans were encouraged to participate in the Artists' Union, formed in 1936 to mediate between the arts projects and their employees.[178]

Much of the art produced under the New Deal programs soon disappeared, but the WPA's most important contribution to the black art community in Chicago remains. Two years after the loss of George Neal's galvanizing presence, the South Side Community Art Center was founded as part of the WPA's community art center initiative to bring art to neighborhoods.[179] The WPA provided seed money, but it was mainly funds collected from throughout Chicago's black community that purchased the abandoned Comiskey mansion at Thirty-eighth Street and Michigan Avenue and transformed it into an art center complete with auditorium, workshops, classrooms, and gallery. Further support was raised at a gala dedication attended by Eleanor Roosevelt, who proclaimed the center's mission to "create a democracy in art."[180] Its first director, Peter Pollack, had operated the Chicago Artists Group, one of the very few galleries to show the work of black artists during the thirties.[181] Under Pollack's direction, the center not only provided a place where a diverse collection of black artists met each other and their community through classes, demonstrations, and exhibitions, but where black and white artists mingled as well. Painters Morris Topchevsky (1899–1947), Harold Hayden (b. 1909), and Aaron Bohrod (b. 1907), and sculptor Si Gordon (1908–1962) crossed paths with Motley and Farrow and the younger generation: Cortor, White, Parks, and Hughie Lee-Smith (b. 1915).[182] Sculptor Marion Perkins (1908–61) received his first art instruction at the center,

painter Vernon Winslow first exhibited there, and Burroughs, later founder of Chicago's DuSable Museum of African American History, was first introduced to black history by Gordon, whom she met at the center.[183] With little exaggeration, Burroughs recalled that "any black artist or writer who amounted to anything passed through the doors of this art center."[184]

Many passed through the center on their way out of Chicago altogether, but the center symbolizes the key developments in the tumultuous half-century that witnessed and shaped Motley's maturation. That period saw the development of Chicago's Black Belt from a small, invisible enclave to a diverse and lively community that meshed modern urbanism with southern roots to become perhaps the nation's quintessential black metropolis. It saw the evolution of Chicago's art scene from genteel conservatism to dynamic eclecticism, both receptive to new artistic ideas and capable of making its own contribution to them. Where its art life and its black community came together, Chicago made notable contributions, nurturing several generations of black America's most important talent.

Both personally and artistically, Motley was one of his hometown's most loyal native sons. His refusal to follow the usual eastward flow of Chicago's creative talent undoubtedly played a part in his own and subsequent generations' failure fully to appreciate the significance of his contribution to the New Negro Movement as a national phenomenon. Ironically, however, Chicago itself was a major source for Motley's achievement. His stylistic outlook drew on the city's artistic traditions, while his early career was nurtured by the sympathetic environment he found both at the school and exhibitions of the Art Institute and among Chicago's progressive art circles. More directly, Chicago gave Motley his inspiration and the subject matter through which he fulfilled his original artistic vision. In the Black Belt's intense urbanism, its highly textured character as America's essential modern black community, and its prominence as a center for innovative popular music, Motley found the occasion for the breakthrough he engineered in the portrayal of the African-American, and the inspiration for the individual stylistic means by which to realize that breakthrough.

Through his art Motley both witnessed and shaped the evolution of black visual self-expression from academic realism to a stylistic diversity inspired equally by the textures of black life and culture and the provocative variety of modern art. Synthesizing artistic professionalism and the search for racial self-identity, Motley gave vision to the central aspirations of twentieth-century black culture. But he also carved out for himself a place in American art in general. He made the African-American the subject of a fine art with an appeal beyond the black community, and shaped a professional life that realized his ideal of artistic quality as transcending racial identity and racial barriers. Drawing on a range of influences and traditions, Motley reflected in his art the diversity, as well as some of the dilemmas, of twentieth-century representational art.

NOTES

1. Artist statement by Motley in J. Z. Jacobson, *Art of Today: Chicago* 1933 (Chicago: L. M. Stein, 1932), 93.

2. The specific boundaries of the Black Belt are discussed below. The term Black Belt was established by 1922, when it is used in Chicago Commission on Race Relations, *The Negro in Chicago: A Study of Race Relations and a Race Riot* (Chicago: University of Chicago Press, 1922). Its residents also referred to the area as Bronzeville, a term that first appeared in a black newspaper in 1930 (St. Clair Drake and Horace R. Cayton, *Black Metropolis: A Study of Negro Life in a Northern City* [New York: Harcourt, Brace and Company, 1945], 383).

3. Motley encountered racial hostility in several incidents as a child, as a student at the Art Institute of Chicago, in Paris, and in his search for professional employment. "Autobiography" by Archibald J. Motley, Jr., n.d., Archibald J. Motley, Jr. Papers, Archives and Manuscripts Collection, Chicago Historical Society, 3. Interview with Archibald J. Motley, Jr., by Dennis Barrie, January 23, 1978, Archibald J. Motley, Jr. Papers, Archives of American Art, Smithsonian Institution, Washington D.C.; copy of transcript in Archibald J. Motley, Jr. Papers, Archives and Manuscripts Collection, Chicago Historical Society, [20–21, 52–53]. Elaine Woodall, "Archibald J. Motley, Jr.: American Artist of the Afro-American People, 1891–1928" (Master's thesis, Pennsylvania State University, 1977), 27–29.

4. Jacobson, *Art of Today*, 93; see also Motley, Autobiography, 9, and Barrie, Interview, [32–4].

5. Barrie, Interview, [26].

6. Barrie, Interview, [9].

7. Barrie, Interview, [33–34].

8. The tradition has been amply surveyed in Guy McElroy, *Facing History: The Black Image in American Art 1710–1941* (San Francisco: Bedford Arts Publishers, 1990). This assessment of Motley's achievement was first articulated by Elaine Woodall in her master's thesis, already cited.

9. On Tanner see Dewey F. Mosby et al, *Henry Ossawa Tanner* (exh. cat.) (Philadelphia: Philadelphia Museum of Art, 1991).

10. Many of the artists for whom he recorded his admiration were mainly past masters, who included Frans Hals, Delacroix, and David. Jacobson, *Art of Today*, 93.

11. Leila Mechlin, "Notes of Art and Artists," *The Sunday Star*, May 19, 1929, sec. 2, p. 4, quoted in Gary A. Reynolds and Beryl J. Wright, *Against the Odds: African-American Artists and the Harmon Foundation* (exh. cat.) (Newark, NJ: The Newark Museum, 1989), 111, and figs. 62 and 63.

12. Woodall, "Archibald J. Motley, Jr.," 31–35. Late in life he remarked that "There are no modern painters, with the exception possibly of George Bellows—none of them have ever influenced me" (Barrie, Interview, [51]). Elsewhere, however, Motley noted his admiration for two other painters associated with the Ash Can School, John Sloan and Randall Davey, as well as the Mexican artist Miguel Covarrubias. Davey taught at the Art Institute in the early twenties and Sloan's work was exhibited frequently at the Art Institute. Barrie, Interview, [22]; Willard Motley, Biography of Archibald Motley, n.d., Archibald J. Motley, Jr. Papers, Archives and Manuscripts Collection, Chicago Historical Society, 2.

13. Woodall, "Archibald J. Motley, Jr.," 34–35; Alain Locke, *Negro Art: Past and Present* (Washington, D.C.: Associates in Negro Folk Education, 1936; reprint ed., New York: Arno Press, 1969), quoted in Woodall, "Archibald J. Motley, Jr.," 34–35. On Adams see McElroy, *Facing History*, 113.

14. Motley, Autobiography, n.p.

15. Motley, Autobiography, 9; Motley, "The Negro in Art," n.d. Personal Collection of Archie Motley; copy in Archibald J. Motley, Jr. Papers, Archives and Manuscript Collection, Chicago Historical Society.

16. On Farrow see Reynolds and Wright, *Against the Odds*, 183–87.

17. Motley, Autobiography, n.p.; Barrie, Interview, [32].

18. Barrie, Interview, [11].

19. Motley, "The Negro in Art," Chicago *Defender*, July 13, 1918.

20. Motley's artist statement in Jacobson, Art of Today, 93. Motley's conviction of the primacy of technique is most evident in his "How I Solve My Painting Problems," 1947, Harmon Foundation Papers, Library of Congress, Washington, D.C.; copy in Archibald J. Motley, Jr. Papers, Archives and Manuscripts Collection, Chicago Historical Society.

21. See for instance Motley, "The Negro in Art," 6. The specific subjects of Motley's criticisms are unidentified.

22. Motley, Autobiography, n.p. Motley was reluctant to join the Chicago Art League of the Wabash Avenue YMCA, and he refused to exhibit in the "Negro in Art Week" exhibition sponsored by the Chicago Woman's Club in 1927. He did, however, participate in white organizations, including the No-Jury Society, and the Illinois Academy of Fine Arts. Woodall, "Archibald J. Motley, Jr.," 111, 112–15.

23. Woodall, "Archibald J. Motley, Jr.," 103–104, 108–11. Farrow was influential as president of the Chicago Art League as well as art critic for the Chicago *Defender*.

24. Motley, Autobiography, 9.

25. Woodall, "Archibald J. Motley, Jr.," 103.

26. The dating of the New Negro Movement is itself problematical. John S. Wright suggests that it may have begun as early as 1895, when, he notes, "editorials in African-American newspapers had appealed to their readership to begin building a new group personality, a new civilization, and a correspondingly new flowering of art" ("A Scintillating Send-Off For Falling Stars: The Black Renaissance Reconsidered," *A Stronger Soul Within a Finer Frame: Portraying African-Americans in the Black Renaissance* [exh. cat.] [Minneapolis: University Art Museum, University of Minnesota, 1990], 15). Wright provides a sensitive discussion of the New Negro Movement as a national phenomenon.

27. David Driskell, *Two Centuries of Black American Art* (exh. cat.) (Los Angeles: Los Angeles County Museum of Art, 1976), 59.

28. Alain D. Locke, *The New Negro* (1925; reprint ed. New York: Atheneum, 1980), [xv].

29. These issues continued to concern black artists and

intellectuals into the thirties. For a discussion of their impact in the context of the Harmon Foundation's activities, for instance, see Clement Alexander Price, "In Search of a People's Spirit: The Harmon Foundation and American Interest in Afro-American Artists," in Reynolds and Wright, *Against the Odds*, 71–87.

30. The Harlem Renaissance's specific legacy in the visual arts is examined in *Since the Harlem Renaissance: 50 Years of Afro-American Art* (exh. cat.) (Lewisburg, PA: The Center Gallery of Bucknell University, 1985).

31. For a profile of the Harlem Renaissance's movers and shakers, see David Levering Lewis, "Harlem My Home" in Mary Schmidt Campbell, et al, *Harlem Renaissance: Art of Black America* (exh. cat.) (New York: The Studio Museum in Harlem and Harry N. Abrams, Inc., 1987), 57–103.

32. Mary Schmidt Campbell provides an overview of the criticism of the Harlem Renaissance's achievements in the visual arts in her introduction to Campbell, et al, *Harlem Renaissance*, 38–55.

33. Romare Bearden, "The Negro Artist and Modern Art," *Opportunity* (1934), quoted in Campbell et al, *Harlem Renaissance*, 49. The latter contains fine summaries on the life and art of all four artists. On Johnson see also Richard J. Powell, *William H. Johnson* (exh. cat.) (Washington, D.C.: National Museum of American Art, 1991).

34. For instance, *Ethiopia Awakening* (1914; The Schomburg Center for Research in Black Culture), the most important work by Fuller (who belongs to an earlier generation than Motley and the others) is an idealized historical subject, while a pair of plaster genre pieces, *Lazy Bones in the Shade* and *Lazy Bones in the Sun* (1937; Collection of Solomon R. Fuller, Bourne, MA) engages the racist tradition of the shiftless darky.

35. Hayden incorporated African sculpture and fabrics into his still-life painting *Fetiche et Fleurs* (1926; Collection of Mrs. Miriam Hayden), and in some early watercolors portrayed African-Americans with a freshness comparable to Motley's work (see Campbell et al,

Harlem Renaissance, pls. 11, 12), but these were not as typical of his work in the twenties as the European landscapes he exhibited with the Harmon Foundation beginning in 1928. Johnson, academically trained, moved from academic realism to emulation of European masters of post-impressionism and expressionism before embracing what he termed primitivism in style and subjects that ranged from everyday black life to Biblical stories reinterpreted with black figures.

36. Barrie, Interview, [6–7].

37. Barrie, Interview, [34, 44].

38. Jontyle Theresa Robinson, "Archibald John Motley, Jr.: A Notable Anniversary for a Pioneer," in *Three Masters: Eldzier Cortor, Hughie Lee-Smith, Archibald John Motley, Jr.* (exh. cat.) (New York: Kenkeleba Gallery, 1988), 42–43.

39. Barrie, Interview, [42].

40. Barrie, Interview, [42].

41. Barrie, Interview, [43, 49].

42. Barrie, Interview, [34].

43. Barrie, Interview, [49].

44. Barrie, Interview, [49, 52].

45. Wright, *A Stronger Soul*, 26.

46. Wright, *A Stronger Soul*, 29.

47. E. Franklin Frazier, "Chicago: A Cross-Section of Negro Life," *Opportunity* 7 (March 1929), 73.

48. Carroll Binder, *Chicago and the New Negro: Studies in a Great Community's Changing Race Relations* (Chicago: Chicago Daily News, 1927), 22; see also Frazier, "Chicago: A Cross-Section," 70–73.

49. Frazier, "Chicago: A Cross-Section," 70.

50. James Weldon Johnson quoted in Wright, *A Stronger Soul*, 29. Drake and Cayton's *Black Metropolis* (1945) drew heavily on research undertaken at the University of Chicago (Introduction, xvii–xix).

51. Locke, "The Legacy of the Ancestral Arts," in *New Negro*, 254–267. Motley produced his African-inspired paintings for his one-man exhibition, at the direct suggestion of the New Gallery's president. Letter from George S. Hellman to Motley, New York, May 9, 1927, Archibald J. Motley, Jr. Papers, Archives and Manuscripts

Collection, Chicago Historical Society; Barrie, Interview, [35].

52. Motley, Autobiography, 9.

53. Allan H. Spear, *Black Chicago: The Making of a Negro Ghetto 1890–1920* (Chicago: The University of Chicago Press, 1967), 12, Table 1.

54. Spear, *Black Chicago*, 11, Table 2.

55. Spear, *Black Chicago*, 11, Table 2.

56. James R. Grossman, *Land of Hope: Chicago, Black Southerners, and the Great Migration* (Chicago: The University of Chicago Press, 1989), 32–33, 148–149.

57. Chicago served as a transit point for many southern blacks who settled in other Northern industrial cities, like Detroit. CCRR, *The Negro in Chicago*, 79–80.

58. Grossman, *Land of Hope*, 96–97. Such networks helped many migrants face barriers to their migration erected by Southern planters and mill operators resisting the rapid hemorrhaging of their cheap labor supply. Southern employers intimidated migrants and erected barriers to the operation of labor agents, while spreading word of Chicago's dangerously harsh climate (see for instance CCRR, *Negro in Chicago*, 88).

59. Motley, Autobiography, 1.

60. CCRR, 107.

61. Motley, Autobiography, 2. Motley wrote that he grew up in Englewood in an atmosphere of "no prejudice, no hatred," but he also recalled hostile racial incidents (Autobiography, 3–4).

62. Spear, *Black Chicago*, 23–24.

63. CCRR, *Negro in Chicago*, 122–29; Spear, *Black Chicago*, 211.

64. Grossman, *Land of Hope*, 127–28.

65. Quoted in CCRR, *Negro in Chicago*, 99.

66. Drake and Cayton, *Black Metropolis*, 107.

67. Similar outbreaks occurred in other cities where returning servicemen competed with African-Americans for jobs. Chicago's riot prompted the formation of the Chicago Commission on Race Relations. Its still invaluable study, *The Negro in Chicago*, opens with a detailed account of the riot. The standard history of the riot remains William Tuttle, *Race Riot: Chicago in the Red*

Summer of 1919 (New York: Atheneum, 1970).

68. On Chicago's black elites old and new, see Spear, *Black Chicago*, chs. 3 and 4.

69. Grossman, *Land of Hope*, 129–30; Spear, *Black Chicago*, 86–88.

70. Grossman, *Land of Hope*, 139–40, 144–53.

71. Urban League statement in *Defender*, Nov. 23, 1918, quoted in Grossman, *Land of Hope*, 144.

72. Quoted in Grossman, *Land of Hope*, 117.

73. Drake and Cayton, *Black Metropolis*, 521.

74. Drake and Cayton, *Black Metropolis*, 495, 499–501

75. Drake and Cayton, *Black Metropolis*, 497–98. The artist's mother is said to have cautioned him against marrying a "black," that is, dark-skinned, girl (Motley quoted in Woodall, "Archibald J. Motley, Jr.," 12).

76. Barrie, Interview, [20].

77. Barrie, Interview, [26].

78. Jacobson, *Art of Today*, 93. This point was likewise reflected in Motley's use of language. Art critic Harold Haydon wrote: "He is old-fashioned enough to prefer 'colored' to 'black,' and modern enough to point out that 'colored' takes in many more people than are black" (*Chicago Sun Times*, Aug. 29, 1971, sec. 5, p. 3).

79. A Black Belt doctor, for instance, noted that a number of his fraternity brothers became hotel waiters and Pullman porters upon graduation, for lack of opportunity. Drake and Cayton, *Black Metropolis*, 515–16.

80. Otis Dudley Duncan and Beverly Duncan, *The Negro Population of Chicago: A Study of Residential Succession* (Chicago: The University of Chicago Press, 1957), 91; Drake and Cayton, *Black Metropolis*, 515–16.

81. Spear, *Black Chicago*, 181–86.

82. Grossman, *Land of Hope*, 182.

83. Spear, *Black Chicago*, 156–57.

84. Spear, *Black Chicago*, 34.

85. The Chicago Commission on Race Relations noted that the level of employment declined for many black southerners when they came North; one tinsmith, for instance, worked as a waiter when he first arrived in Chicago, and was a laborer a year later. CCRR, *Negro in Chicago*, 95.

86. Spear, *Black Chicago*, 36–40.

87. Spear, *Black Chicago*, 159–66; Grossman, *Land of Hope*, 182.

88. CCCR, *Negro in Chicago*, 378–79; Drake and Cayton, *Black Metropolis*, 242–52.

89. Grossman, *Land of Hope*, 127, 196.

90. Frazier, "Chicago: A Cross-Section," 72.

91. Spear, *Black Chicago*, 187–89.

92. Drake and Cayton, *Black Metropolis*, 86–88.

93. Spear, *Black Chicago*, 177; CCRR, *Negro in Chicago*, 143.

94. Spear, *Black Chicago*, 175–77.

95. Frazier, "Chicago: A Cross-Section," 71.

96. Langston Hughes, *The Big Sea: An Autobiography* (New York, 1945), quoted in Grossman, *Land of Hope*, 117.

97. On vice industries in the Black Belt see Thomas Philpott, *The Slum and the Ghetto: Neighborhood Deterioration and Middle-Class Reform, Chicago 1880–1930* (New York: Oxford University Press, 1978).

98. Drake and Cayton, *Black Metropolis*, 486–87.

99. Drake and Cayton, *Black Metropolis*, 385–87.

100. Grossman, *Land of Hope*, 131–32.

101. See Chadwick Hansen, "Social Influences on Jazz Style," *American Quarterly* 12 (Spring 1960), 493–507; on the fascinating history of jazz in Chicago in general see Dempsey J. Travis, *An Autobiography of Black Jazz* (Chicago: Urban Research Institute, 1983), and Leroy Ostransky, *Jazz City: The Impact of Our Cities on the Development of Jazz* (Englewood Cliffs, NJ: Prentice-Hall, Inc., 1978).

102. See Mike Rowe, *Chicago Blues: The City & the Music* (New York: Da Capo Press, 1975).

103. As David Levering Lewis points out, "much of its [Harlem's] music was tested in and imported from Chicago." "The Politics of Art: The New Negro, 1920–1935," *Prospectus: An Annual of American Cultural Studies* (1977), 237.

104. Wright, *A Stronger Soul*, 29.

105. Motley, "The Negro in Art," 2; Barrie, Interview, [31].

106. Motley, Autobiography, 8–9. In contrast, it was whites, like his high school art teacher, Frank W.

Gunsaulas of the Armour Institute, and Harsche who early recognized and encouraged Motley's ambition and talent, and sought opportunities for him to train and exhibit.

107. Barrie, Interview, [31]. See also Motley, Autobiography, 9, and Motley, "The Negro in Art."

108. The most comprehensive survey of art in Chicago remains Esther Sparks, "A Biographical Dictionary of Painters and Sculptors in Illinois 1808–1945" (PhD dissertation, Northwestern University, 1971), Introductory Essay, 1:1–232. See also William H. Gerdts, *Art Across America: Two Centuries of Regional Painting 1710–1920* (New York: Abbeville Press, 1990). The publication of *The Old Guard and the Avant-Garde: Modernism in Chicago, 1910–1940*, Sue Ann Prince, ed. (Chicago: The University of Chicago Press, 1990) represents a major advance in the critical examination of Chicago's art history.

109. Art publishing in late nineteenth- and early twentieth-century Chicago has been extensively researched by William H. Gerdts. For a summary of this and of Chicago's art clubs see his *Art Across America*, v. 2, 293–94, 302–303.

110. On the history of the Art Institute, see Helen Lefkowitz Horowitz, *Culture and the City: Cultural Philanthropy in Chicago from the 1880s to 1917* (Lexington: The University of Kentucky Press, 1976), and Horowitz, "The Art Institute of Chicago: The First Forty Years," *Chicago History* 8 (Spring 1979), 2–15.

111. The Society's history is detailed in Louise Dunn Yochim, *Role and Impact: The Chicago Society of Artists* (Chicago: The Chicago Society of Artists, 1979).

112. On Chicago's art society in the late nineteenth century see Timothy J. Garvey, *Public Sculptor: Lorado Taft and the Beautification of Chicago* (Urbana, IL: University of Illinois Press, 1988), ch. 3.

113. On Chicago's private collectors see Patricia Erens, *Masterworks: Famous Chicagoans and Their Paintings* (Chicago: The Chicago Review Press, 1979).

114. The Art Institute inaugurated its series of annual exhibitions of American art in 1888 and its annual exhi-

bitions of art by artists of Chicago and vicinity in 1897. In 1910 the Friends of American Art was established to purchase works by living American artists for the museum.

115. See Stefan Germer, "Traditions and Trends: Taste Patterns in Chicago Collecting," in Prince, ed., Old Guard, ch. 10.

116. The failure of Chicagoans to patronize hometown artists and the tendency of the latter to move to New York remained concerns of Chicago's art community. See for instance Philip J. Huth, "Community Encouragement—A Plea to the Patron," The Art Student (Jan. 1916), 85–87, and Neil Harris, "The Chicago Setting," in Prince, ed., Old Guard, 7–14.

117. Harris, "The Chicago Setting," in Prince, ed., Old Guard, 4–7.

118. George W. Eggers, "Chicago as an Art Center. Introduction," Art and Archaeology 12:3–4 (Sept./Oct. 1921), 100.

119. On the history of the School see Peter C. Marzio, "A Museum and a School: An Uneasy But Creative Union," Chicago History 8 (Spring 1979), 20–23, 44–52, and Charlotte Moser, "'In the Highest Efficiency': Art Training at the School of the Art Institute of Chicago" in Prince, ed., Old Guard, 193–208.

120. School of the Art Institute of Chicago, Circular of Instruction for 1910–1911, 9.

121. Although Vanderpoel died in 1911, three years before Motley entered the School, his outlook continued to influence the School's conservative course of instruction. See Moser, "'In the Highest Efficiency'," in Prince, ed., Old Guard, 196–98.

122. On the Chicago showing of the Armory Show see Milton W. Brown, The Story of the Armory Show (New York; Abbeville Press, 1988), ch. 10, and Richard R. Brettell and Sue Ann Prince, "From the Armory Show to the Century of Progress: the Art Institute Assimilates Modernism" in Prince, ed., Old Guard, 209–14.

123. Moser, "'In the Highest Efficiency'," in Prince, ed., Old Guard, 201.

124. Susan Weininger, "Modernism and Chicago Art,

1910–1940," in Prince, ed., Old Guard, 64–66. See also "Stanislaus Szukalski's Lost Tune," Chicago History 20 (Spring and Summer 1991), 39–55.

125. L. W. H., "North of the River," The Art Student, Published by the Students of the Art Institute of Chicago, Christmas 1915, 44; Dr. Albrecht Montgalas, "American National Art and the American Test," The Art Student, Christmas 1915, 45–46.

126. Two other members of the Ashcan School, Leon Kroll and Randall Davey, taught at the School in the early twenties. See Moser, "'In the Highest Efficiency'," in Prince, ed., Old Guard, 202–204.

127. Barrie, Interview, [33].

128. Late in life he claimed to have no recollection of the exhibition. Barrie, Interview, [22–23].

129. Motley, Autobiography, 7–8; Woodall, "Archibald J. Motley, Jr.," 16–18.

130. On Buehr see Gerdts, Art Across America, 2:316.

131. On Krehbiel see Gerdts, Art Across America, 2:319–20.

132. The work of George Walcott, Motley's teacher for color composition in oils, is little known, and he apparently never exhibited at the Art Institute. Motley names Buehr, Krehbiel, and Walcott as his main teachers in his Autobiography, but Buehr, Krehbiel, and John Norton are mentioned in the biography for Motley in Jacobson, Art of Today, 146–7.

133. Information courtesy of Jim L. Zimmer, Assistant Administrator of the Lockport Gallery, Illinois State Museum, who is curating an exhibition of John Norton's work.

134. Motley, Autobiography, 7–8, 10.

135. On Harper see Florence Lewis Bentley, "William A. Harper," Voice of the Negro 3 (Feb. 1906), 118–22, and Elsa Honig Fine, The Afro-American Artist: A Search for Identity (New York: Holt, Rhinehart and Winston, Inc., 1973), 76–77.

136. On Scott see Fine, Afro-American Artist, 78–80, and Reynolds and Wright, Against the Odds, 255–58.

137. On Farrow see Reynolds and Wright, Against the Odds, 182–87.

138. Woodall, "Archibald J. Motley, Jr.," 110.

139. On Dawson see Reynolds and Wright, Against the Odds, 172–74.

140. Woodall, "Archibald J. Motley, Jr.," 119.

141. Woodall, "Archibald J. Motley, Jr.," 27–30.

142. James Porter and B. Horowitz, Images of Dignity: The Drawings of Charles White (Los Angeles: Ward Ritchie Press, 1967), 11. White later studied at the Art Institute.

143. Woodall, "Archibald J. Motley, Jr.," 46–47.

144. Reynolds and Wright, Against the Odds, 17.

145. Reynolds and Wright, Against the Odds, 17.

146. Reynolds and Wright, Against the Odds, 284–88.

147. Modern Paintings and Sculpture (exh. cat.) (Chicago: The Chicago Art Institute [sic], 1927).

148. Motley quoted in Woodall, "Archibald J. Motley, Jr.," 113.

149. Barrie, Interview, [19–20].

150. Paul T. Gilbert, "Exhibit in Fair at San Francisco Under Fire," Herald and Examiner, Aug. 13, 1939; Eleanor Jewett, "Paintings at the Palette and Chisel," Chicago Tribune, Apr. 28, 1929. On Tomanek see Sparks, "Dictionary," 2:637.

151. Willard Motley, Biography, 3; Woodall, "Archibald J. Motley, Jr.," 67.

152. On Schwartz see Jacobson, Art of Today, 120–21, 151, and Manuel Chapman, William S. Schwartz (Chicago: L. M. Stein, 1930).

153. See Paul Kruty, "Declarations of Independents: Chicago's Alternative Art Groups of the 1920s," in Prince., ed., Old Guard, 77–94.

154. Woodall, "Archibald J. Motley, Jr.," 114. During his involvement with the organization, Motley was its only black member.

155. Motley, "The Negro in Art," Defender, July 13, 1918.

156. Barrie, Interview, [33–34].

157. See for instance Motley's statement in Jacobson, Art of Today, 93.

158. Harris, "The Chicago Setting," in Prince, ed., Old Guard, 4–7.

159. The work of Robert Henri, John Sloan, and George Bellows could be seen at both establishment

and independent venues, thanks in part to the contacts between them and Strain and her husband, painter Fred Biesel. Kruty, "Chicago's Alternative Art Groups," in Prince, ed., *Old Guard*, 78, 83.

160. Barbara Rose, *American Art Since 1900: A Critical History* (New York: Frederick A. Praeger, 1967), 115. Both paintings aroused the ire of the city's art conservatives but won medals at Art Institute American Annual shows and were purchased for the museum by the Friends of American Art (Sparks, "Dictionary," Introductory Essay, 1:162–64). The Friends added to these purchases another painting which has become a hallmark of regionalism, Edward Hopper's *Nighthawks* (1942).

161. "Specimens of Mexican Artistic Genius Are Shown at Chicago Art Institute," *Chicago Tribune*, Jan. 3, 1932. The Chicago showing may have been added as an afterthought. The catalogue does not mention the Art Institute among the exhibition's venues, and gives the tour's dates as 1930–31. *The Exposition of Mexican Art* (*Bulletin of the Pan American Union*, Oct. 1930) (Washington, D.C.: The Pan American Union, 1930), 1.

162. On Pappelendam see Jacobson, *Art of Today*, 130, 153; Sparks, "Dictionary," 1:187; on Siporin see Sparks, "Dictionary," 1:209–10 and 2:609–10.

163. Motley met Covarrubias in New York in 1928, when each was having a one-man exhibition (Willard Motley, Biography, 2). Covarrubias had just published his *Negro Drawings* (New York: Alfred A. Knopf, 1927), a collection of his satirical caricatures of Harlem "types." During the fifties, when Motley worked in Mexico, he produced *Another Mexican Baby* (cat. no. 59), a mural-like work whose serious social theme and peasant protagonists are reminiscent of the work of Diego Rivera.

164. Willard F. Motley, "Negro Art in Chicago," *Opportunity* 18 (Jan. 1940), 19.

165. See McElroy, Facing History, xxii-iii, 114–15, 120–23, 125.

166. Likewise, the era saw the publication of the first surveys of African-American artists, notably Alain Locke's *Negro Art, Past and Present* (1936) and *The Negro in Art* (1940), and James A. Porter's *Modern Negro Art* (1943).

167. Willard Motley, "Negro Art in Chicago."

168. Fine, *Afro-American Artist*, 170; Locke, *Modern Negro Art*, 131–32.

169. Transcript of Interview with Margaret Taylor Goss Burroughs, Archives of American Art, 1988, 22; Transcript of Interview with William Carter, Archives of American Art, 1988, 23.

170. Locke, *Modern Negro Art*, 131.

171. An exhaustive history of the various projects in Illinois is contained in George J. Mavigliano and Richard A. Lawson, *The Federal Art Project in Illinois 1935–1943* (Carbondale, IL: Southern Illinois University Press, 1990); see also *After the Great Crash: New Deal Art in Illinois* (exh. cat.) (Springfield, IL: Illinois State Museum, 1983), and Sparks, "Dictionary," v.1, ch. 10.

172. Mavigliano and Lawson, *Federal Art Project*, 18–24.

173. Sparks, "Dictionary," 1:226.

174. Quoted in Susan Weininger, *Gertrude Abercrombie* (exh. cat.) (Springfield, IL: Illinois State Museum, forthcoming).

175. Mavigliano and Lawson, *Federal Art Project*, 68.

176. Transcript of Interview with William Carter, Archives of American Art, 1988, 25–28; see also Transcript of Interview with William McBride, Archives of American Art, 1988, 26–27.

177. On black artists and the WPA see *New York/Chicago: WPA and the Black Artist* (exh. cat.) (New York: The Studio Museum in Harlem, 1976), and Mavigliano and Lawson, *Federal Art Projects*, 67–69.

178. Mavigliano and Lawson, *Federal Art Projects*, 69.

179. The SSCAC is the only community art center of several founded under the WPA that survives.

180. Quoted in Sparks, "Dictionary," 1:224. The opening and its accompanying exhibition were described by Locke in "Chicago's New Southside Art Center," *Magazine of Art* 34 (Aug.–Sept. 1941), 370–74. See also Burroughs interview, 40–43.

181. Sparks, "Dictionary," v. 1, 224; Mavigliano and Lawson, *Federal Art Projects*, 67–68; Burroughs interview, 40.

182. Carter interview, 24; Burroughs interview, 44–45.

183. Burroughs interview, 45.

184. Burroughs interview, 42–43.

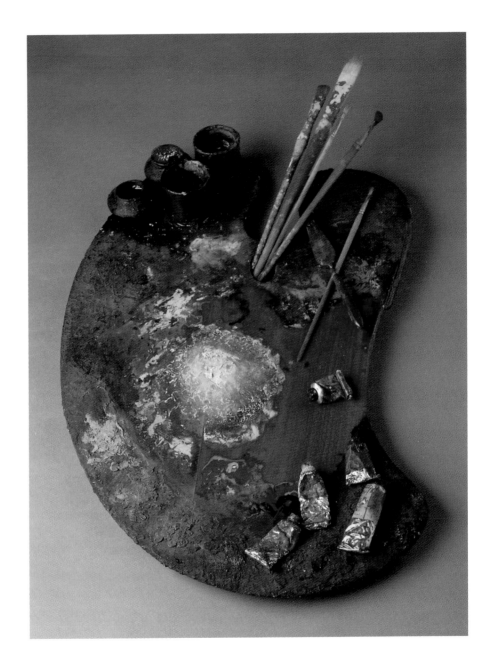

2

Seated Nude, c. 1916–18
Oil on canvas, 37⅝ x 33¾ in.
(95.6 x 85.7 cm). Collection of Archie
Motley and Valerie Gerrard Browne.

Like *The Chef* (c. 1916–18, cat. no. 1),
this rendering of a nude woman is proba-
bly a product of Motley's study at the Art
Institute. Only advanced students painted
from the live model, following mastery
of the rendering of plaster casts. In this
exercise Motley explored the problem of
giving convincing three-dimensionality to
the soft contours of flesh, muscle, and
bone. Leaving surrounding space unde-
fined and unfinished, he focuses on the
seated figure, quietly posed with her back
to the viewer. The muted colors and
slightly broken brushwork of Motley's
Seated Nude reflect the stylistic influence
of Chicago's conservative painters, who
dominated the Art Institute's faculty while
Motley studied there.

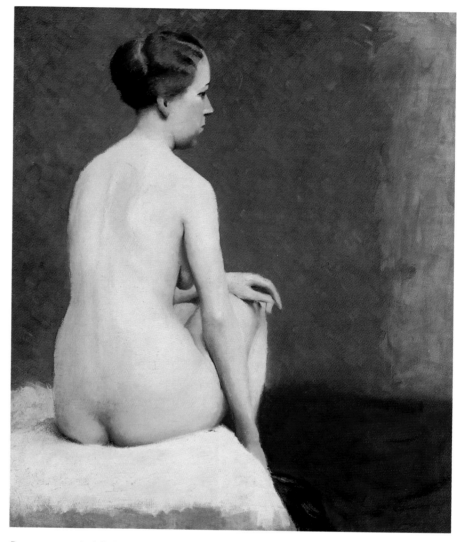

PROVENANCE: Archibald J. Motley, Jr.,
c. 1916–81; Archie Motley, 1981–86;
Archie Motley and Valerie Gerrard
Browne, 1986.

3

Rita, c. 1918
Oil on canvas, 17⅛ x 14¼ in.
(43.4 x 36.2 cm). Inscribed, lower right:
A. J. Motley, Jr./1927. Collection of Archie
Motley and Valerie Gerrard Browne.

Motley probably painted this likeness of
Rita, his niece, in his earliest years as a
portraitist, adding his signature and the
date later in life. Motley's only known
portrait of a child, *Rita* shares its dark
tones and straightforward composition
with other early portraits, such as
the images of the artist's parents and the
self-portrait of about 1920. Rita's softly
painted face, framed by the halo of her
hair, fills the image as her dark eyes
engage the viewer.

PROVENANCE: Archibald J. Motley, Jr.
1918–81; Archie Motley, 1981-86;
Archie Motley and Valerie Gerrard
Browne, 1986.
REFERENCES: Woodall, 1977, no. 1.

4

Portrait of My Mother, 1919
Oil on canvas, 32⅛ x 28¼ in.
(81.6 x 71.8 cm). Inscribed, lower right:
A. J. Motley, Jr./1919. Collection of Archie
Motley and Valerie Gerrard Browne.

The artist's mother, Mary F. Huff Motley
was a schoolteacher in Louisiana before
her marriage to Archibald J. Motley, Sr. A
source of constant encouragement to her
son in his early ambition to become an
artist, she visited him and his wife during
the year they spent in Paris, in 1929–30.

The first of two portraits Motley paint-
ed of his mother, this was the first painting
he exhibited as a professional artist. He
had hesitated to submit it to The Art Insti-
tute of Chicago's annual exhibition "Artists
of Chicago and Vicinity" in 1921, but his
friend, painter Josef Tomanek (1889– ?),
encouraged Motley to do so by offering
to frame it himself.

The composition of *Portrait of My
Mother* is almost symmetrically simple,
with the sitter posed facing the viewer
head-on. The image is saturated with
shades of brown, punctuated by the
white collar of Mary Motley's dress and
the stones in her pendant necklace. She
clasps her hands and gazes directly at the
viewer with a slightly enigmatic expres-
sion in which curiosity, resignation, and
bemusement all seem a part.

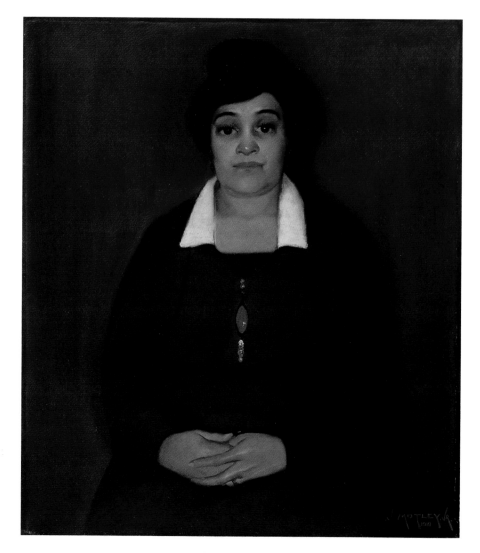

PROVENANCE: Archibald J. Motley, Jr.
1919–81; Archie Motley, 1981–86; Archie
Motley and Valerie Gerrard Browne, 1986.
EXHIBITIONS: Chicago, 1921; Chicago, 1922.
REFERENCES: Art Institute, 1921; Woodall,
1977 no. 2.

5

Mulatress With Figurine and Dutch Seascape, c. 1920
Oil on canvas, 31⅜ x 27⅝ in.
(79.7 x 95.6 cm). Inscribed, lower right:
A. J. Motley, Jr. Collection of Archie
Motley and Valerie Gerrard Browne.

In the early twenties, Motley executed a
series of portraits of beautiful women of
mixed racial ancestry in which he "worked
diligently to give them the respect, dignity
and honor they deserve. . . . I find in the
black women such a marvelous range of
color, all the way from very black to the
typical Caucasian type."[1] Here Motley
portrays a very light-skinned woman
whose pallor is set off by her mass of
dark hair.

This unidentified model is a fashionable
young women who fixes the viewer
with a slightly quizzical gaze. To her right
Motley has placed a still-life arrangement
of studio props, including a plaster model
of a male torso, reminiscent of the
anatomical studies that formed part of
his education at The School of the
Art Institute. The Dutch-style landscape
above is one of many, usually fanciful,
paintings that the artist included within
his compositions.

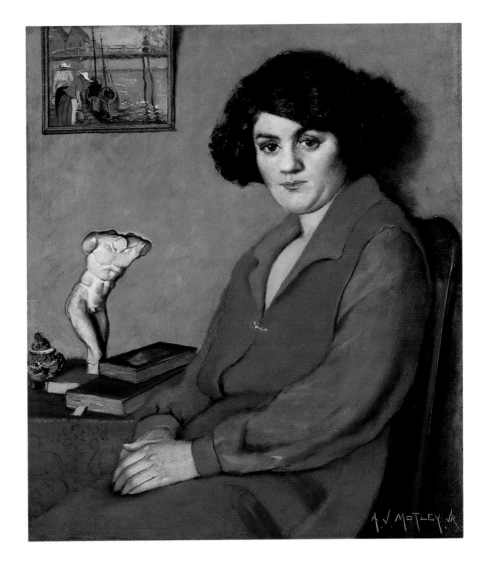

PROVENANCE: Archibald J. Motley, Jr.,
c. 1920–81; Archie Motley, 1981–86;
Archie Motley and Valerie Gerrard
Browne, 1986.

6

Self-Portrait, c. 1920
Oil on canvas, 30⅛ x 22⅛ in.
(76.5 x 56.2 cm). Collection of
Charlotte C. Duplessis.

Although this early self-portrait was not
intended for exhibition or sale, it projects
the public persona of the professional
artist. Emerging from an undefined dark
background, Motley confronts the viewer
with an uncompromising gaze. He is for-
mally attired in a dark suit, white shirt and
collar, and diamond-studded tie pin, his
hair and mustache carefully groomed.
The artist's brilliantly colored palette, the
symbol of his vocation, presses forward
against the picture plane. Although Motley
painted his face and head with almost
finicky particularity, he daubed the image
of his palette with heavy blobs of different
colored paints to replicate the thickly
laden surface of his actual palette. The
painting of the hands, which Motley later
perfected, is awkward and tentative here.

PROVENANCE: Archibald J. Motley, Jr.,
c. 1920– ?; Mrs. Flossie Moore, ?–1985;
Charlotte C. Duplessis, 1985.

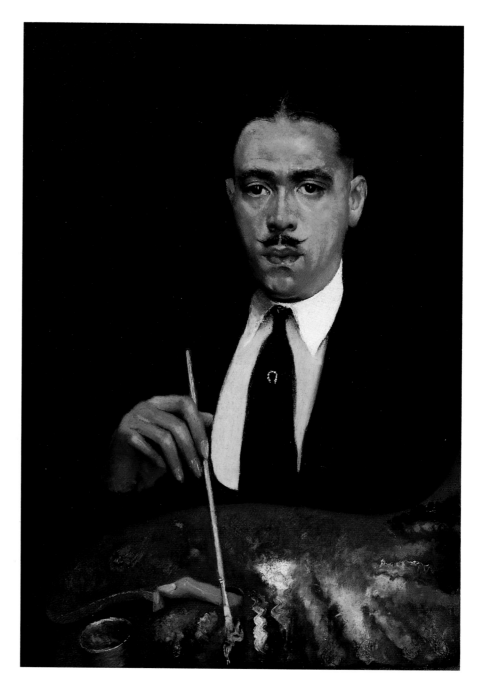

7

Portrait of the Artist's Father (Portrait of My Father), c. 1921
Oil on canvas, 36 x 29 in. (91.4 x 73.7 cm). Inscribed, lower right: A. J. Motley, Jr. Collection of Archie Motley and Valerie Gerrard Browne.

Family members remember Archibald J. Motley, Sr. (c. 1870–1935) as a strict but tender father. With his son occasionally accompanying him, Motley, Sr., worked as a Pullman porter on trains that traveled throughout the continental United States. Among the many acquaintances he made on his travels was Frank W. Gunsaulus, president of the Armour Institute, who was so impressed with the younger Motley that he paid his first year of tuition at The Art Institute of Chicago.

Portrait of the Artist's Father is Motley's tribute to his parent. Posed in a dark interior as a gentleman of leisure, reading a book and smoking a cigar, the rather stern-looking, bespectacled elder Motley is conservatively attired in a dark suit and tie. On the table to Motley's right is a figurine with a laughing or grimacing face. It lends a satiric touch to this otherwise sober portrait, which is rendered in the same almost monochromatic palette of Motley's slightly earlier *Portrait of My Mother* (1919, cat. no. 4).

PROVENANCE: Archibald J. Motley, Jr., 1921–81; Archie Motley 1981–86; Archie Motley and Valerie Gerrard Browne, 1986.
EXHIBITIONS: Chicago, 1922.
REFERENCES: Woodall, 1977, no. 3.

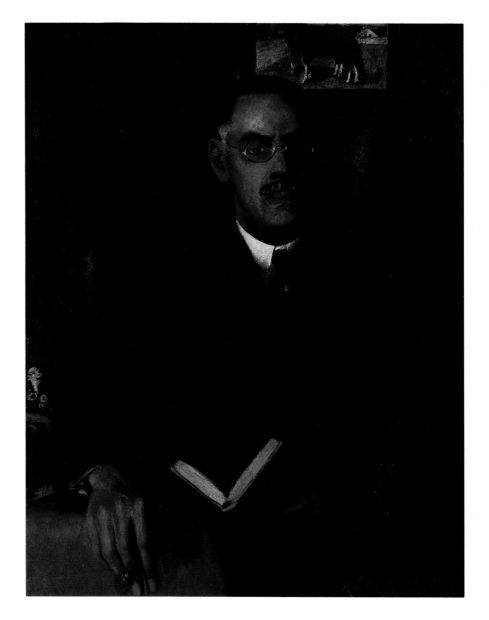

8

Octoroon (Portrait of an Octoroon, The Octoroon), 1922
Oil on canvas, 37¾ x 29¾ in.
(95 x 75.6 cm). Inscribed, lower right:
A. J. Motley, Jr./1922. Collection of
Judge Norma Y. Dotson.

As he honed his talents as a portraitist in the early twenties, Motley favored women of mixed racial ancestry for models, drawing attention to this in the paintings' titles. In addition to *Octoroon* he painted *The Octoroon Girl* (1925, cat. no. 12) and *Aline, An Octoroon* (1927, checklist no. 11), of which he wrote: ". . . I have tried to show that delicate one-eighth strain of Negro blood. Therefore, I would say that this painting was not only an artistic venture but a scientific problem."[2]

The subject of *Octoroon* is a beautiful young woman who engages the viewer with a playful expression. Her gracefully posed, long-fingered hands, as well as the composition and lighting of her portrait, bear a strong resemblance to *Portrait of My Grandmother*, painted in the same year (cat. no. 9). But while Motley uses shades of white and pale gray to set off his grandmother's dark skin, the octoroon's whiteness is emphasized by contrast with her black dress and the dull red drapery behind her.

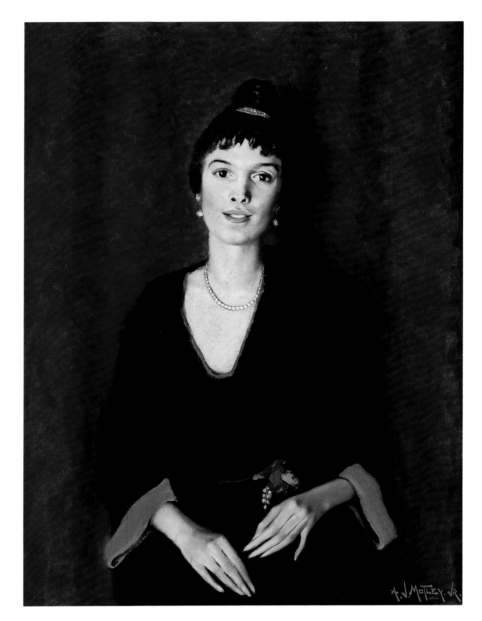

PROVENANCE: Archibald J. Motley, Jr., 1922–81; Judge Norma Y. Dotson, 1981.
EXHIBITIONS: Chicago, 1923; New York, 1928; New York, 1929; New York, 1988.
REFERENCES: Art Institute, 1923; Harmon Foundation, 1929; New Gallery, 1928; Robinson, 1987; Woodall, 1977, no. 6.

9

Portrait of My Grandmother, 1922
Oil on canvas, 38¼ x 23⅞ in.
(97.1 x 60.6 cm). Inscribed, lower right:
A. J. Motley, Jr./1922. Collection of Archie
Motley and Valerie Gerrard Browne.

Motley painted this portrait of his paternal
grandmother on a piece of a canvas laun-
dry bag from the Wolverine, a train on
which he had worked as a porter with his
father.[3] In the early twenties the artist had
little money to purchase art supplies, so
he improvised and sometimes reused his
materials.

Emily Motley was a former slave who
lived with the Motley family in Chicago.
An artistically inclined woman, according
to her grandson, she exerted a profound
influence on the young artist and encour-
aged his early efforts.[4] Motley particularly
admired her patience and her humility.[5]
His straightforward portrait conveys these
qualities, presenting the octogenarian
woman as if she has just interrupted her
housework to sit for the artist. Her slen-
der, work-worn hands lie quietly in her
aproned lap as she gazes directly at the
viewer. Motley portrays her aged face
and wrinkled neck both tenderly and
unsparingly, setting her against a plain,
light-colored background.

PROVENANCE: Archibald J. Motley, Jr.,
1922–81; Archie Motley, 1981–86;
Archie Motley and Valerie Gerrard
Browne, 1986.
EXHIBITIONS: Chicago, 1923; New York,
1928; Chicago (Woman's Club), 1933;
Los Angeles, 1976; Chicago, 1988; New
York, 1988.

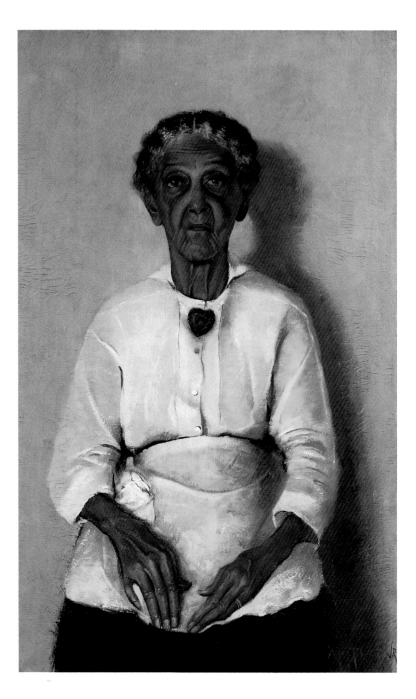

REFERENCES: Art Institute, 1923; *Tribune*,
1933; New Gallery, 1928; Woodall,
1977, no. 5.

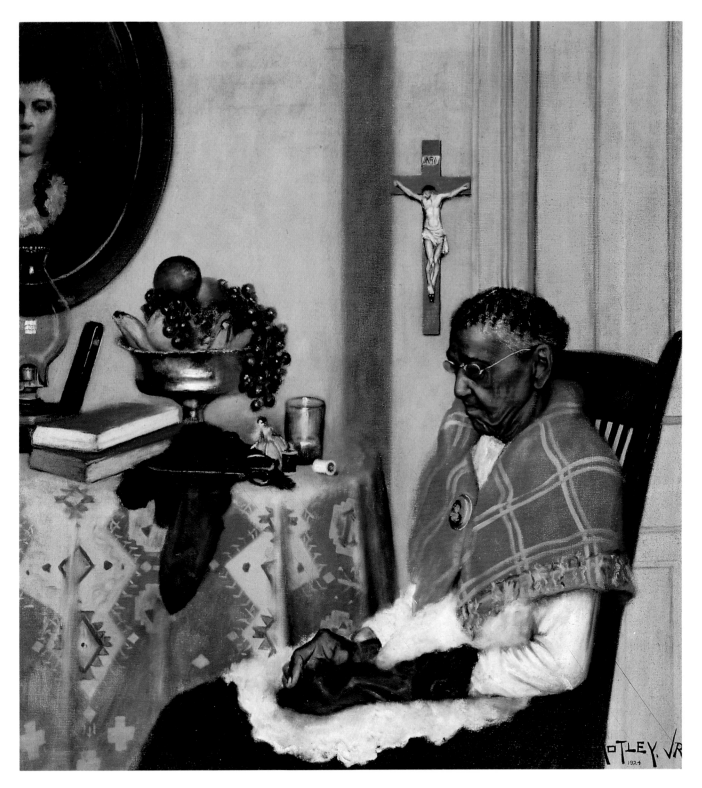

10

Mending Socks, 1924
Oil on canvas, 43⅞ x 40 in. (111.4 x
101.6 cm). Inscribed, lower right: A. J.
Motley, Jr./1924. Ackland Art Museum,
The University of North Carolina at
Chapel Hill, Burton Emmett Collection.

The artist's paternal grandmother, Emily
Motley, was eighty-two years old when
Motley portrayed her in this tender por-
trait. He shows her engaged in her accus-
tomed task of mending the family's socks,
and surrounded by much-loved objects
that represent her character and her
story.[6] Emily Motley wears her old red
shawl, pinned with a brooch that bears
a picture of her only daughter. A deeply
religious woman, as suggested by the
crucifix hanging just behind her, she daily
read the Bible, seen on the table to her
right. Fruit, her favorite food, fills a bowl
on the table, where a pile of socks and
scissors and thread are close at hand.
The pattern of the blue tablecloth suggests
the abstract, geometric designs of Native
American arts, possibly Motley's refer-
ence to Emily Motley's husband, a Native
American. Content among her favorite
things, the elderly, bespectacled woman
is intent on her mending, seemingly
oblivious to the viewer.

This highly personal image served not
only as Motley's homage to his grand-
mother, but as a powerful demonstration
of his special talent for portraiture. The
objects and details that profile the sitter's
life also function on a more abstract level,
forming a carefully constructed compo-
sition in which elemental geometric
shapes, light and dark masses, and prima-
ry colors are balanced and juxtaposed.
Here Motley employs his most natural-
istic style, rendering surfaces and vol-
umes softly yet specifically. The subdued
harmony of his composition reinforces
the portrait's theme of the dignity of age
and patient toil. One of the most widely
exhibited of Motley's paintings, it has also
been perhaps the most popular, and the
artist considered it his finest portrait.

PROVENANCE: Carl Hamilton, 1928–32;
George S. Hellman Collection/Anderson
Galleries, 1932–50; Ackland Art
Museum, The University of North
Carolina at Chapel Hill, Burton
Emmett Collection, 1950.
EXHIBITIONS: Chicago, 1925; Newark,
1927; New York, 1928; Washington,
D. C., 1929; New York, 1929; New
York, 1932; Los Angeles, 1976;
Huntsville, Alabama, 1979; Charleston,
1979; New York, 1984; Bellevue,
Washington, 1985; Newark, 1990.
REFERENCES: *Reader's Digest*, 1978;
American Negro Artists, 1929; Dover,
1960; Driskell, 1976; Harmon
Foundation, 1929; New Gallery, 1928;
Hellman, 1932; Hudson, 1979; Newark
Museum, 1927; Reynolds, 1990;
Woodall, 1977, no 7.

11

Woman Peeling Apples (Mammy)
(Nancy), 1924
Oil on canvas, 32½ x 28 in. (82.5 x
71.1 cm). Inscribed, lower right: A. J.
Motley, Jr./1924. Art & Artifacts Division,
Schomburg Center for Research in Black
Culture, The New York Public Library,
Astor, Lenox and Tilden Foundations.

In *Woman Peeling Apples*, Motley pays
homage to working people. No stranger
to the demands of physical labor, Motley
had worked at odd jobs such as porter,
plumber, laborer, and waiter, since his
youth. He always took his sketchbook
with him to work, and he drew the peo-
ple and activity around him whenever he
had a chance. This figure, dressed in a
loose-fitting plaid gown, her gray hair
bound by a kerchief, and peeling an apple
over a bowl in her lap, may have been a
co-worker or acquaintance from one of
his jobs.

Motley provides no setting beyond a
light-colored wall against which the apple
peeler's solid form casts a slight shadow.
While he renders her clothing with fuzzy
softness, Motley depicts her face clearly
and specifically. A raking light casts a pur-
ple hue on her skin, highlighting her
strong, and handsome features. The
painter thus focuses our attention not on
the woman's occupation but on the com-
manding presence of her direct, frank
gaze. Motley's *Woman Peeling Apples*
transcends the mundane task it portrays
to express the dignity of work.

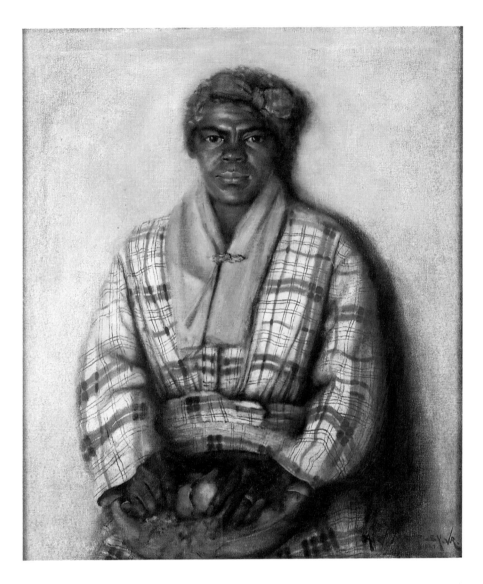

PROVENANCE: John Nail, 1928– ?; Art &
Artifacts Division, Schomburg Center for
Research in Black Culture, The New York
Public Library, Astor, Lenox and Tilden
Foundations, ?– date.
EXHIBITIONS: New York, 1928; Hudson,
1976; New York, 1987, New York,
1988; Newark, 1990.
REFERENCES: Black Dimensions, 1976;
New Gallery, 1928; Studio Museum,
1987; Woodall, 1977, no.8

12

The Octoroon Girl, 1925

Oil on canvas, 38 x 30 in. (96.5 x 76.2 cm). Inscribed, lower right: A. J. Motley, Jr./1925. Collection of Carroll Greene.

In *The Octoroon Girl*, Motley portrayed a beautiful young woman he met in a Black Belt grocery store:

> I looked at her, I didn't know whether I should say anything to her or not. . . . I wasn't thinking about the groceries I wanted to buy, I was thinking about her. Not that I was in love with her! I was in love with what she'd look like on canvas; I could just imagine. Finally I got up enough steam to walk over to her.

The young woman agreed to pose for Motley. The result was a work that the artist called the best portrait he ever painted, aside from *Mending Socks* (1924, cat. no. 10).[7]

The octoroon poses elegantly, her hands displayed gracefully. Her head is just off the center of the canvas, its mass counterweighted by the gold-framed picture partially seen in the upper left corner. The warm colors of the woman's golden skin, her red-trimmed dress, and the brown wall behind her are offset by her fashionable, close-fitting green hat. The contrast of green and red is reiterated in the books on the table by her left elbow. The setting and costume, which convey an atmosphere of refined formality, profile the woman's genteel social persona more than her individual psychology. Yet the self-composed dignity of sitter and portrait alike are challenged by a grinning,

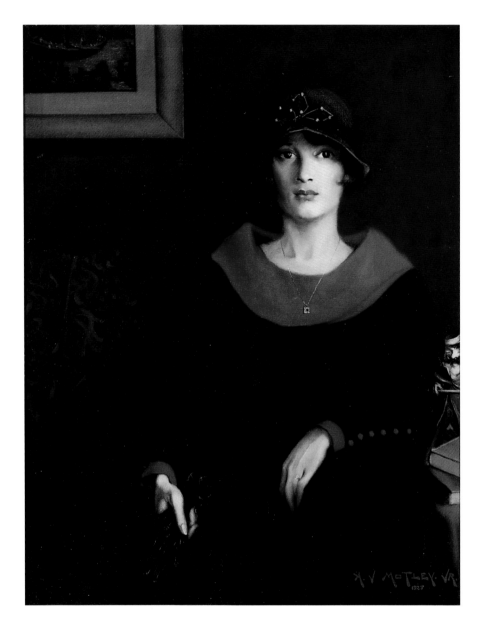

mustachioed figurine, which appears at the picture's right edge like the little figure in the background of Motley's *Portrait of the Artist's Father* (c. 1921, cat. no. 7).

PROVENANCE: Carl W. Hamilton, 1928– ?; Galerie Osten-Kashey, ? –c. 1965; Carroll Greene, c. 1965.

EXHIBITIONS: New York, 1928; Harmon Foundation, 1929; Washington, 1929; New York, 1932.

REFERENCES: Anderson Galleries, 1932; *Herald and Examiner*, 1929; Fauset, 1990; Harmon Foundation, 1928; National Gallery, 1929; New Gallery, 1928; New Yorker, 1928; Patterson, 1967; Woodall, 1977, no. 11.

79

13

Reception (Afternoon Tea), 1926
Oil on canvas, 29 x 36¼ in. (73.6 x 92 cm). Inscribed, lower right: A. J. Motley, Jr./1926. Collection of Judge Norma Y. Dotson.

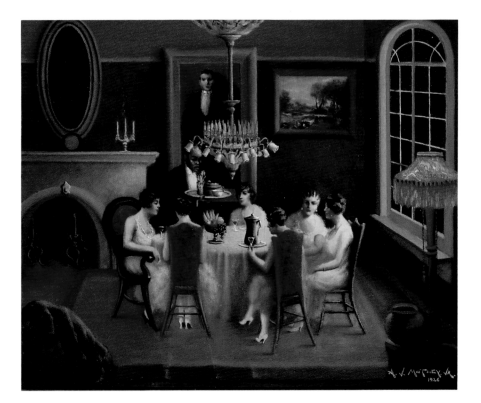

Reception shows a domestic interior, a rare setting for Motley. In a well-appointed room lit by a large central chandelier and a floor lamp to the right, a group of ladies is gathered around a table while a formally attired black butler hovers nearby with his tray. A guest's coat is draped over a chair at the picture's lower left, and the winter evening darkens the window at right. The fashionably coifed women are dressed in dinner gowns of low-cut design and pastel colors, and despite the picture's alternate title, *Afternoon Tea*, they appear to be drinking sherry or wine. The massive marble fireplace, on which rest a gold candelabra and clock, and the paintings—a landscape and a large formal portrait—hanging on the back wall of the room suggest the wealth and high social status of the gathering's hostess.

Motley leaves the occasion of this reception unspecified, directing our attention instead to the elegant ease of the assembled ladies, the pleasant atmosphere of the gathering, and the warm, enclosed setting. As in *Jockey Club* (1929, cat. no. 24), the figure of the black man appears at the center of the composition, but remains outside of the social interaction of the scene.

PROVENANCE: Archibald J. Motley, Jr., 1926– ?; Mrs. Flossie Moore, ? –1965; Judge Norma Y. Dotson, c. 1965.
EXHIBITIONS: Detroit, 1988; New York, 1988.
REFERENCES: Hunter, 1988; Woodall, 1977, no. 60.

14

Kikuyu God of Fire, 1927
Oil on canvas, 36 x 41⅛ in. (91.4 x
104.4 cm). Inscribed, lower right:
A. J. Motley, Jr./1927. Collection of Judge
Norma Y. Dotson.

Kikuyu God of Fire is among five canvases
Motley painted on African themes at the
suggestion of George S. Hellman, direc-
tor of the New Gallery in New York City,
where Motley's one-person show was
held in early 1928. Hellman encouraged
the artist to do a series of paintings on
African themes. He was surely aware, as
was Motley, of current interest in African
tribal arts both among European avant-
garde artists such as Picasso and among
writers and intellectuals of the Harlem
Renaissance, notably Alain Locke, a pro-
fessor at Howard University. In the influ-
ential book *The New Negro* (1925), Locke
advocated that African-Americans look to
the arts of their ancestral homeland for
inspiration in their efforts to formulate a
distinct black cultural idiom.

Kikuyu God of Fire depicts a menancing
deity who glows with a supernatural light
as he rains fire down upon a terrified band
of diminutive warriors in a forest. Ngai,
the supreme god of the Gikuyu or Kikuyu
people of Kenya, was thought to manifest
himself through natural phenomena such
as thunder and lightning. Motley's image
may also incorporate elements of Kibuka,
a Ugandan war god said to hover over
the battleground, shooting arrows down
upon the enemy.

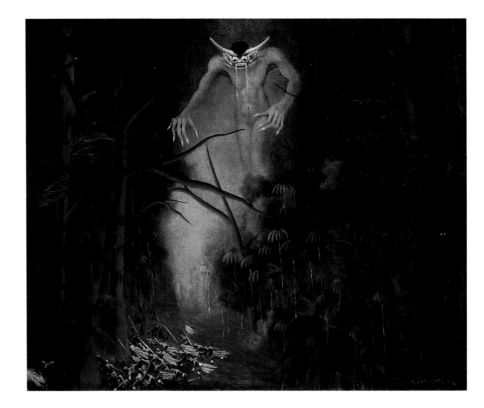

African subjects posed special chal-
lenges for Motley, who never visited his
ancestral homeland, but he drew inspira-
tion from his grandmother's stories of
Africa. In depicting a myth, however, the
artist could imagine and invent, portraying
the idea of the African locale rather than
its actuality. The theme of fire, dramatized
by the nighttime setting, gave Motley an
opportunity to explore complex light
effects and heighten the fantastic quality of
his mythic subject. The composition's
high vantage point above the scene is
typical of his early genre paintings, such
as *Tongues* (1929, cat. no. 25).

PROVENANCE: Archibald J. Motley, Jr.
1927–81; Judge Norma Y. Dotson, 1981.
EXHIBITIONS: New York, 1928; Chicago
(Woman's Club), 1933; Chicago (Knights
of Pythias), 1933; Detroit, 1988;
New York, 1988.
REFERENCES: Hunter, 1988; Robinson,
1988; Woodall, 1977, no. 15.

15

Barn and Silo, 1928
Oil on canvas, 29¾ x 35½ in.
(75.6 x 90.2 cm). Inscribed, lower left:
A. J. Motley, Jr. Collection of Judge
Norma Y. Dotson.

Barn and Silo may portray the farm
owned by the artist's Uncle Bob in
Arkansas. From a high vantage point we
look out over a large barn partly shielded
by a row of trees in full leaf. To the left
horses graze. Beyond, white flecks
appear to be sheep scattered across an
open field. Motley renders the barn and
silo with specific detail, but otherwise
paints the scene loosely, with almost
fuzzy softness. The work suggests the
challenges presented by an open land-
scape to an artist trained in figurative
painting and accustomed to the closely
confined spaces of city streets and
interiors.

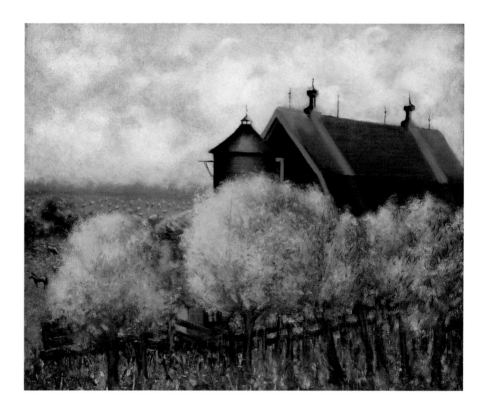

PROVENANCE: Archibald J. Motley, Jr.,
1928–81; Norma Y. Dotson, 1981.

16

Boat and Houses by the River, 1928
Oil on canvas, 28½ x 35½ in.
(72.4 x 90.2 cm). Inscribed, lower left:
A. J. Motley, Jr. Collection of Judge
Norma Y. Dotson.

In this intimate, uninhabited landscape the
solitude of the Arkansas scenery is intensi-
fied by the presence of an empty boat tied
to a crude dock by a cabin at the water's
edge. The precision of the boat's reflec-
tion is belied by the rippled water as the
river curves off in the distance, where
two cottages are visible. Motley, fascinat-
ed by the problem of rendering light and
its effects, paid careful attention to the
wide range of colors reflected in the
water's broken surface, which varies from
an almost black dark-green to bluish
white. His resolution of the relationship
between the river and the banks and dis-
tant horizon is less sure.

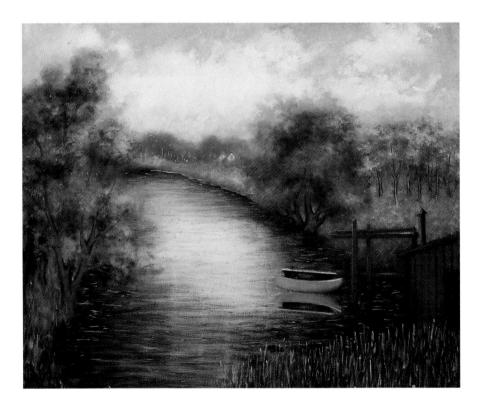

PROVENANCE: Archibald J. Motley, Jr.,
1928–81; Judge Norma Y. Dotson 1981.

17

Landscape, 1928

Oil on canvas, 16 x 20 in. (40.6 x
50.8 cm). Inscribed: A. J. Motley, Jr./Ark.
1928. Collection of Judge Norma Y.
Dotson and Sharon Y. Holland.

The flat, barren Arkansas scenery inspired
Motley's only forays in the pure portrayal
of nature. After the raucous clamor of his
genre scenes Motley's Arkansas landscapes
are strikingly silent. This *Landscape* pre-
sents a desolate tract seen through the
partial screen of four leafless, angular trees
that rise out of swampy ground on swollen
trunks. Sunlight flickers on the broken sur-
face of the water. A high horizon encloses
the view, suggesting the loneliness that the
sparse Arkansas landscape may have
evoked for the city-bred Motley. His vision
of nature imbued with its own intense psy-
chic energy is reminiscent of the haunted
landscapes of his contemporary, painter
Charles Burchfield (1893–1967).

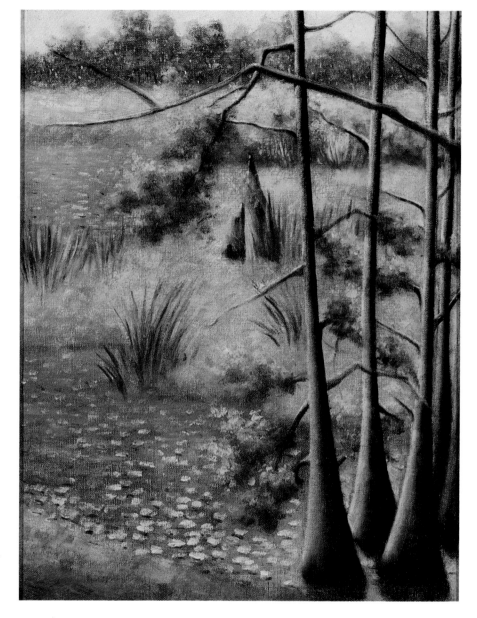

PROVENANCE: Archibald J. Motley, Jr.,
1928–81; Judge Norma Y. Dotson and
Sharon Y. Holland, 1981.
EXHIBITIONS: Detroit, 1988; New York, 1988.
REFERENCES: Robinson, 1988.

18

Landscape–Arkansas, 1928
Oil on canvas, 18 x 14 in. (45.7 x
35.6 cm). Collection of Judge Norma
Y. Dotson and Sharon Y. Holland.

In this intimate landscape, smoke rises
from the chimney of a wood-frame
cottage as sunlight filters through the tall
trees that surround it. The scene is suf-
fused in pale golds and greens under a del-
icately tinted pale blue sky, suggesting early
morning. Motley handles both the applica-
tion of paint and the construction of distant
space with greater confidence here than
he displayed in *Boat and Houses by the
River* (1928, cat. no. 16) and *Barn and Silo*
(1928, cat. no. 15). His rendering of
ground and trees with short, rapidly
applied brushstrokes to evoke flickering
light and atmosphere suggests the influ-
ence of Chicago's impressionist landscape
painters of the teens and twenties, includ-
ing Karl Albert Buehr (1866–52) and
Albert Krehbiel (1873–45), Motley's
teachers at The School of the Art Institute.

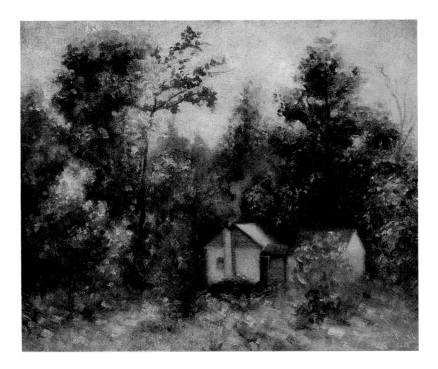

PROVENANCE: Archibald J. Motley, Jr., 1928–81; Judge
Norma Y. Dotson and Sharon Y. Holland, 1981.
EXHIBITIONS: Detroit, 1988; New York, 1988.
REFERENCES: Robinson, 1988.

19

The Snuff Dipper, 1928
Oil on canvas, 22¼ x 16⅜ in.
(56.5 x 41.6 cm). Inscribed, lower right:
A. J. Motley, Jr./Ark. 1928. DuSable
Museum of African American History.

This portrait and *Uncle Bob* (1928, cat.
no. 20) are the only two recorded por-
traits that Motley painted while in
Arkansas. The identity of this strong-fea-
tured older woman is not known, but she
may have been a neighbor of the artist's
Arkansas relatives. She poses somewhat
stiffly, regarding the viewer with a skepti-
cal, almost suspicious gaze. The formality
of her hat, with its ostrich feather orna-
ment, contrasts with the reed that hangs
from her lips, suggesting a knowing
toughness of character. In rural Arkansas,
a certain reed or grass was chewed at
one end to flatten it into a spoonlike
shape for dipping into snuff. Thus the title
of Motley's portrait may apply to both the
sitter and to the reed that she chews.

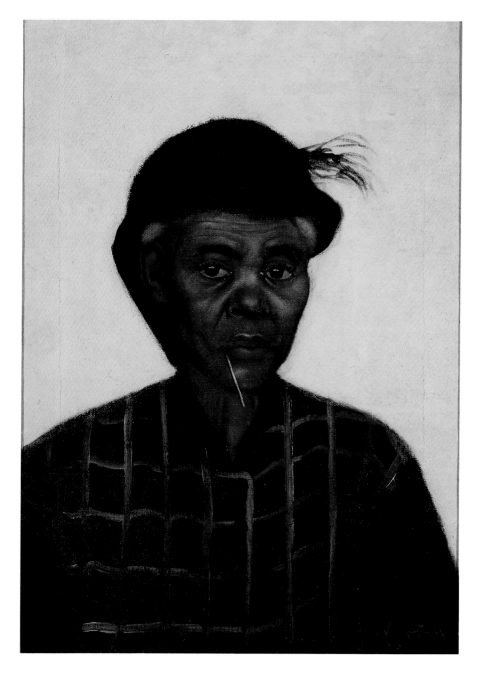

20

Uncle Bob, 1928
Oil on canvas, 40⅛ x 36 in. (101.9 x
91.4 cm). Inscribed, lower right: A. J.
Motley, Jr./Ark. 1928. Collection of Archie
Motley and Valerie Gerrard Browne.

Robert White, Mary Motley's half-brother,
moved from New Orleans to Arkansas,
where he became a farmer. Motley paint-
ed the elderly man sitting on the porch of
his home. Although Uncle Bob is pictured
relaxing with his pipe, one elbow resting
on the table to his left, his somewhat erect
posture and head-on position suggest a
man unaccustomed to posing under an
artist's close scrutiny. Motley pays special
attention to the work-worn hands of his
venerable subject. Shortly after Motley
executed this portrait, while he was work-
ing in Paris in 1929–30, he received word
of Uncle Bob's death.

 In later years the artist painted the back-
ground clapboarding of this scene a brilliant
blue, and added touches of blue highlight-
ing to the figure's beard and hair. The
painting has been restored to its original
appearance. Its soft brown and green hues
evoke the subject's rural surroundings.

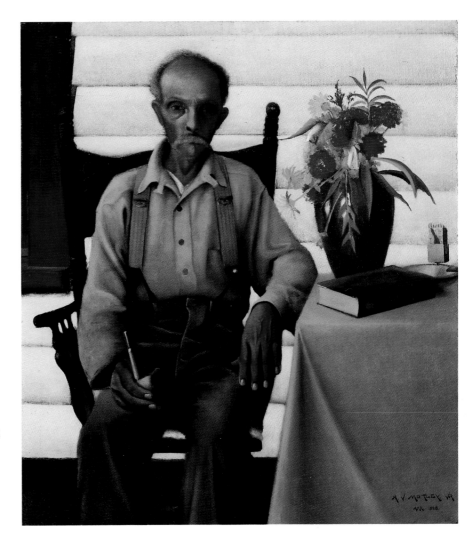

PROVENANCE: Archibald J. Motley, Jr.,
1928–81; Archie Motley 1981–86;
Archie Motley and Valerie Gerrard
Browne, 1986.
EXHIBITIONS: Chicago, 1930;
Chicago (Woman's Club), 1933;
Washington, D.C., 1940.
REFERENCES: *Tribune*, 1933;
Woodall, 1977, no. 29.

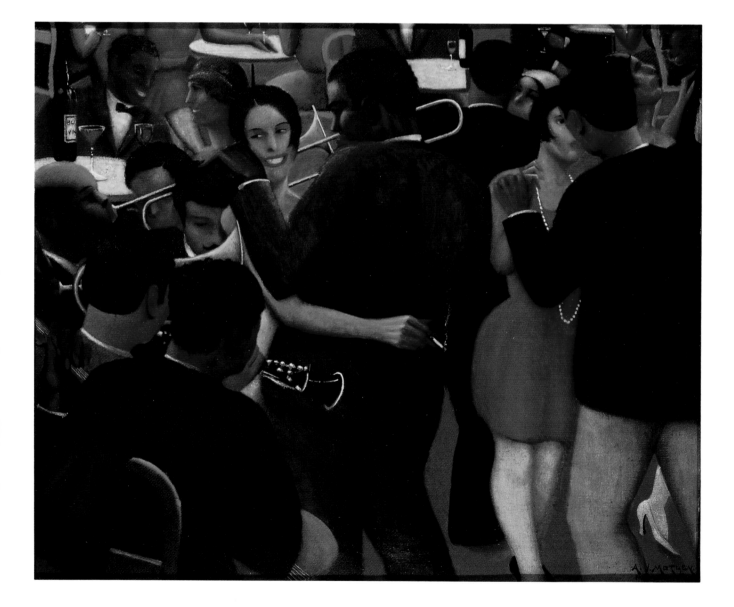

21

Blues, 1929
Oil on canvas, 36 x 42 in. (91.47 x 106.7 cm). Inscribed, lower right: A. J. Motley, Jr./ Paris. Collection of Archie Motley and Valerie Gerrard Browne.

Superbly evocative of the Jazz Age in both its subject and style, *Blues* has become perhaps Motley's best-known work. The artist had already explored the theme of black cabaret life in early works like *Black and Tan Cabaret* (1921, checklist no. 3) and *Syncopation* (1924, checklist no. 4). But in *Blues* he developed a new style more directly influenced by the music that inspired it. He crowds the swaying musicians, dancing couples, and seated onlookers up against the picture plane. The mass of figures and objects resolves itself into an almost abstract pattern of flat, colored shapes in which the repetition and variation of motifs sets up syncopated rhythms. The painting's warm tonalities and its apparently spontaneous composition, in which figures are casually cropped by the boundaries of pictorial space, convey the crowded atmosphere of this lively nightspot.

Blues shows the interior of the Petite Café, a stylish haunt of Paris's community of expatriate Africans and West Indians. Motley made numerous sketches there, from which he created this carefully orchestrated composition in his studio. Although the scene includes no Americans, it makes reference to Motley's Chicago roots in both its musical and social content. The artist's hometown is considered a birthplace of modern jazz as well as of urban blues, nurturing important musical innovators such as Louis Armstrong, whose unique style has been likened to the rhythms of Motley's *Blues*.[8]

One of Motley's most indelible images, *Blues* anticipates in style and theme many of Motley's most important works in the decades to come.

PROVENANCE: Archibald J. Motley, Jr., 1929–81; Archie Motley, 1981–86; Archie Motley and Valerie Gerrard Browne, 1986.
EXHIBITIONS: Stockholm, 1930; Chicago, 1931; American Federation of Arts 1931–32; Brooklyn, 1932; Chicago (Woman's Club), 1933; Toledo, 1934; New York 1937; Chicago, 1947; St. Louis, 1977; Washington, 1980; Washington, 1989.
REFERENCES: Art Institute, 1931; Barter, 1977; Brooklyn Museum, 1932; Jacobson, 1933; Kramer, 1974; Powell, 1989; Roberts, 1937; Robinson, 1987; Toledo Museum, 1934; Wallace, 1986; Woodall, 1977, no. 34.

22

Café, Paris, 1929
Oil on canvas, 23⅝ x 28⅞ in. (58.7 x
73.3 cm). Inscribed, lower right: A. J.
Motley, Jr./Paris 1929. Collection of Archie
Motley and Valerie Gerrard Browne.

The cafes of Paris were a venerable
artistic subject by the time Motley
arrived in the French capital in 1929 as
a Guggenheim fellow. As a locale for the
social interactions of the French bour-
geoisie the cafe had attracted the talents
of many French impressionist and post-
impressionist artists, as well as Americans
such as William Glackens, whose cafe
scene called *Chez Mouquin* (1905), was
acquired by the Art Institute of Chicago
in 1925.

Motley pictures a cafe bar where
patrons stand and chat as the proprietor
looks on. At lower right, two men drink
at a small table. The dog, a motif that
reappears in several of Motley's Bronze-
ville genre paintings, sits by the door
observing the scene. Through a large
plate-glass window that takes up most of
the background of the painting, Motley
provides a glimpse into the street, the
subject of his *Dans la Rue, Paris* (1929,
cat. no. 23). The composition of *Café,
Paris* is structured around a series of
repeating, interlocking rectangles formed
by the window and exterior wall of the
cafe, and repeated in the mirror behind

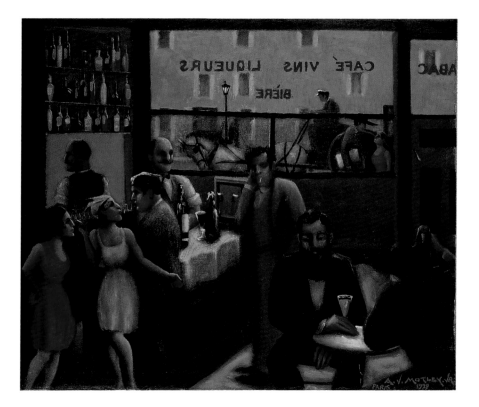

the bar and the shelves of bottles above
it. The reversal of the red letters which
advertise the cafe on its window is
echoed in the reflection of the bar-
tender's head in the mirror behind him.
The scene is rendered in relatively cool
tones of gray, black, and brown, with
notes of red, similar to the palette of
Dans la Rue, Paris. Motley probably later
added the highlights of blue on the bar
and on the black hair of the male patron
talking to the women.

PROVENANCE: Archibald J. Motley, Jr.,
1929–81; Archie Motley, 1981–86;
Archie Motley and Valerie Gerrard
Browne, 1986.

23

Dans la Rue, Paris, 1929
Oil on canvas, 23¾ x 28½ in. (60.3 x
72.4 cm). Inscribed, lower left: A. J.
Motley, Jr./1929. Art & Artifacts Division,
Schomburg Center for Research in Black
Culture, The New York Public Library,
Astor, Lenox and Tilden Foundations.

Motley's scene of Paris's characteristic
urban architecture and inhabitants is
divided vertically into two busy sections.
On the left, a variety of figures crowd the
wide sidewalk in front of an outdoor cafe
with a pink-trimmed awning and white
tables, where uniformed waiters serve
seated patrons. On the right, cars and a
cyclist advance and recede along a stone-
paved street as a man with a cane makes
his way to the safety of the far sidewalk.
As in his Bronzeville street scenes, Motley
balances figures of contrasting ages and
pursuits: a pair of lovers and a cleric
absorbed in a prayerbook, a blue-clad
street sweeper bent to his task and the
flower seller offering a bouquet, the
elderly man with the cane and the cyclist
who has just careened past him.

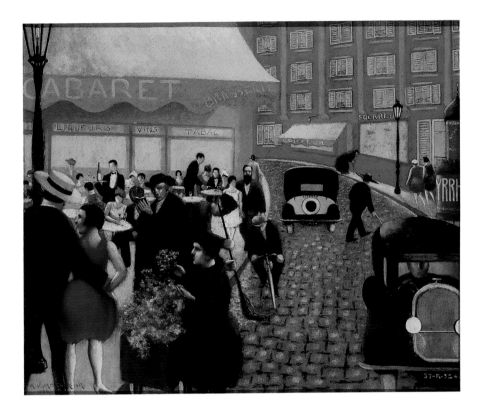

The artist's interest in capturing the
flavor of his Paris setting is evident in the
cool, blue-gray and black color scheme
leavened by flashes of red and the bright
yellow of the receding automobile, and in
his attention to such peculiarly local details
as the stone-paved street, the news
kiosk, and the shutters of the building on
the right. One of Motley's earliest street
scenes, *Dans la Rue, Paris* (1929, cat. no.
23) heralded a long series of Bronzeville
street views he painted in the next two
decades.

PROVENANCE: Agnes and Irvin C. Mollison,
? –1973; Art & Artifacts Division,
Schomburg Center for Research in
Black Culture, The New York Public
Library, Astor, Lenox and Tilden
Foundations, 1973.
EXHIBITIONS: New York, 1931; New York,
1967; New York, 1968; New York,
1988; Newark, 1990.
REFERENCES: Fine, 1973; Ghent, 1968;
Woodall, 1977, no. 32.

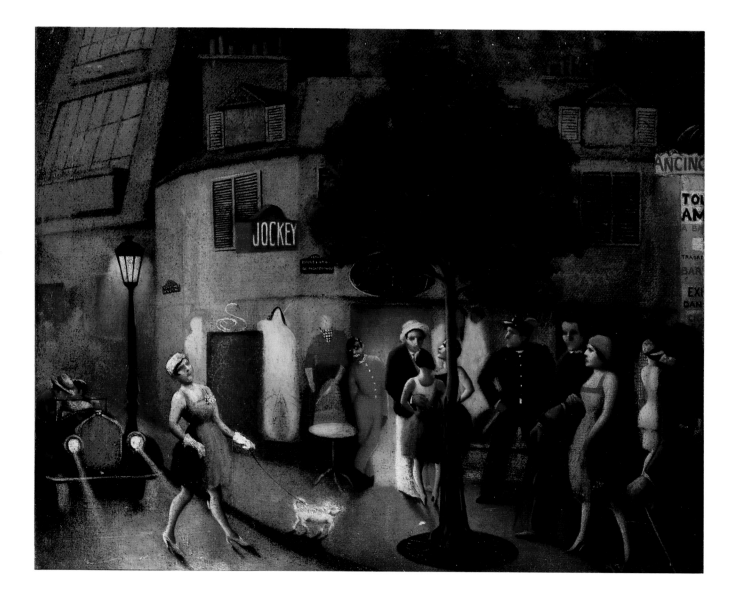

24

Jockey Club, 1929
Oil on canvas, 26 x 32 in. (66 x 81.3 cm).
Art & Artifacts Division, Schomburg
Center for Research in Black Culture,
The New York Public Library, Astor,
Lenox and Tilden Foundations.

In *Jockey Club* Motley returns to the
themes of nighttime and entertainment.
But instead of the crowded interiors of
night spots represented in his early
Chicago cabaret scenes and in *Blues*
(1929, cat. no. 21), here he pictures that
world from outside. Stylishly dressed
women and men, a *gendarme* (a French
policeman) among them, mingle near the
entrance to a night club, anticipating but
not yet enjoying the entertainment with-
in. The scene is punctuated by light shed
by street lights, car headlights, and stars,
lending an aura of romance and excite-
ment to this scene suffused in shades of
red, rose pink, and soft blue.

Figures of a cowboy and an Indian deco-
rate the building's walls, suggesting, along
with the club's name, an American
theme. These references to the artist's
homeland are complemented ironically
by the presence of a lone black figure, the
grinning, red-uniformed doorman, who
stands at the club's entrance framed by
the flood of light from within. Although
Motley has placed him in the composi-
tion's very center, he is ignored by the
other figures, suggesting the isolation
and marginalization of blacks in
American society.

PROVENANCE: Agnes and Irvin C. Mollison,
?–1973; Art & Artifacts Division,
Schomburg Center for Research in
Black Culture, The New York Public
Library, Astor, Lenox and Tilden
Foundations, 1973.
Exhibitions: New York, 1931; Chicago
(Kroch's), 1933; Chicago (Woman's
Club), 1933; New York, 1967; New
York, 1978; New York, 1987;
New York, 1989.
REFERENCES: Art Institute, 1933; Bernard,
1989; Campbell, 1987; City University of
New York, 1967; Fine, 1973; National
Urban League, 1978; Woodall, 1977,
no. 33.

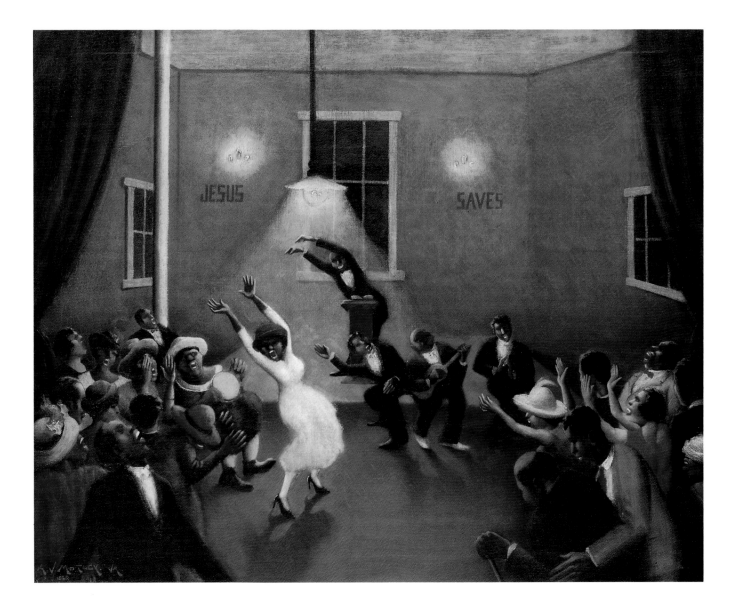

25

Tongues (Holy Rollers), 1929
Oil on canvas, 29¼ x 36⅛ in.
(74.3 x 91.7 cm). Inscribed, lower left:
A. J. Motley, Jr./ 1929. Collection of Archie
Motley and Valerie Gerrard Browne.

In *Tongues* Motley captures the excitement
of a church meeting in rural Arkansas. To
the sounds of a guitar, a tambourine, and
two exuberant singers, and the vigorous
hand-clapping and foot-stomping of the
congregation, a woman in white, as if
possessed by the spirit, sways with the
preacher. The varied worshippers, from
fashionably dressed young women to the
heavy, bald man leaning on a cane in the
right foreground (a figure who reappears
in other Motley paintings), enthusiastically
heed the message "JESUS SAVES" embla-
zoned on the back wall. The bare, stage-
like space, framed by black curtains, is illu-
minated by a trio of lights, suggesting
the Trinity.

Lively music, spontaneous demon-
strations of the spirit, and "speaking in
tongues" were all features of the
Pentecostal or Holiness churches that
black southerners established in Chicago.
Although Motley, a Roman Catholic,
viewed their services as an outsider, he
brings a sympathetic vision to this scene.

Compositionally, *Tongues* resembles
other early genre works by Motley,
notably *Reception* (1926, cat. no. 13)
and *Stomp* (1927, checklist no. 8), in its
high vantage point over the scene, its
deliberately naive rendering of perspec-
tive, and the miniaturized quality of the
figures. Ironically, Motley's view of an
Arkansas church meeting is particularly
related to *Stomp*, a lively nightclub scene.
The two works share a boxlike construc-
tion of space, such details as framing cur-
tains and an illuminated central chandelier,
and even the gestures of some of the
participants.

PROVENANCE: Archibald J. Motley, Jr.,
1929–81; Archie Motley, 1981–86;
Archie Motley and Valerie Gerrard
Browne, 1986.
EXHIBITIONS: Chicago, 1930; Chicago
(Renaissance Society), 1930; Chicago
(Woman's Club), 1933; Chicago (Knights
of Pythias), 1933; New York, 1933.
REFERENCES: Art Institute, 1930; *Chicago
Daily News*, 1929; *Tribune*, 1933;
Renaissance Society, 1930; Whitney
Museum, 1933; Woodall, 1977, no. 30.

26

Nude (Portrait of My Wife), 1930
Oil on canvas, 28¾ x 23½ in. (73 x
59.7 cm). Inscribed, lower right: A. J.
Motley, Jr./ Paris 1930. Collection of
Archie Motley and Valerie Gerrard
Browne.

Motley's nude portrait of Edith Granzo
(1894-1948), whom he married in 1924,
is both tender and uncompromisingly
honest. Shown to hip level, the figure is
posed with confrontational straightfor-
wardness, facing the viewer head-on and
illuminated by a raking light from the left.
Motley renders the rounded contours of
Edith's full figure with a seemingly photo-
graphic realism and a particularity that
recalls the obsessive surface detail of early
Renaissance portraiture, of which he
encountered numerous examples in the
Louvre. Edith's made-up face, in contrast,
is deliberately mask-like in its enigmatic,
virtually frozen expression, framed by
her fashionably styled hair.

 This *Nude*, painted in Paris during
Motley's stay there as a Guggenheim fel-
low in 1929–30, is one of only a handful
of nudes in his oeuvre. It seems likely,
however, that Motley would have painted
more had he had opportunity. In portrai-
ture he favored female over male mod-
els. Significantly, in his self-portrait of 1933
(cat. no. 31) he depicts himself working
on a painting of a nude woman. *Nude*
offers a glimpse of the level of achieve-
ment Motley might have reached in the
genre of pure figurative art.

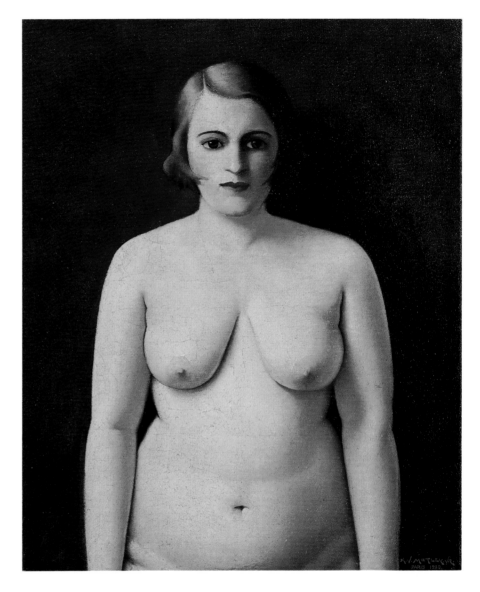

PROVENANCE: Archibald J. Motley, Jr.,
1930–81; Archie Motley 1981–86; Archie
Motley and Valerie Gerrard Browne, 1986.
EXHIBITIONS: Chicago (Woman's Club), 1933
REFERENCES: Woodall, 1977, no. 40.

27

Portrait of Mrs. A. J. Motley, Jr., 1930
Oil on canvas, 39⅝ x 32 in. (100.6 x
81.3 cm). Inscribed, lower right:
A. J. Motley, Jr./ Paris 1930. Collection
of Archie Motley and Valerie Gerrard
Browne.

This portrait of his wife, executed, along
with *Nude* (cat. no. 26), in Paris in 1930,
probably represents the type of conven-
tional society portraiture by which Motley
had originally hoped to make a living.
Dark and somewhat somber, *Portrait of
Mrs. A. J. Motley, Jr.* presents the sitter less
as the wife of the artist than as a society
matron. Her fixed expression is some-
what reserved and even forbidding. Mrs.
Motley sits comfortably but formally,
attired in a stylish dress strikingly orna-
mented with a fox stole arranged on her
shoulders. The artist draws our attention
to her hands, one of which holds a pair of
gloves. This detail, along with the sitter's
dress and pose, the dark tones of the
image, and even the dark gold-framed
picture partially seen in the upper corner
of the composition, all recall one of the
artist's favorite portraits, *The Octoroon Girl*
(cat. no. 12), painted five years earlier.

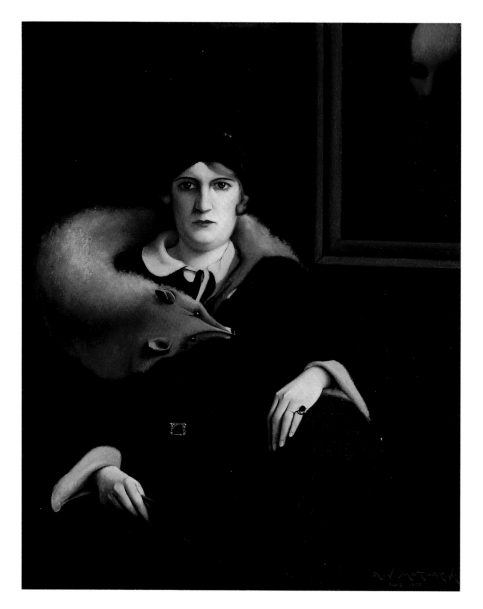

PROVENANCE: Archibald J. Motley, Jr.,
1930–81; Archie Motley, 1981–86; Archie
Motley and Valerie Gerrard Browne, 1986.
REFERENCES: Woodall, 1977, no. 38.

28

Brown Girl After the Bath, 1931
Oil on canvas, 48¼ x 36 in. (122.5 x
91.4 cm). Inscribed, lower left: A. J.
Motley Jr./1931. Collection of Archie
Motley and Valerie Gerrard Browne.

Brown Girl is Motley's most ambitious
portrayal of an individual figure. Undressed
except for her clumsy, fashionable shoes,
the young woman turns away from the
viewer but makes eye contact in the
dressing table mirror, which reflects her
shy, almost startled expression. The soft
light of the lamp falls fully on her breasts
in her mirrored image. Her left hand cra-
dles a cosmetic jar, and in her right hand
she holds a powder puff. The dimly lit
interior, framed at left by a swept-back
curtain, includes the curving outline of the
headboard of a bed, reflected in the mir-
ror. These details enhance the impression
that the viewer has intruded on a private
moment.

Painted shortly after Motley's return
from Paris, *Brown Girl After the Bath* is a
far more complex essay in figurative
painting than his straightforward *Nude*
(1930, cat. no. 26), both thematically and
compositionally. It suggests his awareness
of the pictorial tradition of the sensuous
nude in a bedroom setting in such exam-
ples as the Louvre's *Olympia* by Edouard
Manet. But in *Brown Girl* Motley recasts
this tradition. He portrays a young black
woman, and details such as the buckled
shoes, the electric lamp, and the twen-
ties-style dresser firmly anchor the scene
in the modern era.

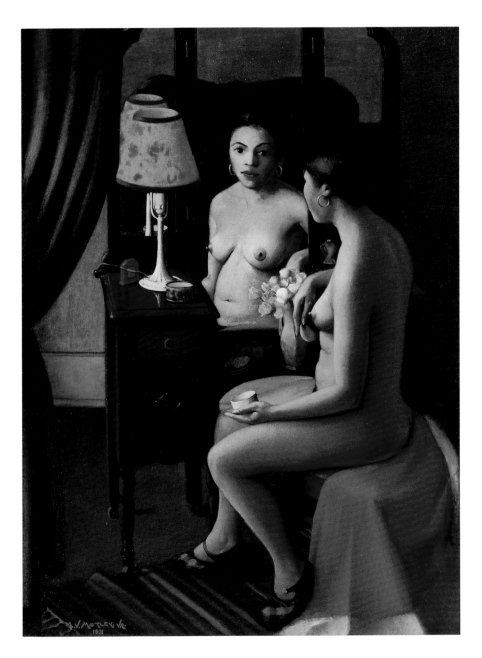

PROVENANCE: Archibald J. Motley, Jr.,
1931–81; Archie Motley, 1981–86;
Archie Motley and Valerie Gerrard
Browne, 1986.

EXHIBITIONS: Michigan, 1932;
Washington, D.C., 1932; Chicago, 1932;
New York, 1933; Chicago (Woman's
Club), 1933; New York, 1988.
REFERENCES: Art Institute, 1932; *Black
Collegian*, 1985; *Chicago Evening Post*,
1932; *Viva*, 1976; Woodall, 1977, no. 44.

29

Portrait of a Woman on a Wicker Settee,
1931
Oil on canvas, 38¾ x 31¼ in. (98.4 x
79.4 cm). Inscribed, lower left: A. J.
Motley, Jr./1931. Collection of Archie
Motley and Valerie Gerrard Browne.

One of Motley's last and most elaborate
portrait compositions, this image of an
unidentified woman presses the sitter
toward the picture plane before a varied
backdrop of furniture and ornament. The
high dresser with its light and dark wood
tones and floral ornament, topped by an
Oriental-style green ceramic vase, and
the greenish wicker settee on which the
woman poses are modern pieces that
speak of a middle-class Chicago home of
the day. In the upper left corner, a partial-
ly visible copy of a portrait by Raphael,
which Motley knew from the collection of
the Louvre in Paris, seems to look down
on the scene. Just behind the sitter's right
elbow, on a table draped with a floral fab-
ric, stands a bronze female figure, possi-
bly an allegorical representation. The stat-
uette was a fixture of Motley's studio and
reappears in two paintings of personal sig-
nificance to the artist: his self-portrait of
1933 (cat. no. 31), and the late allegorical
work known as *The First One Hundred
Years* (c. 1963–72, cat. no. 69).

 The elaborate setting complements
Motley's representation of his sitter, an
apparently well-to-do woman. One arm
resting on the arm of the settee, she
seems to lay claim to the space around
her and its substantial contents.

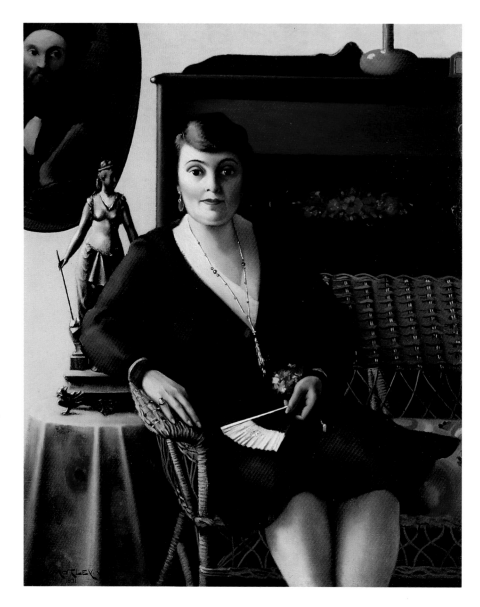

This may be a portrait of Motley's moth-
er. It is similar to the unlocated *Portrait of
My Mother* (checklist no. 36; fig. 16),
which the artist first exhibited in the
Harmon Foundation exhibition of 1931.

PROVENANCE: Archibald J. Motley, Jr.,
1931–81; Archie Motley 1981–86; Archie
Motley and Valerie Gerrard Browne, 1986.

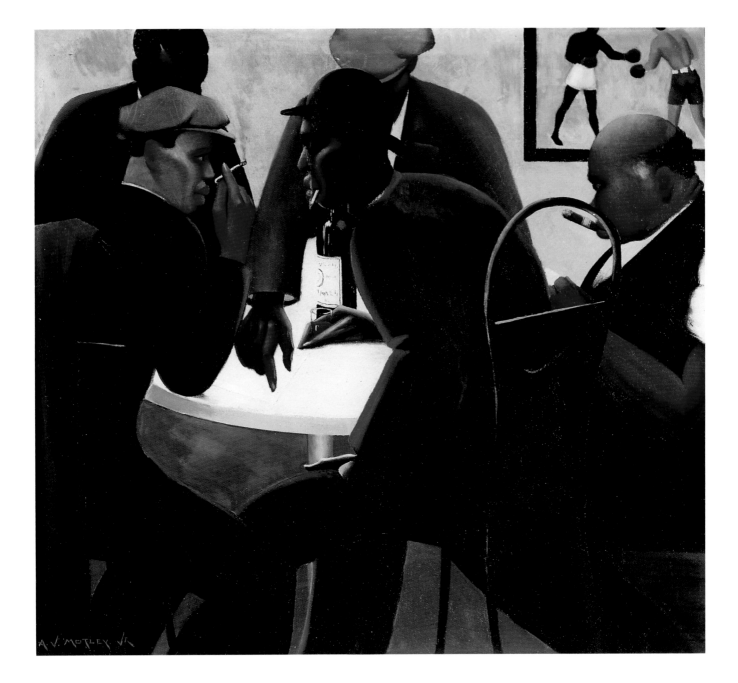

30

The Plotters, 1933
Oil on canvas, 36⅛ x 40¼ in.
(91.7 x 102.2 cm). Inscribed, lower left:
A. J. Motley, Jr. Collection of Walter
O. Evans, M.D.

The Plotters is one of several works, including *The Liar* (cat. no. 38) and *The Boys in the Back Room* (cat. no.34), in which Motley focuses closely on a small number of figures, a compositional formula explored earlier in *Blues* (1929, cat. no. 21). But here the artist has exchanged his typically congenial or jaunty mood for a conspiratorial air in a carefully observed study of a closed circle of men gathered around a table. As the two men in the foreground look intently at one another, a green-coated figure behind them points to a sheet of paper on the table. The nature of the plot is unknown, but the figures' concentrated expressions and tense postures convey secrecy and intrigue.

Motley reiterates the mood of his subject by a tightly confined composition in which every figure is cut off by the picture's edge. This device applies even to the image in the background, where a black boxer is seen taking on a white opponent, perhaps a reference to the pride that African-Americans felt in boxing heroes like Jack Johnson. In the group of five plotters, repeated shapes of heads and hats and the strong angles of gesturing hands, bent arms, and protruding cigarettes sets up a complex though seemingly spontaneous rhythm. In contrast to the sometimes vibrant colors of Motley's Bronzeville street scenes, *The Plotters* offers a subdued palette appropriate to the quiet tension of its subject.

PROVENANCE: Commissioned by the WPA, 1933; Margaret Burroughs, ?–1985; Walter O. Evans, M.D., 1985.
EXHIBITIONS: New York, 1967; Detroit, 1988; New York, 1988.
REFERENCES: Robinson, 1988; Woodall, 1977, no. 62.

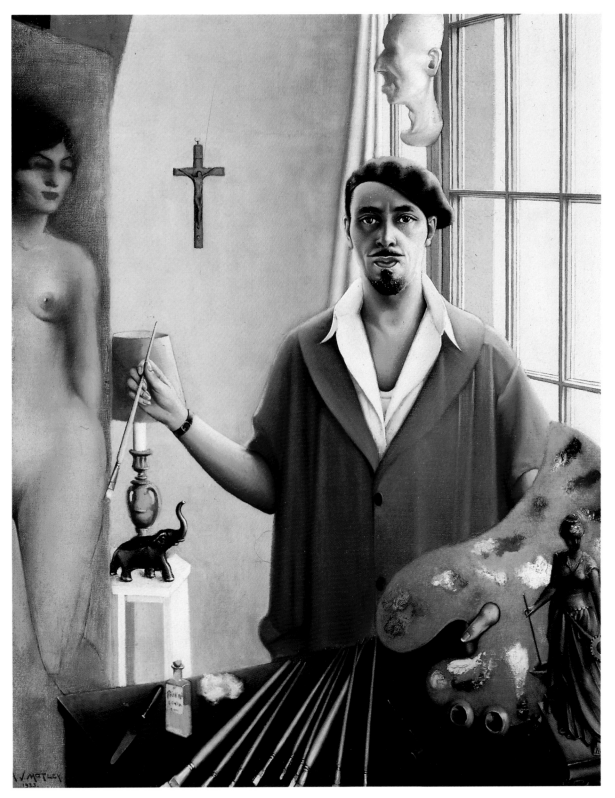

31

Self-Portrait (Myself at Work), 1933
Oil on canvas, 57⅛ x 45¼ in.
(145 x 114.9 cm). Inscribed, lower left:
A. J. Motley, Jr. 1933. Collection of Archie
Motley and Valerie Gerrard Browne.

The second of two self-portraits Motley executed, this work may be read as a complex allegory of his life and aspirations. Standing in the clear northern light of his studio, the artist faces the viewer with an almost confrontational boldness. While apparently in the act of applying paint to the large canvas at his side, he looks straight ahead with a concentrated expression, which is partly the result of Motley painting himself by looking in a mirror (he reversed what he saw there in order to correctly show himself as right-handed). The artist holds his palette, bearing blobs of different colored paints, with his left hand; spread before him are other tools of his trade: long-handled brushes, a palette knife, a bottle of linseed oil, and a rag. Significantly, given his interest in and talent for nude painting, Motley works here on a painting of a nude; with his signature, at lower left, he signs both his self-portrait and this painting-within-a-painting.

The objects surrounding Motley describe his personal and artistic identity. Above his head, a plaster mask, like those that he studied and copied as a student at The Art Institute of Chicago, pays homage to his laborious academic training. The Roman Catholic crucifix at upper left, positioned almost as a similar crucifix appears in relation to his grandmother in *Mending Socks* (1924, cat. no. 10), serves as an emblem both of religion and of family history. Immediately in front of his palette, at lower right, is the bronze statuette that appears in other works. European, perhaps classical, in style and content, the statuette and the artist's attire (the beret, smock, and open-necked shirt he adopted during his year in France) suggest Motley's identification with the academic artistic traditions. In contrast to his formal *Self-Portrait* of more than a decade earlier (c. 1920, cat. no. 6), Motley's 1933 likeness bears out its alternate title *Myself at Work*. A realistic image of the artist painting in his studio, it also summarizes his confident acceptance, at the mid-point of his career, of his personal and artistic self-identity.

PROVENANCE: Archibald J. Motley, Jr., 1933–81; Archie Motley, 1981–86; Archie Motley and Valerie Gerrard Browne, 1986.
EXHIBITIONS: Chicago, 1935; Chicago (Davis Store), 1935; New York, 1988.
REFERENCES: Davis Store, 1935; Woodall, 1977, no. 45.

32

Black Belt, 1934
Oil on canvas, 31¾ x 39⅜ in.
(50.6 x 100 cm). Inscribed, lower left:
A. J. Motley, Jr./1934. Hampton
University Museum.

Black Belt is Motley's earliest recorded
depiction of Bronzeville's lively street life,
one of many such works he executed
between the mid-thirties and the late for-
ties. This work established a pattern for
the series in several respects.

As in many of his Black Belt street
scenes, a nighttime setting provides an
opportunity for the interplay of numerous
light sources, from the stars dotting the
dark sky overhead to the lights from a
street lamp, storefronts, and upstairs win-
dows to the beams of an oncoming car
broken by the figure of a pedestrian who
dashes in front of it. Of *Black Belt* Motley
wrote: "I have always possessed a sincere
love for the play of light in painting and
especially the combination of early moon-
light and artificial light. This painting was
born first of that desire and secondly to
depict a street scene, wherein I could
produce a great variety of Negro charac-
ters."[9]

In *Black Belt*'s friezelike row of fore-
ground figures, a pattern of alternating
men and women is broken by the group
formed by the white-gloved policeman
in profile, a bent old man to whom he
extends his right hand, and a newsboy

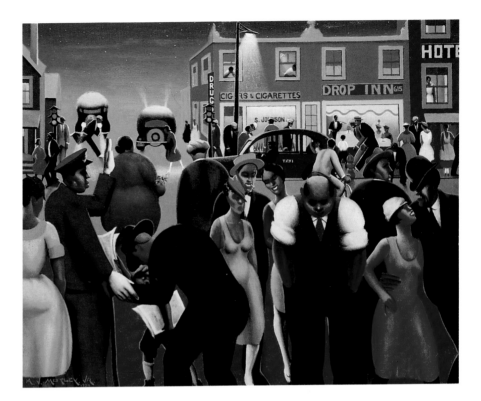

who shouts up into the pedestrian's face
while waving his papers. A further con-
trast is set up between the fat, shirt-
sleeved, bald man who faces the viewer
but is lost in thought, and several pairs of
conversing men and women who sur-
round him. This figure's self-absorption
seems out of place in the cheerful scene
Motley creates. In the background, a
drugstore featuring cigars and cigarettes,
a restaurant with the welcoming name
"Drop Inn," a hotel, and a taxi in which
a pair of lovers embrace, all describe
Motley's nighttime Black Belt as a place of
carefree pleasure.

PROVENANCE: The Harmon Foundation,
1935–67; Hampton University Museum,
1967.
EXHIBITIONS: Texas, 1935; Chicago, 1935;
Baltimore, 1939; Chicago, 1940; New
York, 1942; New York, 1945; Bellevue,
Washington, 1985; New York, 1988.
REFERENCES: American Heritage, 1986;
Art Institute, 1935; Locke, 1940; Locke,
1945; Halpert, 1942; Woodall, 1977, no.
64.

33

Barbecue, c. 1934
Oil on canvas, 36¼ x 40⅛ in (91.5 x
101.6 cm). Inscribed, A. J. Motley, Jr.
Permanent Collection, Howard University
Gallery of Art, Washington, D.C.

Barbecue combines two of Motley's
favorite settings: evening out-of-doors
and the elegant gathering spot. While
waiters scurry in the background, clusters
of fashionable couples mingle amid a sea
of white-draped cafe tables. The scene
is punctuated by strings of electric lights
that play against the starry sky in the
background.

One of a number of nightlife scenes
that Motley painted during his appoint-
ment as visiting instructor at Howard
University in Washington, D.C., *Barbecue*
exemplifies his style in the mid-1930s.
Streamlining the forms of objects and
people, Motley contrasts flat colors and
shapes for formal effect. His figures
almost float in a barely defined space
where a pale rose ground softly blends
with the night sky. Stressing the mood of
his setting rather than the individuality of
his figures, Motley defines a range of
characters by varying facial expressions
and gestures.

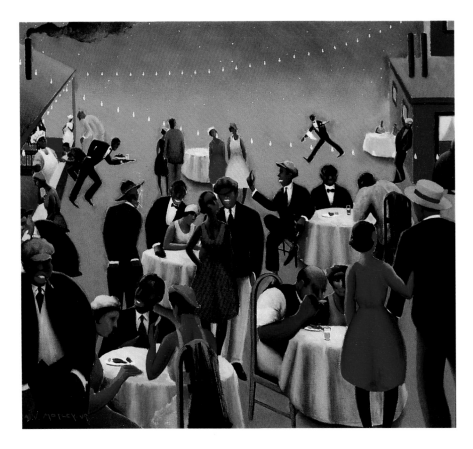

PROVENANCE: Fort Huachuca, Arizona,
WPA Allocation, c. 1941–47; Howard
University Gallery of Art, 1947.
EXHIBITIONS: Washington, D.C., 1934;
Texas, 1936; Baltimore, 1939; Maryland,
1939; New York, 1988.
REFERENCES: Baltimore Museum, 1939;
Corcoran Gallery, 1934; McElroy, 1990;
Robinson, 1988; Dallas, 1936; Woodall,
1977, no. 59.

34

The Boys in the Back Room (Card Players), c. 1934
Oil on canvas, 30 x 40 in. (76.2 x 101.6 cm). Inscribed, lower left: A. J. Motley, Jr. Collection of Reginald Lewis.

In this reworking of the composition of *The Plotters* (1933, cat. no. 30), Motley presents a poker game in the "back room" of a Black Belt bar or pool hall. Three players are seated at a table draped with a white cloth, while a pair of onlookers enjoys the game and a waiter, seen from behind, approaches with refreshment. On the wall behind the group, an image of a horse race complements the theme of competition in the card game.

As in *The Plotters*, Motley's color scheme is subdued, with gray walls and floors setting off the dark clothing of the figures. The arrangement of hands and arms against the white tablecloth, the men's hats, and even the physical type of the shirt-sleeved, bald, heavy man echo from one canvas to the other. But *The Boys in the Back Room*, from the smiles of the onlookers to the very subject of game playing, returns us to Motley's characteristically upbeat view of Black Belt life.

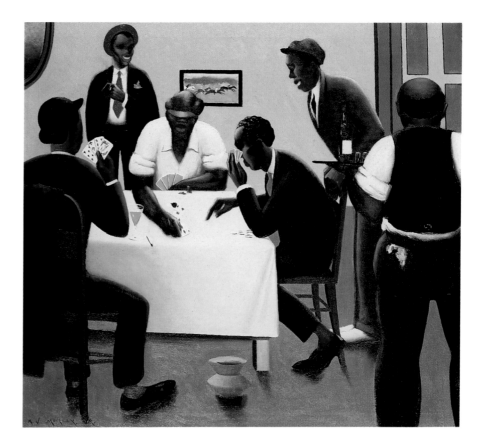

PROVENANCE: WPA, 1934–?; International Gallery, ?–1957; Erwin Weiner, c. 1957–88; Reginald Lewis, 1988.
REFERENCES: Woodall, 1977, no. 61.

35

Between Acts, 1935

Oil on canvas, 39⅜ x 32 in. (100 x 81.3 cm). Inscribed, lower right: A. J. Motley, Jr. Collection of Mr. and Mrs. Terrence L. Bailey.

Between Acts takes us backstage to the dressing room of two female performers who relax in seminudity. Beyond the open door at right, a vaudevillian figure, perhaps awaiting his cue to step onstage, suggests the varied character of the revue, in which the women may appear as dancers or strippers. One, wearing only shoes and stockings and a push-up bra, smokes a cigarette as she slouches in a chair. The other, in bra and high-heeled shoes, brushes her hair as she stands before a mirrored dresser.

The theme of the woman at her toilette, the device of the mirrored image, and even the electric lamp on the dresser all recall Motley's *Brown Girl After the Bath* (1931, cat. no. 28). Here, however, the subject is interpreted as a glimpse into the somewhat tawdry world of cheap entertainment. These women share little of the Brown Girl's shy modesty. Patently indifferent to the open door and the presence of a man just outside, they are absorbed in passing the time between acts. Painted in the same period that saw such upbeat images as *Barbecue* (1934, cat. no. 33) and *Saturday Night* (1935, cat. no. 36), *Between Acts* offers an unusual view of the unglamorous reality behind some of the attractions of Bronzeville night-life.

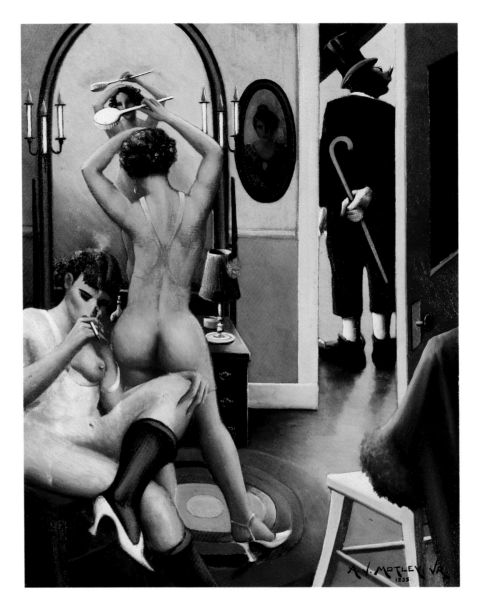

PROVENANCE: Archibald J. Motley, Jr., 1935–74; Frederica Westbrooke, c. 1974–87; Mr. and Mrs. Terrence L. Bailey, 1987.

36

Saturday Night, 1935

Oil on canvas, 32 x 40 in. (81.3 x 101.6 cm). Inscribed, lower right: A. J. Motley, Jr./ 35. Permanent Collection, Howard University Gallery of Art, Washington, D.C.

Saturday Night, executed during Motley's tenure at Howard University in 1935, might have been inspired as much by the black community of Washington, D.C., as by the Black Belt of the artist's hometown. Painted almost entirely in boldly contrasting tones of black, white, and warm reds, *Saturday Night* is alive with the excitement of nightlife. To the sounds of the band in the far right background, a dancer struts among the tables, entrancing most of the patrons. One of two rushing waiters, the buttons of his white jacket echoing the line of lights over the bar, glances over to take in the performance. We are drawn into the scene by the rapt attention of the thin, bald-headed man in the foreground, whose forgotten but still smoking cigar is balanced precariously on the edge of his table. As the dancer arches back, the forward-leaning torso of the waiter behind her provides a counterbalance to her movement, while his lifted arm, and that of the drinking patron seated between them, echo her gesture. The tightly foreshortened perspective of the composition, in which bodies recede precipitously toward the top of the image, suggests the pressing din of conversation, clinking glasses, and jazz music.

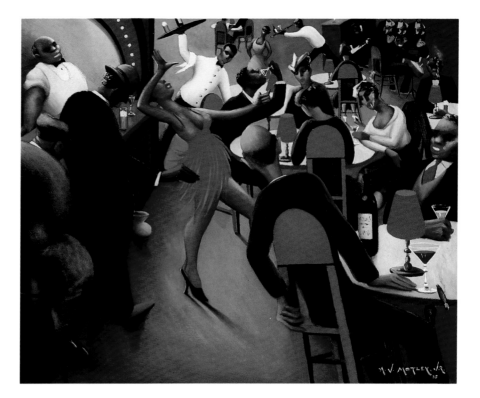

PROVENANCE: Fort Huachuca, Arizona WPA Allocation, c. 1941–47; Howard University Gallery of Art, 1949.
EXHIBITIONS: Texas, 1936; Maryland, 1939; Washington, D.C., 1945; Boston, 1975; New York, 1988.
REFERENCES: Gaither, 1975; Locke, 1939; Robinson, 1987; Dallas, 1936; Woodall, 1977, no. 69.

37

Progressive America, c. 1935
Oil on canvas, 27 x 63 in. (68.6 x 160
cm). Inscribed, lower left: A. J. Motley,
Jr./1938. DuSable Museum of African
American History.

Progressive America is apparently a sketch
for a WPA mural project, but was not
executed as such. A symbolic representa-
tion of American history, the composition
gives center stage to Christopher
Columbus, in an image borrowed from
the painting by John Vanderlyn in the
United States Capitol. Behind Columbus
stands a priest, Motley's special acknowl-
edgement of the importance of the
Roman Catholic church in the history
of European settlement in America.

A New England Pilgrim also appears.
These figures look toward the right,
where Abraham Lincoln stands before
the kneeling figure of a freed slave, a
common symbol of emancipation that
looks back to sculptor Thomas Ball's
Emancipation Group of 1865. On the left,
a group of pioneers heads west, driving a
pair of oxen pulling a covered wagon.
The only women who appear are three
faceless ladies in nineteenth-century
dress who admire the locomotives, their
backs to the viewer.

The figures are surrounded by numer-
ous symbols of Chicago's particular con-
tribution to the economic development
of the United States: old fasioned and
modern locomotives, an automobile, a
ship, and overhead, a blimp and an air-
plane. Smokestacks, factory building, and
electrical power lines suggest the city's
might in industry and communications.

In its stilted composition and its stock
images of historic figures and events,
Progressive America seems an attempt to
cater to conservative tastes and expecta-
tions. While Motley's ability in the field of
mural painting is evident from such works
as *United States Mail*, here he seems
uncomfortable with the constraints
imposed in the illustration of a grandiose
national historical theme.

PROVENANCE: WPA c. 1935– ?; Agnes and
Irvin C. Mollison, ?–1985; DuSable Mu-
seum of African American History, 1985.
REFERENCES: Woodall, 1977, no. 51.

38

The Liar, 1936
Oil on canvas, 32 x 36 in. (81.28 x
91.44 cm). Inscribed, lower right: A. J.
Motley, Jr.,/1936. Permanent collection,
Howard University Gallery of Art,
Washington, D.C.

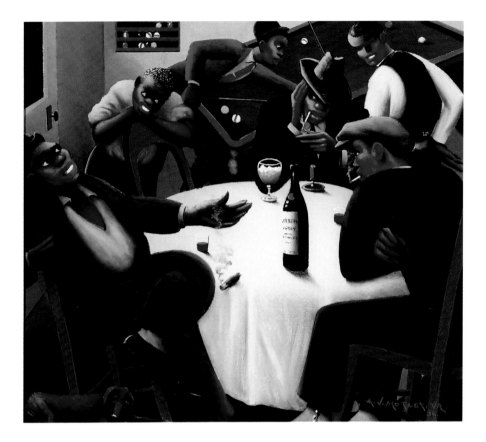

Compositionally, *The Liar* is an exploded
version of *The Plotters* (1933, cat. no.
30). While the figures in the earlier work
form a closed circle around the white
table as they lean toward one another in
their conspiratorial whisperings, here the
figures are only loosely related in a scene
whose mood is humorous. The liar him-
self, seated at the left, leans back and
away from his hearers as if swelling bodily
with the exaggeration of his story. His
seated companions, lips closed on
cigarettes, demonstrate their skepticism
by folded arms or one hand covering an
ear, even as their gazes and their atten-
tion are locked on the storyteller. Leaning
on the back of a chair, a boy smiles with
delight at the tale, while glancing across
the table at the skeptics for agreement.
The liar has caught the attention of the
visor-wearing manager, in the right back-
ground, who turns to take in the story
while a pool player remains intent on his
move.

 In his Bronzeville scenes Motley typical-
ly renders facial features sketchily, barely
suggesting eyes by dark smudges. In *The
Liar*, however, he delineates the faces of
the men with special attention to the
pointed glances exchanged between the
liar and his youthful ally on the left, and
the listeners on the right.

These two pairs are separated by more
than the expanse of white tablecloth
between them. The open gestures and
convivial smiles of the liar and boy, as well
as their relatively casual dress, contrast
with the reserved manner and sophisti-
cated urban attire of the skeptics. With
these features, Motley may be suggesting
that the liar is a recent arrival to the nor-
thern metropolis, whose sophisticates
meet his friendly loquacity with big-city
cynicism.

PROVENANCE: Fort Huachuca, Arizona
WPA Allocation c. 1941–47; Permanent
Collection, Howard University Gallery of
Art, Washington, D.C., 1947.
EXHIBITIONS: New York, 1988; Newark,
1990.
REFERENCES: *Centre Daily Times*, 1972;
Porter, 1943; Woodall, 1977, no. 78.

39

The Picnic, 1936
Oil on canvas, 30⅛ x 36⅛ in.
(76.5 x 91.7 cm). Inscribed, lower left:
A. J. Motley, Jr./1936. Permanent
Collection, Howard University Gallery
of Art, Washington, D.C.

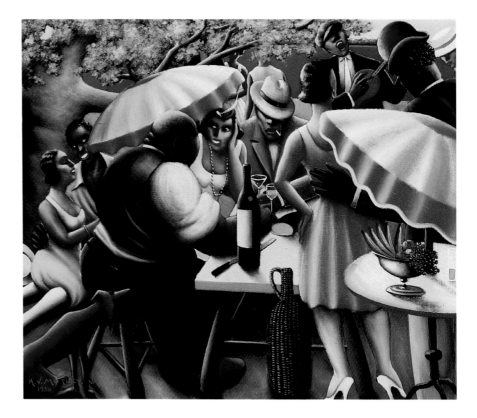

Two gaily-colored oversized umbrellas,
their frills echoed in the folds of the skirt
worn by the woman in the foreground,
dominate this crowded image of a picnic.
In the background a crooning musician
provides casual entertainment for the
picnickers, who seem more interested in
drinking than eating. The figures include
slender, flirtatious women and a variety
of men, from the taciturn slicker with his
hat concealing his eyes and a cigarette
dangling from his lips to the bald, fat
man who engages their mutual female
companion in conversation.

These are familiar inhabitants of
Motley's Bronzeville. Indeed, they seem
to have strolled directly from its streets to
the South Side's parks or Lake Michigan
shore, for their attire, from the men's
suits and hats to the stylishly exaggerated
high heels of the woman in the fore-
ground, all indicate an urban milieu. The
dog at lower left is similar to the one that
appears in Motley's *Café, Paris* (1929, cat.
no. 22) and *The Liar* (1936, cat. no. 38);
the silver bowl of fruit at lower right
seems less a feature of the picnic itself
than an artistic signature that appears fre-
quently in the artist's work, including
Mending Socks (1924, cat. no. 10) of a
decade earlier.

PROVENANCE: Fort Huachuca, Arizona
WPA Allocation, c. 1941–47; Howard
University, 1947.
EXHIBITIONS: La Jolla, 1970; Pennsylvania,
1984; California, 1987.
REFERENCES: Center Gallery, 1984;
Le Falle-Collins, 1987; Teilbet, 1970;
Washington Post, 1980; Woodall, 1977,
no. 76.

40

United States Mail sketch

Oil sketch, 13½ x 12 in. (34.3 x 30.5 cm). Collection of Archie Motley and Valerie Gerrard Browne.

During the mid-thirties, Motley joined numerous other Illinois artists working for federally sponsored art projects that alleviated unemployment in the artistic community while providing art for public places. In the mural division of the Illinois Art Project Motley competed for commissions to decorate schools, post offices, and other public facilities. These projects demanded an art that was broadly didactic and yet accessible, both stylistically and thematically, to a broad public. Competition entries, in the form of highly finished, small-scale studies, were exhibited publicly. Motley submitted designs for numerous mural projects and received three commissions in Illinois.

For the Wood River, Illinois, post office Motley chose the theme of the stagecoach mail because the site was an early stop in U.S. mail service. His interpretation emphasizes the danger and discomfort of the stagecoach service. A clumsy, heavily laden coach creaks up a steep incline, its drivers and the armed guard walking alongside bent with effort and weariness. A mother and child riding within suggest the precious nature of the vehicle's cargo, while a wanted poster on the tree at right testifies to the hazards of postal transportation in frontier America.

Changes made between the oil sketch and the finished work, such as eliminating the background scene and turning the armed guard to face uphill, unify the composition and enhance Motley's theme of the perils of early mail service.

PROVENANCE: Archibald J. Motley, Jr., 1935–81; Archie Motley, 1981–86; Archie Motley and Valerie Gerrard Browne, 1986.

41

United States Mail, 1936
Oil on canvas, 40 x 36 in. (101.6 x
91.4 cm). United States Postal Service.

PROVENANCE: United States Postal
Service, 1936.
EXHIBITION: Chicago, 1935.
REFERENCES: *Tribune*, 1935; Fine, 1973;
Mandel Brothers, c. 1935.

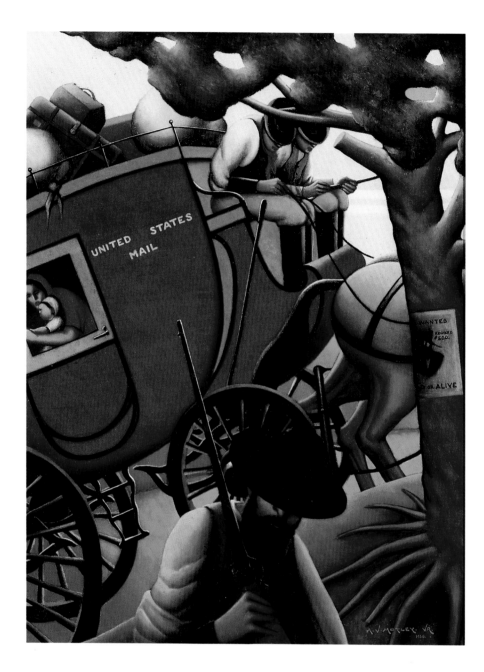

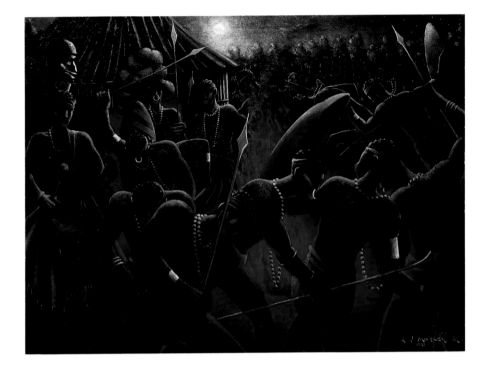

42

Africa, 1937
Oil on canvas, 30 x 40 in. (76.2 x 101.6 cm). Inscribed: A. J. Motley, Jr./1937. Collection of William Watson Hines III.

It had been a decade since Motley had executed his five African works for his New York exhibition when he again took up the subject of his ancestral history. *Africa* appears to be the first in the series of images portraying the history of African-Americans, which occupied Motley during the mid-thirties. It portrays a romanticized Africa in a pre-colonial period when religious and social traditions were as yet unaffected by European influences. Before a wood dwelling, a circle of men dance around a fire. Their armlets, beaded necklaces, nose rings, and metal spears, perhaps indicative of status or role in the community, glint in the firelight. A drummer at left accompanies the dancers; behind, a totemic carved head seems to guard the company.

It is not known whether Motley intended to portray a specific people, religion, or ceremony in *Africa*. In either case, he chose to represent Africa in the stereotypical terms most readily accessible to both his black and white publics. *Africa* thus underscores the prevailing perception of the "Dark Continent," while illustrating the importance of religious life, particularly its ceremonial aspects, in many indigenous African cultures.

PROVENANCE: William Watson Hines III.
REFERENCES: Woodall, 1977, no. 81

114

43

Carnival, 1937
Oil on canvas, 30 x 40 in. (76.2 x 101.6 cm).
Inscribed, lower left: A. J. Motley, Jr./1937.
Permanent Collection, Howard University Gallery of Art, Washington, D.C.

"FATTEST WOMAN IN [THE WORLD] 700 POUNDS," "FLEA SHOW," and "DANCING EVERY NIGHT" proclaim the banners on three tents at a traveling carnival in this scene rendered in soft tones of pink, brown, and orange, with flashes of purplish blue. Under glowing street lamps in early evening, pairs of lovers, a trio of well-dressed ladies, a boy on a bicycle, and others mingle in the expectation of cheap entertainment. The foreground is dominated by three odd figures: a bulky woman, with her hair in a bun and her back to the viewer; a short, fat man in a red suit and a boater hat that reveals only a broad smile; and a contrastingly tall, thin accordion player. Of all these figures, only the faces of the trio of women in the left foreground are fully described. Through their eyes Motley invites the viewer to join this slightly fantastic scene, in which the grotesque and the romantic are mingled.

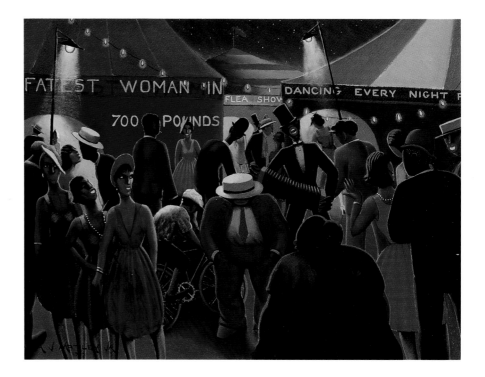

PROVENANCE: Fort Huachuca, Arizona WPA Allocation, c. 1941–47; Howard University, 1947.
EXHIBITIONS: Chicago, 1940; New York, 1988.
REFERENCES: Robinson, 1988; South Side Community Art Center, 1940; Woodall, 1977, no. 80.

44

The Jazz Singers, c. 1937
Oil on canvas, 32⅛ x 42¼ in.
(81.6 x 107.3 cm). Inscribed, lower left:
A. J. Motley, Jr. Western Illinois University
Art Gallery/Museum, Macomb, Illinois.

The Jazz Singers was among the approxi-
mately ten paintings Motley completed
for the easel division of the WPA. The
program provided each participating
painter with art materials and required
him or her to complete one canvas per
month for placement in public buildings.
Motley's easel paintings were distributed
to libraries, park field houses, hospitals,
and other facilities in Chicago and in
nearby locations in Indiana.

Like *The Liar* (1936, cat. no. 38) and
The Plotters (1933, cat. no. 30), Motley's
close-up view of five musicians in *The Jazz
Singers* is a crowded, seemingly casual
arrangement of figures in a barely defined
space. He places his singers for maximum
contrast, juxtaposing fat and thin figures,
light and dark complexions, even clenched
and open hands. Motley's combination
of men dressed in work clothes and in
business suits in this extemporaneous
quintet suggests music's universal appeal,
a socially inspiring theme that reflects the
democratic populism of WPA art.

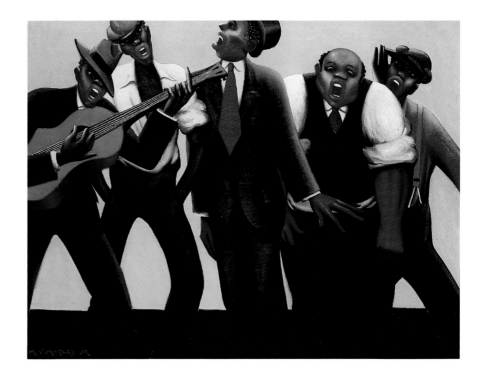

PROVENANCE: WPA, c. 1937–c. 1945;
Western Illinois University Art Gallery/
Museum, Macomb, Illinois, c. 1945.
EXHIBITIONS: Springfield, 1983; Bellevue,
1985.
REFERENCES: McKenna, 1983.

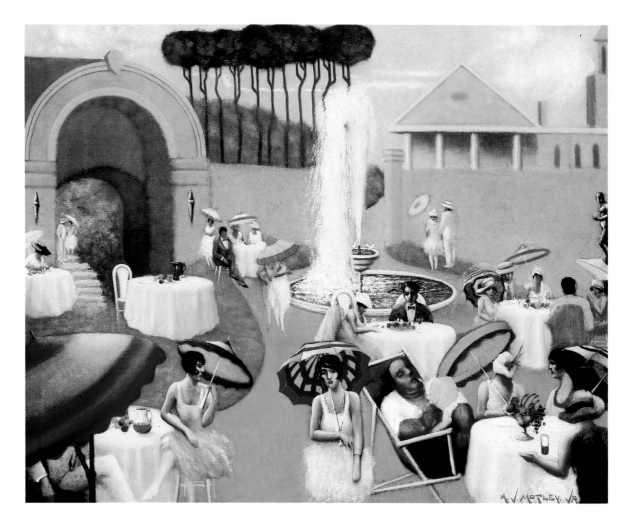

45

Lawn Party, c. 1937
Oil on canvas, 32 x 40 in. (81.3 x
101.6 cm). Inscribed: A. J. Motley, Jr./
[in pencil in later hand] 1927. Collection
of Denise LaMonte-Smith.

Although inscribed sometime after exe-
cution with the date 1927, *Lawn Party*,
like another work of the same title (cat.
no. 46), probably dates to the mid-thirties,
when Motley's talent for out-of-door
genre scenes reached its fullest scope.

Both works feature lines of eccentric,
stylized trees and an interplay of brightly
tinted parasols. In this work, set in an
idyllic enclosed garden, a high jet of
water from the central fountain cools a
scattered group of light-skinned men and
women elegantly dressed in pale summer
colors. Only the fat shirt-sleeved man
in the foreground gives in to the heat,
fanning himself as he leans back in his
lawn chair with closed eyes. With its
fanciful architectural backdrop and pale,
cream-colored sky, the scene strikes a
dreamy note.

PROVENANCE: Archibald J. Motley, Jr.,
c. 1937–81; Denise LaMonte-Smith,
1981.

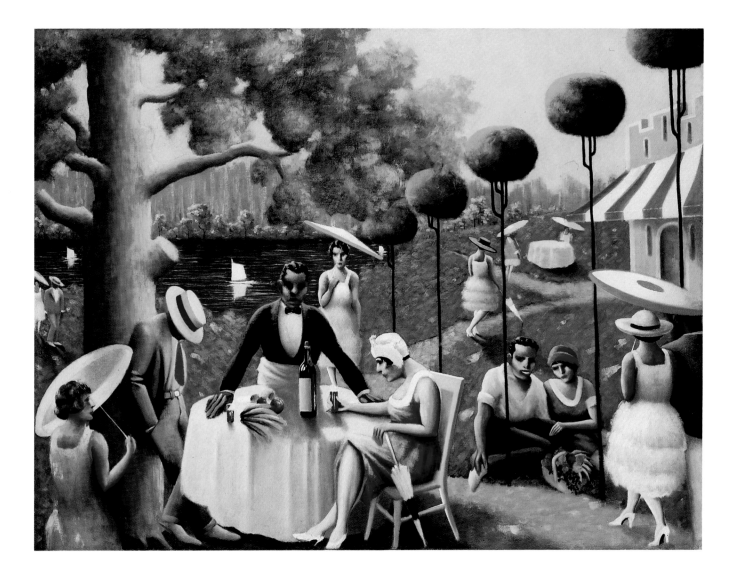

46

Lawn Party, c. 1937
Oil on canvas, 35½ x 47½ in.
(90.2 x 120.7 cm). Collection of Judge
Norma Y. Dotson.

Motley's *Lawn Party* is highly stylized. The
surreal trees, like lollipops descending in a
line from the right, are counterweighted
by the saucerlike disks of the parasols
held by solitary promenading ladies.
The foreground contrasts two couples: a
pair sits on the grass on the right, and, at
left, a man and woman separated by the
table and waiter, and are isolated by the
indifference conveyed by their poses. Toy
sailboats and their reflections meander on
the lake in the background.

PROVENANCE: Archibald J. Motley, Jr.,
c. 1937–81; Judge Norma Y. Dotson,
1981.
EXHIBITIONS: Detroit, 1988; New York,
1988.

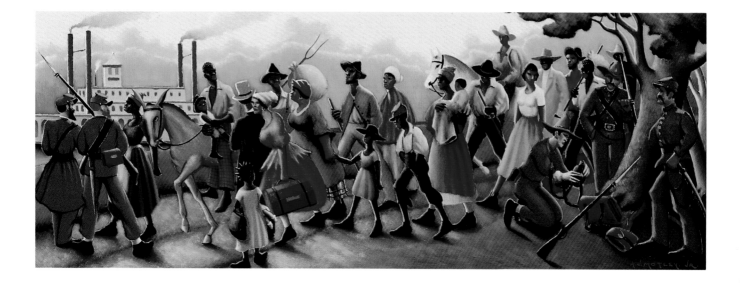

47

Arrival at Chickasaw Bayou of the Slaves of President Davis, c. 1938
Oil on board, 14¾ x 39½ in.
(37.5 x 100.3 cm). Inscribed, lower right:
A. J. Motley, Jr. Permanent Collection,
Howard University Gallery of Art,
Washington, D.C.

In a long, narrow painting Motley depicts a procession of slaves freed during the Civil War. Formerly the property of Jefferson Davis, president of the Confederate States of America, these men, women, and children make their way from Jefferson's Mississippi plantation to a waiting steamboat at Chickasaw Bayou, on the Mississippi River by Vicksburg, under the guard of blue-coated Union soldiers. The site may have had particular interest for Motley, for just across the river is his native state of Louisiana.

A few of the ex-slaves carry bags, but most seem to have nothing more than the clothes on their backs and the anticipation of opportunity as they march toward a new life. The group includes a variety of ages, coloration, dress, and demeanor. Many of the men look like farmers in their open-necked shirts and shapeless hats, but there are also well-dressed figures, such as the man in the pale grey suit and hat and the woman in the pink flounced dress and white turban who carries a suitcase.

Motley painted this historical work for the WPA. Its long, narrow format and friezelike arrangement of figures suggest that it may have been intended as a study for a large-scale mural. Although probably not specifically a part of the artist's projected cycle of paintings illustrating the history of African-Americans, it demonstrates his continuing interest in the subject.

PROVENANCE: Fort Huachuca, Arizona WPA Allocation c. 1941–47; Howard University Gallery of Art 1947.
EXHIBITIONS: New York, 1988.
REFERENCES: Woodall, 1977,, no. 68.

48

Lawd, Mah Man's Leavin', 1940
Oil on canvas, 30 x 40 in. (76.2 x 101.6
cm). Inscribed, lower right: A. J. Motley,
Jr./1940. Saint Louis Art Museum, Gift of
the Federal Works Agency, Work Projects
Administration.

In this rare rural scene, Motley portrays
a farmer leaving for a distant though un-
specified destination, perhaps a northern
city. By the eve of World War II, most
residents of Chicago's Black Belt were
migrants from the South, and the war
triggered yet another influx. Motley here
imagines the wrenching effect of such
migration on family life. Laden with bag-
gage, the departing man is arrested by
his wife's mournful appeal to Heaven,
as, standing on the step of their shack,
she raises her arms in a praying gesture
and cries aloud. Between the pair, a child
seems to stare uncomprehendingly at her
father's bundles, as farm animals surround
the group.

Motley's style translates easily from the
realism of his urban scenes to this rustic
setting, which, in contrast to his serene
Arkansas landscapes of 1928, he renders
in exaggerated colors: the raw wood
buildings are lavender, and a turquoise
sky looks down on electric-green grass.
The intense color scheme of *Lawd, Mah
Man's Leavin'* further reinforces the trau-
matic scene unfolding before the viewer.

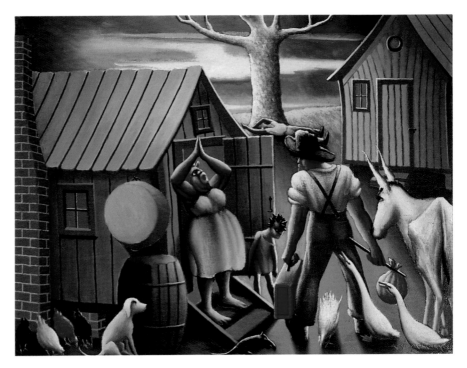

PROVENANCE: WPA Easel Program,
1940– ? ; Saint Louis Art Museum, Gift of
the Federal Works Agency, Work Projects
Administration, c. 1945.
EXHIBITIONS: Washington, D.C., 1940;
Illinois, 1983.
REFERENCES: Aden, 1940; McKenna, 1983

49

Playground (Recess), c. 1940
Oil on masonite, 25¼ x 29¼ in. (64.1 x
74.3 cm). Inscribed, lower right:
Motley. Collection of Dr. Harmon and
Harriet Kelley.

Playground may be related to or a study
for *Recreation* (checklist no. 60), Motley's
mural project for the Doolittle School at
535 East Thirty-fifth Street in Chicago.
Completed around 1940, the murals
have been covered over or destroyed, a
fate shared by much of the art created
under the sponsorship of the WPA.

Painted in a simple palette of green,
red, black, and white, *Playground* is remi-
niscent of children's art in its naive per-
spective, high horizon, and simplistic
treatment of the figures. As its alternate
title implies, the image concerns the play-
time of school children. Motley shows
youngsters on swings and a slide, running
and chatting, and generally expending in
frenetic physical and social activity ener-
gies pent up during hours in the class-
room. The foreground is dominated by a
pair of boys who face the viewer: the
white child with his arm around the
shoulder of the black youth. This depic-
tion of interracial harmony is in accord
with the often idealistic tenor of WPA
mural art, in which children are typically
presented with optimistic innocence.

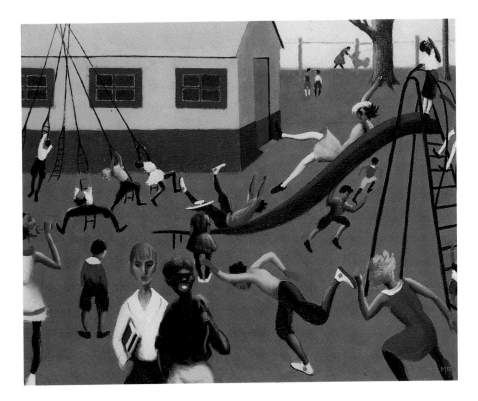

PROVENANCE: Archibald J. Motley, Jr.,
c. 1940–50; Barnett-Aden, c. 1950–86;
Thurlow Tibbs Gallery, 1986–89;
Dr. Harmon and Harriet Kelly, 1989.

50

Sunday in the Park, 1941
Oil on canvas. 30 x 40 in. (76.2 x
101.6 cm). Inscribed: A. J. Motley,
Jr./1941. South Side Community Art
Center.

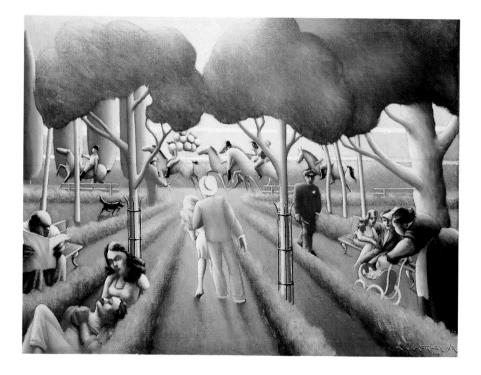

In the distance in *Sunday in the Park*,
Chicago's well-to-do ride their horses
past empty park benches. Radiating
from this background, parallel lines of
low hedges divide the space into narrow
bands. Each contains one of a varied
collection of urban dwellers pursuing a
Sunday activity, from newspaper reading
to romance. Though somewhat surreal in
its fanciful turquoise hues offset by touch-
es of lavender, *Sunday in the Park* reveals
Motley's sensitivity to the social realities of
modern, urban life. The band of hedges,
across which there is little communica-
tion, seem to isolate the clusters of figures
within them. The painting's title evokes
rest and leisure, but the picture includes
three figures at work: the policeman, the
massive, uniformed black nanny pushing a
blonde baby in a carriage, and the balloon
seller in the background. *Sunday in the
Park* is a soothing scene whose buoyant
palette and leisure-life subject is reminis-
cent of the work of French Fauve painter
Raoul Dufy (1877–1953).

Sunday in the Park was among the
paintings Motley created for the easel
division of the Illinois Art Project toward
the end of the program's existence. It
was included in the exhibition "We Too
Look at America," which opened with the
inauguration of the South Side Com-
munity Art Center in May, 1941.

PROVENANCE: South Side Community Art
Center, 1941.
EXHIBITIONS: Chicago, 1940
REFERENCES: WPA, 1943; Locke, 1940;
Woodall, 1977, no. 94.

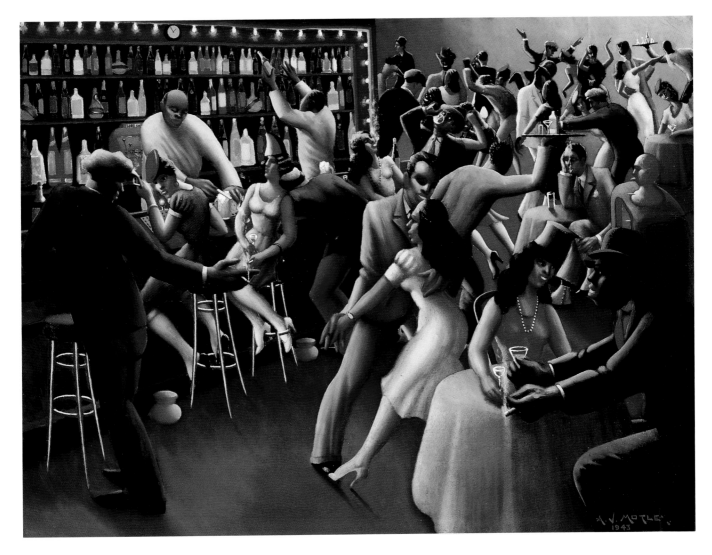

51

Nightlife, 1943
Oil on canvas, 36 x 47¾ in. (91.4 x 121.3 cm). Inscribed, lower right: A. J. Motley, Jr./1943. Collection of Deborah Gwin Hill.

Nightlife recalls *Saturday Night* (1935, cat. no. 36) in its rich red-dominated color scheme and in its composition, with a bar at left and tables at right. In *Nightlife* these elements, and the figures of dancers and a waiter between them, comprise a series of three diagonal bands that plunge toward the dancing crowd in the right distance. A lively tune blasts from the lighted jukebox at the right, and a dancing couple occupies the composition's center. The woman looks toward the left, where a blue-suited man gestures toward her as a woman in green seated at the bar boldly observes. Motley leaves the viewer free to speculate on the stories behind these figures and their interrelated gestures.

Instead, *Nightlife*, one of Motley's busiest scenes, emphasizes the spirit with which residents of Chicago's Black Belt put the cares of the straightened wartime economy temporarily behind them.

PROVENANCE: Archibald J. Motley, Jr., 1943– ?; Costella M. Gwin, ?–1985; Deborah Gwin Hill, 1985.

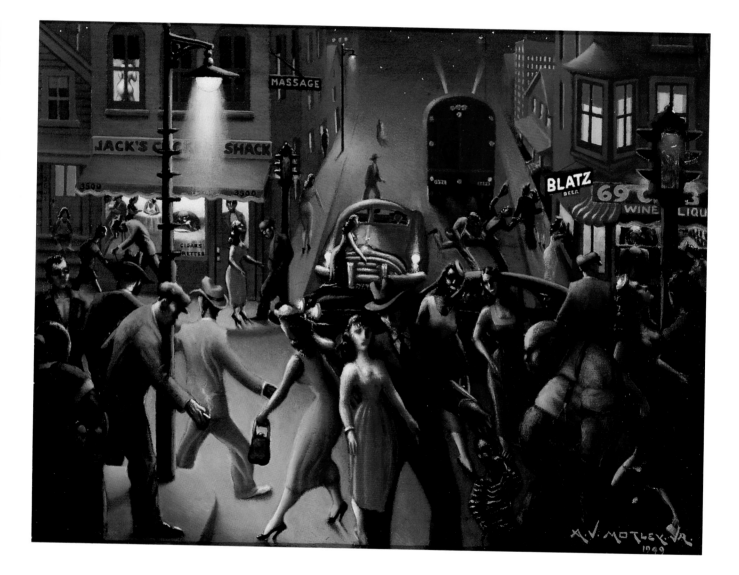

56

Bronzeville at Night, 1949
Oil on canvas, 32 x 39½ in. (81.3 x 100.3 cm). Inscribed, lower right: A. J. Motley, Jr./1949. Collection of Camille O. and William H. Cosby, Jr.

Bronzeville at Night, Motley's last recorded Chicago street scene, recalls *Black Belt* (1934, cat. no. 32), perhaps his first such work. Though separated by almost fifteen years, the two paintings, both set at evening time, share a compositional formula that features a receding street with automobiles, brightly lit storefronts including a restaurant, light flooding from a high street lamp, and two of Motley's favorite figures: the fat man in shirtsleeves and the old, bent man with a cane.

But *Bronzeville at Night* differs from the earlier painting in some key respects. Taking in the view from a high vantage point, Motley here shuts us into a concrete world with no horizon, a street in which passersby and somewhat monstrous cars seem perpetually in danger of collision. We know that this is an evening scene only because of the glow of the street light and storefront windows and the painting's title, for instead of the starry night skies of such related images as *Gettin' Religion* (1948, cat. no. 55), *Bronzeville at Night* shows an urban landscape bounded by streets and buildings.

However, the sense of the street as an urban canyon is challenged in this painting by the sociability of the figures and the nature of the businesses pictured. On the street corner to the right, a bar beckons with signs for Blatz Beer and wine, and on the left, Jack's Chicken Shack offers southern specialties. The crowd includes couples and pairs, as well as individuals who seem isolated amidst the bustle. Above all, *Bronzeville at Night* conveys the sometimes bewildering speed and variety of the Black Belt's street scene.

PROVENANCE: Archibald J. Motley, Jr., 1949–77; Camille O. and William H. Cosby, Jr., 1977.
EXHIBITIONS: Los Angeles, 1976
REFERENCES: Woodall, 1977, no. 96.

feature, seems to stand for Motley's life-long interest in nude painting. Portrayed as if posing in the artist's studio, with drapery on her arm and standing under a bare light fixture, she recalls the fact that Motley pictured himself in the act of painting a nude in his 1933 self-portrait, alternately called *Myself at Work* (cat. no. 31).

The prismlike geometric construction of *Nude* looks back to the work of such American pioneers of modernism as Lionel Feininger (1871–56), the synchronist painters Stanton McDonald-Wright (1890–73) and Morgan Russell (1886–53), and the Chicago modernist William S. Schwartz (1896–77), Motley's friend from his student days. But *Nude* also serves as a graphic demonstration of Motley's own approach to painting, one that he had absorbed during his training at the Art Institute. The artist conceived his paintings in terms of abstract geometric shapes and color arrangements,[10] an approach that is evident in the strong sense of structural integrity that underlies his otherwise realist paintings. In *Nude*, then, Motley has assembled the basic elements of his art. Though apparently anomalous in his oeuvre, the painting is a graphic credo that demonstrates the consistency of Motley's artistic approach and ideals over the course of his career.

PROVENANCE: Archibald J. Motley, Jr., 1952–c. 1955; Mrs. Flossie Moore, c. 1955–90; Charlotte C. Duplessis, 1990.

57

Nude, 1952
Oil on canvas, 30⅛ x 20⅛ in. (76.5 x 51.1 cm). Inscribed, lower right: A. J. Motley, Jr./1952. Collection of Charlotte C. Duplessis.

Nude exemplifies the spirit of experimentation in Motley's late work. It appears to be his only painting in sympathy with the modernist rejection of traditional modes of representation.

Although it does incorporate recognizable forms—a nude female figure beneath an overhead light, and two windows—it is otherwise an abstract composition of bubblelike spheres juxtaposed against flat facets that shade from intense hues of brilliant color into almost pure light.

Executed toward the end of the artist's career, *Nude* is less the signal of a new direction in Motley's art than a distillation of long-held artistic ideals. The nude female, the painting's most prominent

58

José With a Serape, 1953
Oil on canvas, 26⅛ x 22¼ in.
(66.3 x 56.5 cm). Inscribed, lower left:
Motley/Mexico 53. Collection of Archie
Motley and Valerie Gerrard Browne.

While in Mexico, Motley returned to
portraiture, a genre in which he had not
worked since the early thirties. In addition
to this work, he painted *Seri Indian Woman*
(checklist no. 70). The two portraits are
both dated 1953 and are of the same
dimensions, suggesting that Motley
thought of them as a pair.

José worked for the artist's nephew
Willard, with whom Motley lived during
his stay in Mexico. In an unlocated paint-
ing, *José Watering the Garden* (c. 1952–53,
checklist no. 66), Motley portrayed him at
work in Willard's garden. In this portrait,
José is shown in typical Mexican dress: a
loose deep-blue shirt with red bow, a
broad-brimmed hat, and a colorful woven
serape thrown over his shoulder. Holding
a smoking cigarette in one hand, he leans
slightly to the left, fixing the viewer with a
somewhat uncommunicative stare.

PROVENANCE: Archibald J. Motley, Jr.,
1953–81; Archie Motley, 1981–86;
Archie Motley and Valerie Gerrard
Browne, 1986.
REFERENCES: Woodall, 1977, no. 97.

59

Another Mexican Baby, c. 1953–4
Oil on woven petate mat, 35¼ x 67 in.
(89.5 x 170.2 cm). Collection of Archie
Motley and Valerie Gerrard Browne.

While in Mexico Motley executed a num-
ber of paintings on large woven mats of
petate grass, which he obtained locally. In
these works the artist treats Mexican sub-
jects in a manner that recalls his designs
for WPA murals in their simple, friezelike
compositions and generalized figures.

Another Mexican Baby demonstrates the
influence of Mexican social realist art, with
its serious social themes and powerfully
rendered figures. The painting's title,
sardonically evocative of bureaucratic
indifference, directs our attention to the
childsize casket held by the father leading
the procession with his grieving wife.
This funeral parade is not only a symbol
of Mexico's high rate of infant mortality,
but an ironic comment on the anonymity
of poverty.

PROVENANCE: Archibald J. Motley, Jr.,
1953–81; Archie Motley, 1981–86;
Archie Motley and Valerie Gerrard
Browne, 1986.

60

Roadside Conference, 1953
Oil on canvas, 16¾ x 11 in.
(42.6 x 28 cm). Inscribed, lower left:
Motley/53. Atlanta University Collection
of Afro-American Art at Clark Atlanta
University.

PROVENANCE: Archibald J. Motley, Jr.,
1953–60; Judge Irvin C. Mollison,
1960–85; Atlanta University Collection
of Afro-American Art at Clark Atlanta
University, 1985.

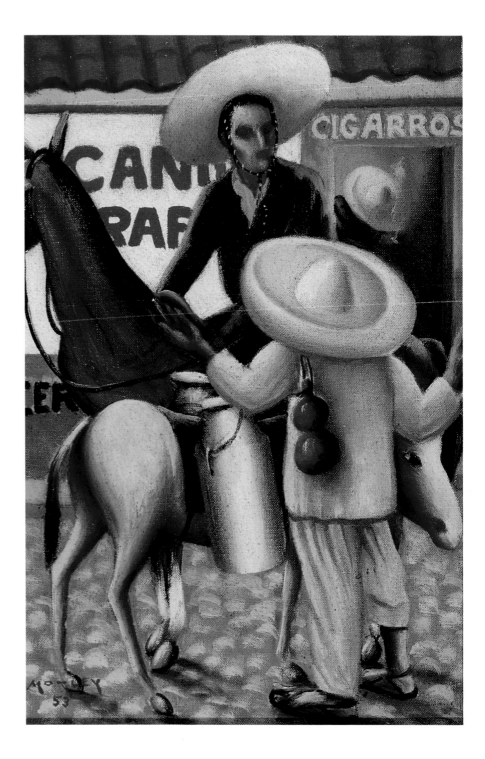

61

Calle del Padre, 1957
Oil on canvas, 12 x 9 in. (30.5 x
29.9 cm). Inscribed, lower left:
Motley. 57. Private Collection.

PROVENANCE: Archibald J. Motley, Jr.,
1957– ?; Judge Irvin C. and Agnes
Mollison; Art & Artifacts Division,
Schomburg Center for Research in Black
Culture, The New York Public Library,
Astor, Lenox and Tilden Foundations;
Margaret Burroughs; Caribe Art Center;
Private Collection, 1987.

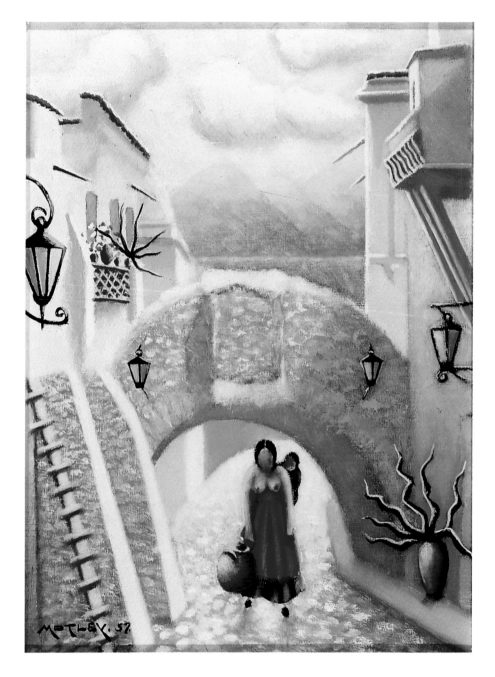

62

Callejon del Beso, 1957
Oil on canvas 12 x 9 in. (30.5 x 29.9 cm).
Inscribed, lower right: Motley/1957.
Kenkeleba Gallery.

PROVENANCE: Archibald J. Motley, Jr.,
1957– ?; Agnes and Irvin C. Mollison;
Margaret Burroughs; Evan-Tibbs Gallery,
?–1988; Kenkeleba Gallery, 1988.

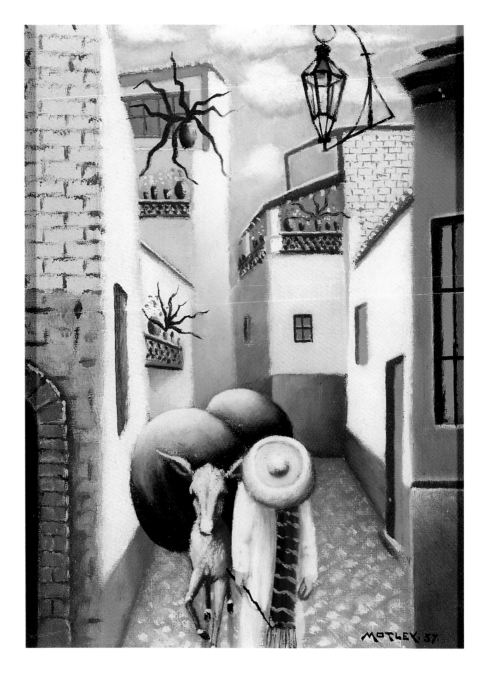

63

Guanajuato, Mexico, 1957
Oil on canvas, 9 x 12 in. (22.9 x 30.5 cm). Inscribed, lower left: Motley 57. Collection of Charlotte C. Duplessis.

Motley's small views of places he visited in Mexico were his first work in the genre of landscape painting since his images of Arkansas scenery painted in 1928. Closely based on tinted postcards of the sites, Motley's Mexican landscapes are themselves like postcards recording the artist's nostalgic memory of his Mexican sojourn. Instead of the deep, rich palette and frequent nighttime setting of his late Bronzeville scenes, Motley worked in bright pastel colors and daytime effects inspired by Mexico's bright natural light and the sunny hues of its architecture.

Guanajuato, Mexico is typical of Motley's Mexican landscapes: *Market Scene, Mexico* (1957, cat. no. 64), *San Miguel de Allende* (1958, cat. no. 65), and *Near San Miguel de Allende* (1958, cat. no. 66). He renders a collection of buildings and walls as simple geometric shapes in bright pastels.

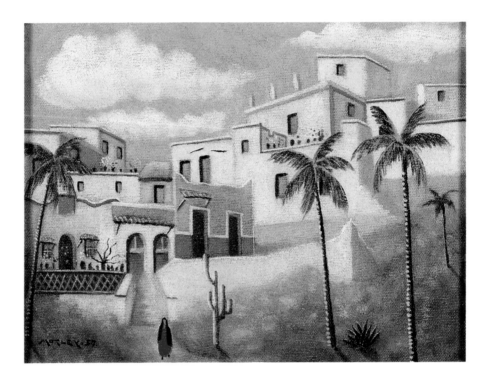

The unvarnished surface of the canvas replicates the matte surface of the adobe structures. The lone small figure of a woman is represented in cursory fashion, dwarfed by stylized palm trees and cactus that lend this scene a dreamlike air.

PROVENANCE: Archibald J. Motley, Jr., 1957–78; Charlotte C. Duplessis, 1978.

64

Market Scene, Mexico, 1957
Oil on canvas, 9 x 12 in. (22.9 x 30.5 cm). Inscribed, lower left: Motley/57. Collection of Charlotte C. Duplessis.

PROVENANCE: Archibald J. Motley, Jr. 1957– ?; Mrs. Flossie Moore, ?–1990; Charlotte C. Duplessis, 1990.

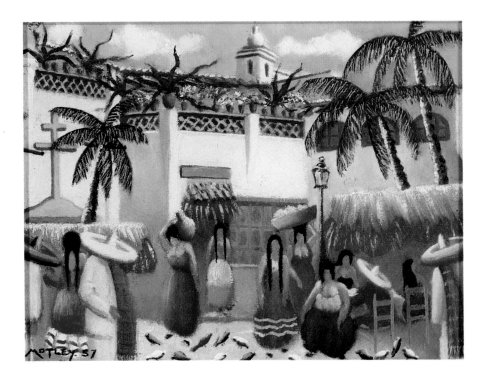

65

San Miguel de Allende, 1957
Oil on canvas, 12 x 9 in. (22.9 x 30.5 cm).
Inscribed, lower left: Motley/57. Collection
of Bernice L. Shields.

PROVENANCE: Archibald J. Motley, Jr.,
1957–62; Father Edward J. Laramie,
1962– ?; Bernice L. Shields.

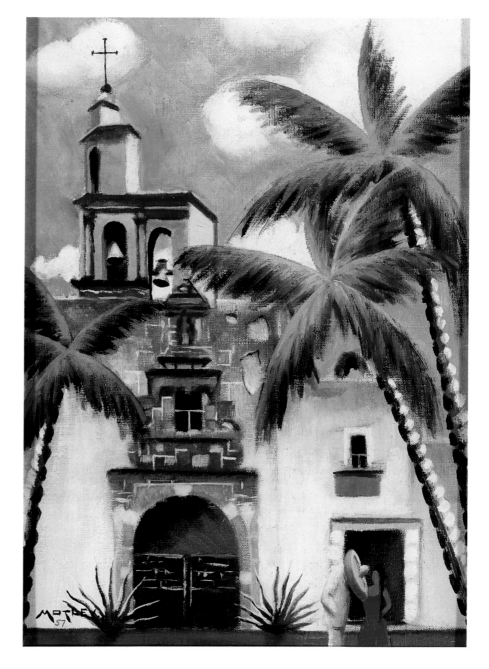

66

Near San Miguel de Allende, Mexico,
1958
Oil on canvas, 9 x 12 in. (22.9 x 30.5 cm).
Inscribed, lower left: Motley 58. Collection
of Frederica Westbrooke.

PROVENANCE: Archibald J. Motley, Jr.,
1958–62; Frederica Westbrooke, 1962.

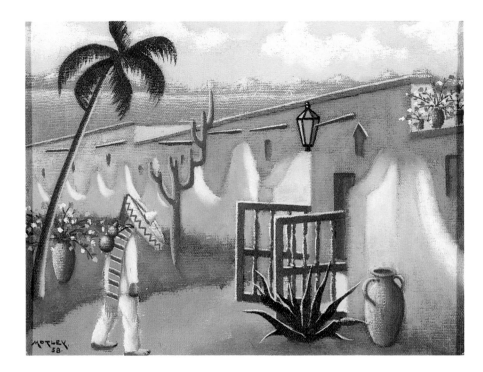

67

Barbecue, 1960
Oil on canvas, 30⅜ x 40 in. (77.7 x
101.6 cm). Inscribed, lower left: Motley/
1960. Collection of Archie Motley and
Valerie Gerrard Browne.

In title and subject this work recalls
Motley's *Barbecue* of about 1934 (cat.
no. 33). Both depict gatherings of varied
Bronzeville types at circular tables set
under starry night skies, across which
strings of electric lights flicker. In contrast
to the more urban milieu of the earlier
painting, here Motley suggests proximity
to water, perhaps the Lake Michigan
shore, in the bathing suit worn by at least
one of the female figures–the woman in
green in the right foreground; a beach ball
rests beneath her chair.

Dominating the composition are the
standing chef in a tall white hat, who
cooks at the open grill, and the familiar
figure of the fat, bald man looming large
in the left foreground. A jukebox in the
background provides music for dancing
couples, but the scene focuses on clusters
of conversing figures at the tables. Motley
includes a figure suggesting himself: a
slender, light-skinned man whose goatee
and open-necked shirt recall Motley's
1933 *Self-Portrait* (cat. no. 31).

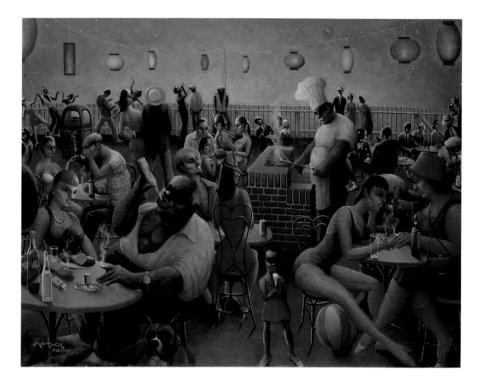

PROVENANCE: Archibald J. Motley, Jr.,
1960–81; Archie Motley, 1981–86;
Archie Motley and Valerie Gerrard
Browne, 1986.
REFERENCES: Woodall, 1977, no. 101

68

Hot Rhythm, 1961
Oil on canvas, 40 x 48⅜ in. (101.6 x
122.9 cm). Inscribed, lower right:
Motley/61. Collection of Archie Motley
and Valerie Gerrard Browne.

In this late work Motley returns to the
cabaret scene, the source of his earliest
depictions of black life in Bronzeville and
Paris. *Hot Rhythm*, with its musical theme
and its almost crushing mass of figures
and instruments pressed up against the
picture plane, recalls *Blues* of 1929 (cat.
no. 21). But here the band and entertain-
ers, rather than the patrons, are given
center stage. Four identical female dancers,
clad in scanty green metallic outfits and
feather headdresses, raise their arms as
they strut along the floor before a seated
audience. The band members, their hair
slicked into place, are dressed in formal
suits as they blast forth the sounds of
hot jazz.

Hot Rhythm resonates with the pulsat-
ing excitement of its musical subject, yet it
also seems to hold the viewer at an aloof
distance. Motley shows almost all of the
figures—whether musicians, dancers, or
patrons—with their eyes averted in self-
possessed reserve. Only two, somewhat
peculiar, figures actually look toward the
viewer: a spectacled man who peers at
us over the shoulder of the leftmost
dancer, his face partly hidden, and the
beret-wearing trumpet player, whose
dark skin and rotundity identify him as the
fat man who haunts Motley's Bronzeville
images.

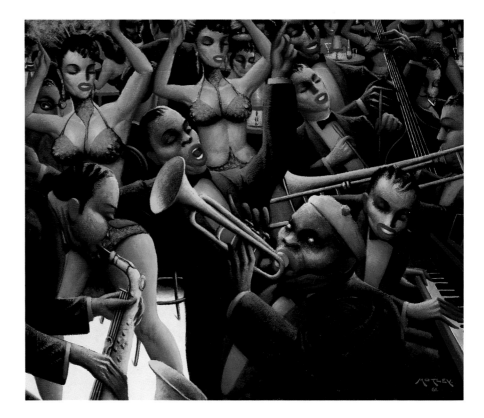

PROVENANCE: Archibald J. Motley, Jr.,
1961–81; Archie Motley, 1981–86;
Archie Motley and Valerie Gerrard
Browne, 1986.
REFERENCES: Woodall, 1977, no. 103

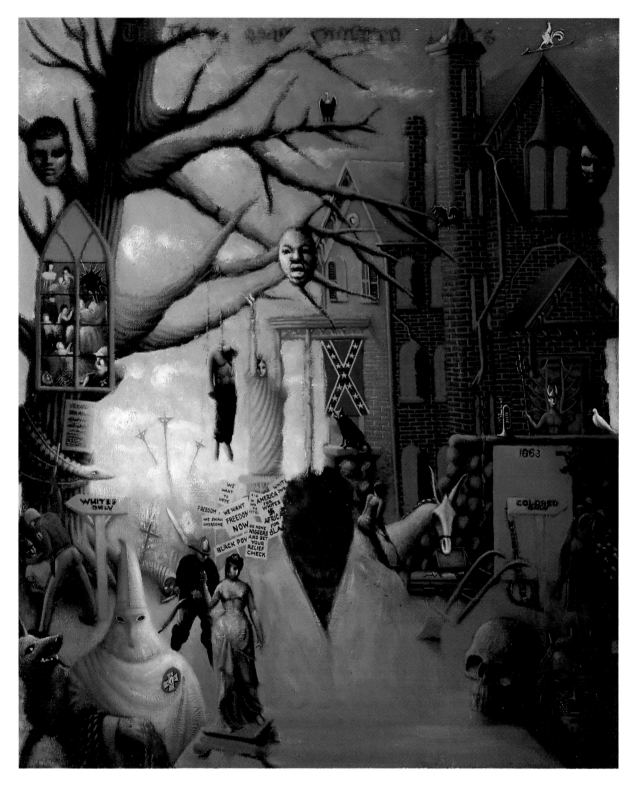

69

The First One Hundred Years: He Amongst You Who is Without Sin Shall Cast the First Stone: Forgive Them Father For They Know Not What They Do, c. 1963–72
Oil on canvas, 48⅞ x 40¾ in. (124.2 x 103.5 cm). Collection of Archie Motley and Valerie Gerrard Browne.

Possibly the last painting on which Motley worked, *The First One Hundred Years* is a montage of symbols describing the history of black-white relations in America in the century following the abolition of slavery. Motley characterizes the South as a derelict gothic mansion on which hangs the Confederate flag. Around it in a surreal landscape are emblems of racial oppression and racist stereotypes, from a white-robed Ku Klux Klansman to a mule and plow. The work is saturated with Motley's trademark deep blue, against which flashes of pure red glow like fresh blood.

In earlier works, from *Jockey Club* of 1929 (cat. no. 24) to the 1941 *Sunday in the Park* (cat. no. 50), Motley had commented obliquely on relations between the races. *The First One Hundred Years* is his only overtly political statement. Resonating with the political upheaval and civil strife of the sixties, it demonstrates stylistic and thematic affinities with the politically charged outdoor murals that appeared in urban sites during that era. Yet it is also an intensely personal statement, which Motley reworked obsessively over almost a decade.

For the lynched man near the picture's center, for instance, the artist may have recalled the cover photograph of a French magazine he had saved from his Paris sojourn in 1929–30. Near the bottom edge of the painting he pictured a figurine of a woman, an object in his own collection that he also incorporated into his 1931 *Portrait of a Woman on a Wicker Settee* (cat. no. 29) and his *Self-Portrait* of 1933 (cat. no. 31). And Motley's religious faith informs the work through details like the broken church window at upper left, the three crucifixes in the far distance, the Trinity-like floating faces of John F. Kennedy, Martin Luther King, Jr., and Abraham Lincoln, and the title. This passionate painting, in which Motley made a radical artistic break from his life's work, sums up personal history as well as national tragedy.

PROVENANCE: Archibald J. Motley, Jr., 1963–81; Archie Motley 1981–86; Archie Motley and Valerie Gerrard Browne, 1986.
REFERENCES: Woodall, 1977, no. 104.

1. "How I Solve My Painting Problems,"
1947, 5. Harmon Foundation Papers,
Library of Congress, Washington, D.C.;
copy in Archibald J. Motley, Jr., Papers,
Archives and Manuscripts Collection,
Chicago Historical Society.

2. Motley, "How I Solve My Painting
Problems," 5.

3. "Biography by Willard," by Willard
Motley, n.d., Archibald J. Motley, Jr.,
Papers, Archives and Manuscripts
Collection, Chicago Historical Society.

4. Motley, "Answers to Farrington-Martin
Questionnaire," by Archibald J. Motley,
Jr., Feb. 16, 1976, and Motley, "How I
Solve My Painting Problems," 3.

5. "Interview with Archibald Motley," by
Dennis Barrie, January 23, 1978, [1].
Archibald J. Motley, Jr., Papers, Archives
and Manuscripts Collection, Chicago
Historical Society.

6. Motley, "How I Solve My Painting
Problems," 3–4.

7. Barrie, "Interview," [24–25].

8. Richard J. Powell, *The Blues Aesthetic:
Black Culture and Modernism* (exh. cat.)
(Washington, D.C.: Washington Project
for the Arts, 1989), [26–27].

9. Motley, "How I Solve My Painting
Problems," 2–3.

10. Motley, "How I Solve My Painting
Problems."

CHECKLIST OF OTHER KNOWN WORKS

This is not a complete or final list of Archibald J. Motley, Jr.'s, works of art, and information on many of art works listed below is incomplete, unknown, or unverified. It is included in this exhibition catalogue to stimulate further research to add to the body of knowledge about the artist's works.

1. *Knitting Girl*, c. 1920
Oil on canvas, 21 x 31 in. (53.3 x 78.7 cm). Collection of Archie Motley and Valerie Gerrard Browne.

2. *Nude Reclining*, c. 1920
Oil on canvas, 26 x 44 in. (66 x 111.8 cm). Collection of Archie Motley and Valerie Gerrard Browne.

3. *Black and Tan Cabaret*, 1921
Oil on canvas. Location unknown. EXHIBITIONS: Chicago, 1922; New York, 1928. REFERENCES: Art Institute, 1922; New Gallery , 1928; Woodall, 1977, no. 4.

4. *Syncopation*, 1924
Oil on canvas. Location unknown. EXHIBITIONS: Chicago, 1925; Chicago, 1926; Copenhagen, 1930; Chicago (Woman's Club), 1933; Chicago (Knights of Pythias), 1933. REFERENCES: American-Scandinavian Foundation, 1930; Art Institute, 1925; ISFA, 1926, Powell, 1989.

5. *A Mulattress*, 1924
Oil on canvas, 34 x 29 in. (86.4 x 73.7 cm). Inscribed, lower right: A. J. Motley, Jr. Location unknown. PROVENANCE: Carl W. Hamilton 1928–? EXHIBITIONS: Chicago, 1925; Springfield, 1926; Chicago, 1926; Chicago (No-Jury), 1926; New York, 1932. REFERENCES: Art Institute, 1925; Brooklyn Museum, 1932; IFSA, 1926; No-Jury, 1926, Woodall, 1977, no. 9.

6. *Portrait of My Brother-in-Law [Charles Worthington]*, c. 1926
Oil on canvas. Collection of Judge Norma Y. Dotson. EXHIBITIONS: Chicago, 1927. REFERENCES: No-Jury, 1927.

7. *Sketch–Farmyard*, c. 1926
Location unknown. EXHIBITIONS: Chicago, 1927. REFERENCES: No-Jury, 1927.

8. *Stomp*, 1927
Oil on canvas. Inscribed, lower right: A. J. Motley, Jr./1927. Collection of Camille O. and William H. Cosby, Jr. PROVENANCE: Archibald J. Motley, Jr., 1927–77; Camille O. and William H. Cosby, Jr., 1977. EXHIBITIONS: New York, 1928; Chicago, 1929; Springfield, 1971. REFERENCES: Art Institute, 1929; New Gallery, 1928; Woodall, 1977, no. 12.

9. *Town of Hope*, 1927
Oil on canvas, 38 1/2 x 31 1/2 in. (100.3 x 80.3 cm). Inscribed, lower left: A. J. Motley, Jr./1927. Location unknown. PROVENANCE: Carl W. Hamilton, 1928–?; Larry Gross; Frank Stewart/Onyx Gallery, ?–1974; Johnson Publications, 1974. EXHIBITIONS: New York, 1932. REFERENCES: Hellman, 1932.

10. *Waganda [Uganda] Woman's Dream*, 1927
Oil on canvas. Inscribed, lower right: A. J. Motley/1927. Location unknown. EXHIBITIONS: New York, 1928; Chicago (Woman's Club), 1933; Chicago (Knights of Pythias), 1933. REFERENCES: New Gallery, 1928; Woodall, 1977, no. 14.

11. *Aline, An Octoroon*, c. 1927
Oil on canvas. Location unknown. Provenance: Ralph Pulitzer, 1928–? EXHIBITIONS: New York, 1928. REFERENCES: New Gallery, 1928; Woodall, 1977, no. 21.

12. *Barbecue In A Garden*, c. 1927
Location unknown. EXHIBITIONS: New York, 1928. REFERENCES: New Gallery, 1928.

13. *Blaine, A Convalescent*, c. 1927
Location unknown. PROVENANCE: Carl Hamilton, 1928–? EXHIBITIONS: New York, 1928. REFERENCES: New Gallery, 1928; Woodall, 1977, no. 20.

14. *Carnival*, c. 1927
Location unknown. EXHIBITIONS: New York, 1928; REFERENCES: New Gallery, 1928; Woodall, 1977, no. 25.

15. *A Colored Man*, c. 1927
Location unknown. EXHIBITIONS: New York, 1928. REFERENCES: New Gallery, 1928; Woodall, 1977, no. 22.

16. *Devil-Devils*, c. 1927
Location unknown. EXHIBITIONS: New York, 1928; REFERENCES: New Gallery, 1928; Woodall, 1977, no. 16.

17. *Head of A Quadroon*, c. 1927
Location unknown. PROVENANCE: Mrs. T. Murray, 1928–?; EXHIBITIONS: New York, 1928. REFERENCES: New Gallery, 1928; Woodall, 1977, no. 19.

18. *In A Garden*, c. 1927
Location unknown. EXHIBITIONS: New York, 1928. REFERENCES: New Gallery, 1928; Woodall, 1977, no. 24.

19. *Interior in Cool and Warm Light*, c. 1927
Location unknown. EXHIBITIONS: New York, 1928. REFERENCES: New Gallery, 1928; Woodall, 1977, no. 26.

20. *Omen*, c. 1927
Location unknown. Provenance: Carl Hamilton, 1928–? EXHIBITIONS: New York, 1928. REFERENCES: New Gallery, 1928; Woodall, 1977, no. 23.

21. *On a Pier*, c. 1927
Location unknown. EXHIBITIONS: Chicago, 1928; Springfield, 1929. REFERENCES: IWAC, 1928; IAFA, 1929.

22. *Parade*, c. 1927
Location unknown. EXHIBITIONS: New York, 1928. REFERENCES: New Gallery, 1928; Woodall, 1977, no. 27.

23. *Picnic at the Grove*, c. 1927
Location unknown. PROVENANCE: Carl Hamilton, 1928–? EXHIBITIONS: New York, 1928; New York, 1929. REFERENCES: New Gallery, 1928.

24. *The Road to Rehabilitation*, c. 1927
Location unknown. EXHIBITIONS: New York, 1928. REFERENCES: New Gallery, 1928; Woodall, 1977, no. 18.

25. *Spell of the Voodoo*, c. 1927
Location unknown. EXHIBITIONS: New York, 1928. REFERENCES: New Gallery, 1928; Woodall, 1977, no. 17.

26. *Waganda [Uganda] Charm-Maker*, c. 1927
Oil on canvas. 39 1/2 x 45 in. (100.3 x 114.3 cm). Inscribed, lower left. Location unknown. PROVENANCE: Carl W. Hamilton, 1928–? EXHIBITIONS: New York, 1928; New York, 1932. REFERENCES: Brooklyn Museum, 1932; New Gallery, 1928; Woodall, 1977, no. 13.

27. *Field Hands Returning Home*, 1928
Location unknown. EXHIBITIONS: Chicago (Knights of Pythias), 1933.

28. *Picking Cotton*, c. 1928
Location unknown. REFERENCES: Woodall, 1977, no. 31, 46.

29. *The Flight*, c. 1929
Location unknown. EXHIBITIONS: Chicago (Woman's Club), 1933; Chicago (Knights of Pythias), 1933. REFERENCES: Jewett, 1933.

30. *Martinique Dancer*, c. 1929–30
Oil on canvas. 39 1/4 x 32 in. (99.7 x 81.3 cm). Location unknown. EXHIBITIONS: Chicago, 1931; Chicago (Merchandise Mart), 1931; Washington, D.C., 1932; Chicago (Kroch's) 1933; Chicago (Olivet Baptist Church), 1933; Chicago (Knights of Pythias), 1933; Chicago (Visitor's), 1933. REFERENCES: Art Institute, 1931; IAFA, 1931; Jewett, 1933; Woodall, 1977, no. 36.

31. *Martinique Youth*, c. 1929–30
Location unknown. EXHIBITIONS: Harmon, 1931. REFERENCES: Woodall, 1977, no. 37.

32. *Refugees (Veterans)*, c. 1929–30
Location unknown. EXHIBITIONS: Chicago (Woman's Club), 1933; Chicago (Knights of Pythias), 1933. REFERENCES: Jewett, 1933; Woodall, 1977, no. 42

33. *Senegalese*, c. 1929–30
Oil on canvas. Collection of Camille O. and William H. Cosby, Jr. PROVENANCE: Archibald J. Motley, Jr.; Oscar Stadeker; Camille O. and William H. Cosby, Jr. EXHIBITIONS: Chicago, 1931; Washington, D.C., 1932; Chicago (Visitor's), 1933; Chicago (Olivet Baptist Church), 1933. REFERENCES: Art Institute, 1931; Woodall, 1977, no. 35.

34. *Sharks (Playing Poker)*, c. 1929–30
Inscribed, lower right: A. J. Motley, Jr. Location unknown. EXHIBITIONS: Chicago (Woman's Club), 1933; Chicago (Knights of Pythias), 1933; Washington, D.C., 1933. REFERENCES: Art Institute, 1933; National Gallery, 1933; Woodall, 1977, no. 43, 61.

35. *Spirituals*, c. 1929–30
Location unknown. EXHIBITIONS: Chicago (Knights of Pythias), 1933.

36. *Portrait of My Mother*, c. 1930
Oil on canvas. Location unknown. EXHIBITIONS: Dallas, 1935; New York, 1931; Chicago, 1932; Chicago (Woman's Club), 1933; Chicago, (Knights of Pythias), 1933; Chicago (Robinson), 1933; REFERENCES: Barnett, 1933; Art Institute, 1932; Studio Gallery, 1933; Woodall, 1977, no. 39.

37. *The Final Consolation*, c. 1932
32 x 40 in (81.3 x 101.6 cm). Inscribed, lower left: A. J. Motley, Jr. Location unknown. PROVENANCE: George S. Hellman, c. 1932–? EXHIBITIONS: New York, 1932. REFERENCES: Hellman, 1932.

38. *Picking Cotton*, c. 1933
Location unknown. PROVENANCE: WPA, c. 1933–? REFERENCES: Woodall, 1977, no. 46.

39. *Baseball in the Schoolyard*, c. 1934
Location unknown. PROVENANCE: WPA, c. 1934–? REFERENCES: Woodall, 1977, no. 49 or 50.

40. *Negro Dancers (The Dancers)*, c. 1934
Location unknown. PROVENANCE: WPA, c.
1934–? REFERENCES: Woodall, 1977, no. 47,
48.

41. *Negro Slaves at Work (Plantation Days)*,
c. 1934
Location unknown. REFERENCES: Woodall,
1977, no. 55.

42. *Reception*, c. 1934
Location unknown. PROVENANCE: WPA, c.
1934–? REFERENCES: Woodall, 1977, no. 60.

43. *A Surprise in Store*, c. 1934
Oil on canvas, 36 x 40 in. (91.4 x 101.6 cm)
(framed). Location unknown. EXHIBITIONS:
Copenhagen, 1930; Chicago, 1934.
REFERENCES: Century of Progress, 1934;
Woodall, 1977, no. 63.

44. *Frederick Douglass*, c. 1935
Location unknown. REFERENCES: Woodall,
1977, no. 56.

45. *Funeral Scene*, c. 1935
Location unknown.

46. *Mural for Douglass Memorial Hall*, c.
1935–36 Commissioned for Howard
University, c. 1935–36–? (destroyed).
REFERENCES: Woodall, 1977, no. 93.

47. *Marijuana Joint*, c. 1935–36
Location unknown. PROVENANCE: WPA, c.
1935–36–? REFERENCES: Woodall, 1977, no.
72.

48. *Massacre*, c. 1935–36
Location unknown. REFERENCES: Woodall,
1977, no. 74.

49. *Street Scene*, c. 1935–36
Location unknown. REFERENCES: Woodall,
1977, no. 70.

50. *Band Playing*, c. 1936
Commissioned for music room (east wall),
Nicholas Elementary School, Evanston, Illinois,
c. 1936–? (destroyed). REFERENCES: Woodall,
1977, no. 66.

51. *Dance Scene*, c. 1936
Commissioned for music room (north wall)
Nicholas Elementary School, Evanston, Illinois,
c. 1936–? (destroyed). REFERENCES: Woodall,
1977, no. 65.

52. *Negro Children*, c. 1936
Commissioned for music room (south wall),
Nicholas Elementary School, Evanston, Illinois,
c. 1936–? (destroyed). REFERENCES:
Mavigliano, 1990; Woodall, 1977, no. 67.

53. *Chicken Shack*, c. 1936
Location unknown. PROVENANCE: Harmon
Foundation, 1967. EXHIBITIONS: Washington,
D.C., 1936; Baltimore, 1939. REFERENCES:
Fine, 1973; Locke, 1939; Patterson, 1967;
Watson, 1936; Woodall, 1977, no. 77.

54. *Mural Sketch for City, Light and Power*,
c. 1937. Location unknown. EXHIBITIONS:
Chicago (Woman's Club), 1933; Chicago,
1938. REFERENCES: Rich, 1938; Woodall,
1977, no. 85.

55. *Historical Piece about African Americans*,
c. 1938
Oil on canvas, 63 x 25 in. (160 x 63.5 cm).
(framed). Collection of Camille O. and
William H. Cosby, Jr. REFERENCES: South Side
Community Art Center, 1981.

56. *In A Garden (A Study in Early Moonlight
and Artificial Light)*, c. 1938
PROVENANCE: Evansville State Hospital, c.
1938–43 (destroyed). EXHIBITIONS: Evansville,
1938. REFERENCES: Woodall, 1977, no. 75.

57. *Introduction of Slavery Into the United
States*, c. 1938
PROVENANCE: Evansville State Hospital, c.
1938–43 (destroyed). EXHIBITIONS: Evansville,
1938. REFERENCES: Evansville Press, 1938;
Woodall, 1977, no. 54; WPA, 1938.

58. *Negroes Captured in Africa*, c. 1938
PROVENANCE: Evansville State Hospital, c.
1938–43 (destroyed). EXHIBITIONS: Evansville,
1938. REFERENCES: Evansville Press, 1938;
Woodall, 1977, no. 53; WPA, 1938.

59. *The Argument*, c. 1940
Oil on canvas, 44 1/2 x 34 1/2 in. (113 x 87.8
cm). Inscribed, lower right: A. J. Motley,
Jr./1940. Barnett-Aden Collection.
EXHIBITIONS: New York, 1988. REFERENCES:
Anacostia, 1974; Driskell, 1975; Woodall,
1977, no. 86.

60. *Recreation*, c. 1940
Oil on canvas, 108 x 40 in. (274.3 x 101.6
cm) (framed). Commissioned for Auditorium,
Doolittle Elementary School, Chicago, Illinois,
c. 1940–? (destroyed). REFERENCES: Woodall,
1977, no. 84

61. *Dancing*, c. 1940
Location unknown. REFERENCES: Woodall,
1977, no. 89; WPA, 1943.

62. *Lakeside General Station*, c. 1940
Location unknown. REFERENCES: Woodall,
1977, no. 90; WPA, 1943.

63. *Lincoln Riding Through Richmond, April 4,
1865*, c. 1940
Location unknown. REFERENCES: Woodall,
1977, no. 91; WPA, 1943.

64. *Subway Construction*, c. 1940
Location unknown. REFERENCES: WPA, 1943.

65. *Joe's Place*, c. 1943
Oil on canvas. Location unknown.
EXHIBITIONS: Atlanta, 1943. REFERENCES:
Atlanta University, 1943.

66. *José Watering the Garden*, c. 1952–53
Location unknown.

67. **On the Salto Chula Vista Bus**, c. 1952–53
Location unknown. REFERENCES: Woodall, 1977, no. 98.

68. **Cabaret at Puebla**, c. 1953
Oil on woven petate, 49 1/2 x 69 1/2 in. (125.7 x 176.5 cm). Collection of Archie Motley and Valerie Gerrard Browne. PROVENANCE: Archibald J. Motley, Jr., 1953–81; Archie Motley, 1981–86; Archie Motley and Valerie Gerrard Browne, 1986.

69. **Cuernavaca, Mexico**, 1953
Oil on canvas. Location unknown. PROVENANCE: Judge Irvin C. and Agnes Mollison; Schomburg Center for Research In Black Culture; Margaret Burroughs, 1983–?

70. **Seri Indian Woman**, 1953
Oil on canvas, 26 x 22 in. (66 x 55.9 cm). Inscribed, lower right: Motley/53. Collection of Archie Motley and Valerie Gerrard Browne.

71. **Mexican Road, Cuernavaca**, c. 1953
Oil on canvas. Location unknown. PROVENANCE: Judge Irvin C. and Agnes Mollison; Schomburg Center for Research In Black Culture; Margaret Burroughs; Caribe Art Center.

72. **God Bless America**, c. 1953
Oil on canvas. Location unknown. EXHIBITIONS: Chicago, 1953. REFERENCES: Chicago Sunday Tribune, 1953.

73. **After Revelry, Meditation (After Fiesta, Remorse, Siesta) (After Revelry and Fiesta, Meditation and Siesta)**, c. 1960
Oil on canvas, 23 1/4 x 33 1/2 (59 x 85 cm). Inscribed, lower left: Motley 1960. The Evans-Tibbs Collection. EXHIBITIONS: New York, 1988; Washington, D.C., 1989. REFERENCES: McElroy, 1989; Tibbs, 1983; Woodall, 1977, no. 102.

74. *El Bodegon*, c. 1970
Oil on canvas, 24 x 18 in. (61.x 45.7 cm). Collection of Dr. and Mrs. Solomon R. Green. REFERENCES: Woodall, 1977, no. 105.

Sketchbooks

A number of sketchbooks of signal importance in documenting the artist's work is found in the collection of Archie Motley and Valerie Gerrard Browne and in the Archibald J. Motley, Jr., Papers, Archives and Manuscripts Collection, Chicago Historical Society. In addition to notes and lists of titles of paintings, they contain numerous sketches, some for recorded works (for instance, the now-destroyed murals for the Nicholas Elementary School, c. 1936, checklist nos. 50, 51, and 52) and some paintings for which there is no evidence of actual execution. In some instances, Motley drew a border around a sketch and noted the work's title and dimensions, suggesting that he may have been recording an idea for a work not yet executed. Occasionally, however, the title or composition recorded in the sketchbook differs in key ways from the seemingly related painting. The nature of the documentation offered by the sketchbooks, therefore, necessitated some speculation in the compiling of a list of Motley's paintings. The above checklist seeks to err on the side of inclusiveness, at the risk of redundancy.

CHRONOLOGY OF THE ARTIST'S LIFE

1891 Motley born, October 7,
New Orleans

1914 Motley graduates from Englewood
High School, Chicago, and enters
The School of the Art Institute of
Chicago

1918 Motley graduates from The School
of the Art Institute

1924 Motley marries Edith Granzo

1925 The Art Institute of Chicago awards
Motley the Frank G. Logan prize for
A Mulattress and the Joseph N.
Eisendrath prize for *Syncopation*.

1926 W.E.B. DuBois lists Motley in *The
Crisis* as a credit to the race for the
year 1925

1927 *Mending Socks* voted the most pop-
ular painting in the exhibition,
"Paintings and Water Colors by
Living American Artists" at The
Newark Museum

1928 Motley shows twenty-six paintings
at his one-person exhibition at the
New Gallery, New York City

1928 Motley wins the Harmon
Foundation Prize for *Octoroon Girl*

1929–30 Motley wins a Guggenheim
Fellowship for a year of study
in Paris

1933 Motley exhibits *Blues*
at the "A Century of Progress"
exhibition at The Art Institute of
Chicago

Motley's son Archibald J. Motley III
born

1933 The Chicago Woman's Club spon-
sors a one-person exhibition
for Motley

1935 Motley is appointed visiting instruc-
tor at Howard University

Motley exhibits *A Surprise in Store*
at the A Century of Progress
Exposition, Chicago

1937 Motley is commissioned to paint
a mural for the Wood River, Illinois,
post office by the Treasury
Department

1941 South Side Community Art
Center opens

1948 Death of Edith Motley

1950 *Gettin' Religion* receives Styletone
prize for unusual composition

1957 Motley has a one-person exhibition
at the Chicago Public Library

1972 Motley honored by the National
Conference of Artists, Chicago

1980 Motley receives an honorary doc-
torate of fine arts from The
School of The Art Institute of
Chicago

Motley is one of ten distinguished
black artists honored by President
Carter at a White House reception

1981 Death of Motley, January 16,
Chicago

SELECTED LIST OF EXHIBITIONS

Exhibitions listed below are cited in abreviated form.

Chicago, 1917
"Paintings by Negro Artists." The Arts and Letters Society, December 21.

Chicago, 1921
"Twenty-fifth Annual Exhibition by Artists of Chicago and Vicinity." The Art Institute of Chicago, January 25 to February 26.

Chicago, 1922
"Twenty-sixth Annual Exhibition by Artists of Chicago and Vicinity." The Art Institute of Chicago, January 26 to March 25.

Chicago, 1923
"Twenty-seventh Annual Exhibition by Artists of Chicago and Vicinity." The Art Institute of Chicago, February 1 to March 11.

Albany, 1923
Literary Roundtable of Albany, February 4 to February 11.

Chicago, 1925
"Twenty-ninth Annual Exhibition by Artists of Chicago and Vicinity." The Art Institute of Chicago, January 30 to March 10.

Chicago (No-Jury), 1926
"Fourth Exhibition of the Chicago No-Jury Society of Artists, Incorporated." The Galleries of Marshall Field & Company, January 30 to March 10.

Chicago, 1926
"First Exhibition by Artists of Illinois." All-Illinois Society of Fine Arts, Incorporated. The Galleries of Carson Pirie Scott & Company, September 27 to October 16.

Springfield, 1926–27
"The First Art Exhibition of the Illinois Academy of Fine Arts." Galleries of the Illinois State Museum, November 20 to January 20.

Chicago, 1927
"Fifth Exhibition of the Chicago No-Jury Society of Artists, Incorporated." The Galleries of Marshall Field & Company, January 10 to January 22.

Newark, 1927
"Paintings and Watercolors by Living American Artists." The Newark Museum, New Jersey, March 22 to April 21.

Peoria, 1927
"Exhibit of Paintings, Etchings and Sculpture by Professional Members of the Illinois Academy of Fine Arts." Hotel Pere Marquette, Peoria, April 24 to May 28; traveled to Springfield, Aurora, Flint, Decatur, Urbana, Elgin, Rockford, Bloomington, and Rock Island.

New York, 1928
"Exhibition of Paintings by Archibald John Motley, Jr." New Gallery, February 25 to March 10.

Chicago, 1928
"Third Annual Exhibition by Members of the Illinois Academy of Fine Arts." Illinois Women's Athletic Club, December 9 to December 30.

New York, 1929
(Harmon Foundation, 1929)
"Exhibit of Fine Arts by American Negro Artists." The Harmon Foundation and the Commission on the Church and Race Relations, Federal Council of Churches. International House, January 13 to April 15.

Springfield, 1929
"Third Annual Exhibition by Members of the Illinois Academy of Fine Arts." Art Galleries of the Illinois State Museum, January 13 to April 15.

Louisville, 1929
"Exhibit of Fine Arts by American Negro Artists." J. B. Speed Memorial Museum, April 7 to April 14; traveled to Atlanta, Spelman College, April 28 to May 5.

Chicago, 1929
"Thirty-third Annual Exhibition of Artists of Chicago and Vicinity." The Art Institute of Chicago, February 7 to March 10.

Washington, D.C., 1929
"Exhibition of Paintings and Sculpture by American Negro Artists. The National Gallery of Art. Smithsonian Institution, May 16 to May 29.

New York, 1930
"Third Annual Exhibition of Fine Arts: Work of Negro Men and Women." The Harmon Foundation and the Commission on the Church and Race Relations, Federal Council of Churches. International House, January 7 to January 19; traveled to Spelman College in Atlanta for 10 days.

Copenhagen, 1930
"Udstilling af Amerikansk Kunst." The American-Scandinavian Foundation, the American Federation of Arts, and the American Institute of Architects, May 3 to May 22. Also at Ny Carlsbergfondet, og Danmarks Amerikanske Selskab, Ny Carlsberg Glyptotek, Copenhagen.

Chicago, 1930
"Thirty-fourth Annual Exhibition by Artists of Chicago and Vicinity." The Art Institute of Chicago, January 30 to March 9.

Chicago (Renaissance Society), 1930
"Exhibition of Paintings Selected from the Annual Exhibition of Paintings by Artists of Chicago and Vicinity." The Renaissance Society of the University of Chicago. The Art Institute of Chicago, Wieboldt Hall, March 12 to March 26.

Chicago, 1931
"Thirty-fifth Annual Exhibition by Artist of Chicago and Vicinity." The Art Institute of Chicago, January 29 to March 1.

Chicago (Merchandise Mart), 1931
"Fifth Annual Art Exhibition by Members of the Illinois Academy of Fine Arts." Merchandise Mart, April 15 to April 25; traveled to Springfield, Illinois, Academy of Fine Arts, May 12 to August 31.

Alabama, 1931
"Works of Negro Artists." The Harmon Foundation. Tuskegee Institute, June 15 to June 30.

New York, 1931
"John Simon Guggenheim Fellows." Grand Central Galleries.

New York (Harmon), 1931
The Harmon Foundation.

American Federation of Arts, 1931–32
"American Federation of the Arts Exhibition by Chicago Artist." Carnegie Institute, December 22 to January 31.

Chicago, 1932
"Thirty-Sixth Annual Exhibition by Artists of Chicago and Vicinity." The Art Institute of Chicago, January 28 to March 30.

Washington, D.C., 1932
The Harmon Foundation. Howard University.

Washington, D.C. (NAACP), 1932
"An Exhibition of the Works of Negro Painters." The Cultural Committee of the Washington Branch of the NAACP. Howard University Gallery of Art, May 17 to May 29.

New York, 1932
"Summer Exhibition of Paintings, Sculptures, and Drawings." Brooklyn Museum, June to October.

Michigan, 1932
"Chicago Artists." University of Michigan.

Anderson Galleries, 1932
Notable Paintings and Drawings Chiefly of the Modern Schools. Property of George S. Hellman. Auction, American Art Association, Anderson Galleries, December 14.

Chicago 1932–33
"Chicago Painters, A Group of Contemporary Oils Selected by Robert B. Harshe, Director of The Art Institute of Chicago." Twenty-fourth season, traveling exhibition. The American Federation of Arts.

Chicago (Woman's Club), 1933
One-person exhibition. Chicago Women's Club, January.

Chicago (Visitor's), 1933
Visitor's Tourist Service, Incorporated.

Chicago (Thirty-seventh), 1933
"Thirty-seventh Annual Exhibition by Artists of Chicago and Vicinity." The Art Institute of Chicago, January 12 to March 5.

Chicago (Robinson), 1933
"Art of Today–Chicago, 1933." Increase Robinson's Studio Gallery, January 21 to February 19.

Chicago (Olivet Baptist Church), 1933
"Exhibition of Negro Artists." Olivet Baptist Church.

New York, 1933
"Paintings and Prints by Chicago Artists." Whitney Museum of American Art, February 28 to March 30.

New York (Guggenheim), 1933
"Exhibition of the Work of Artists Fellows of the J. S. Guggenheim Memorial Foundation." April 3 to April 27.

Chicago (Kroch's), 1933
Kroch's Art Gallery.

New York (Whitney), 1933
"Contemporary Black Artists in America." Whitney Museum of American Art.

Chicago (Knights of Pythias), 1933
"The African American Negro Exhibition." Knights of Pythias Temple.

Washington, D. C., 1933
"Exhibition of Works of Negro Artists." Association for the Study of Negro Life and History. National Gallery of Art, October 31 to November 6.

Chicago (Century of Progress), 1933–34
"Chicago Exhibition of Paintings and Sculpture." A Century of Progress International Exposition.

Chicago, 1934
"Thirty-eighth Annual Exhibition by Artists of Chicago and Vicinity." The Art Institute of Chicago, February 1 to March 18.

Washington, D. C., 1934
"National Exhibition of Art by the Public Works of Art Project." Corcoran Gallery of Art, April 24 to May 20.

Toledo, 1934
"Twenty-first Annual Exhibition of Selected Paintings by Contemporary American Artists." Toledo Museum of Art, June 3 to August 26.

Chicago, 1935
"Negro Artists: An Illustrated Review of their Achievements." The Harmon Foundation, Delphic Studios, April 22 to May 4.

Chicago (Davis Store), 1935
"Salon Des Refusés Exhibition by Artists of Chicago and Vicinity." The Davis Store Galleries.

Chicago (Art Institute), 1935
"Thirty-ninth Annual Exhibition by Artists of Chicago and Vicinity." The Art Institute of Chicago, January 31 to March 10.

Chicago (Mandell Brothers), 1935
"Exhibition of Sketches Submitted for the Federal Mural Competition." Mandell Brothers Loop Store, July 15 to July 30.

Gary, 1935
Roosevelt High School.

Texas, 1936
"Exhibition of Fine Arts Productions by America Negroes." Hall of Negro Life, Texas Centennial, June 19 to November 29.

Washington, D. C., 1936
"Treasury Department Art Projects Paintings and Sculpture for Federal Buildings." Corcoran Gallery of Art, November 17 to December 13.

Washington, D. C. (Howard), 1937
Howard University Gallery of Art.

New York, 1937
Dance International 1900–1937. International Building, Rockefeller Center, November 28.

Evansville, 1938
"Fifty Paintings from the Chicago Works Progress Administration Art Project." Evansville State Hospital, Indiana, May 1 to May 2.

Chicago, 1938
"Art for the Public by Chicago Artists." Federal Art Project, Works Progress Administration. The Art Institute of Chicago, July 28 to October 9.

Baltimore, 1939
"Contemporary Negro Art." Baltimore Museum of Art, February 3 to February 19.

Chicago, 1940
"We, Too, Look at America: National Negro Art Exhibition." Southside Community Art Center, Dedication Exhibition, May 11 to May 31.

Chicago (Tanner Galleries), 1940
"Exhibition of the Art of the American Negro, 1851 to 1940." American Negro Exposition. Tanner Art Galleries, July 4 to September 2.

Chicago, 1940–41
Opening exhibition of paintings by negro artists of the Illinois Art Project. Work Projects Administration. Southside Community Art Center, December 15 to January 28.

Washington, D. C., 1940
Commemoration of the Seventy-fifth Anniversary of the Proclamation of the Thirteenth Amendment to the Constitution. United States Library of Congress, December 18 to January 18.

New York, 1942
"American Negro Art, 19th and 20th Centuries." The Downtown Gallery, December 9 to January 3.

Atlanta, 1943
"Atlanta University Annual Art Exhibition, Second Annual Exhibition of Paintings by Negro Artists of America." Atlanta University Art Gallery, April 4 to May 2.

New York, 1945
"The Negro Artist Comes of Age, A National Survey of Contemporary American Artists." Albany Institute of History and Art, January 3 to February 11.

Washington, D. C., 1945
"Some Modes in Modern Painting, Festival of Fine Arts." Howard University Gallery of Art, Founders Library, May 3 to May 5.

Chicago, 1946
"Exhibition of Independent Citizens Committee of the Arts, Sciences and Professions, Incorporated." 75 East Wacker Drive, May 4.

Chicago (Art Institute), 1946
"The Chicago Newspaper Guild's Exhibition of Paintings and Drawings of the Newspaper Industry." The Art Institute of Chicago, November 4 to November 30.

Chicago, 1947
"Representative Works by Chicago Artists." The Student Committee of the Renaissance Society University of Chicago, July 12 to August 8.

Chicago, 1949
"Fifty-third Annual Exhibition by Artists of Chicago and Vicinity." The Art Institute of Chicago, February 10 to March 20.

Springfield, 1949
"Fifth Annual Exhibition, North Mississippi Valley Artists." Illinois State Museum, June 5 to August 28.

Chicago, 1953
Chicago Public Library.

Chicago, 1957
Archibald John Motley, Jr. Chicago Public Library, October 1 to October 30.

New York, 1967
"The Evolution of Afro-American Artists: 1800-1950." City University of New York in cooperation with the Harlem Cultural Council and the New York Urban League City College, October 16 to November 5.

New York, 1968
"Invisible Americans: Black Artists of the 1930s." Studio Museum in Harlem, November 19 to January 5.

La Jolla, 1970
"Dimensions of Black." La Jolla Museum of Art, February 15 to March 29.

Springfield, 1971–72
"Painters and Sculptors in Illinois 1820–1945." Illinois Arts Council. Illinois State Museum, October 30 to December 12; in 1972 traveled to Krannert Art Museum, February 6 to February 27; Chicago Historical Society, April 26 to June 24.

Washington, D. C., 1974
"The Barnett-Aden Collection." Anacostia Neighborhood Collection, Smithsonian Institution.

Nashville, 1975
"Amistad II, Afro-American Art." Fisk University Department of Art in cooperation with the American Missionary Association and the United Church Board for the Homeland Ministries. Van Vechten Gallery, Fisk University Department of Art.

Boston, 1975
"Jubilee: Afro-American Artists on Afro-America." Museum of the National Center of Afro-American Artists, November 14 to January 4.

Schenectady, 1976
"Black Artists in Historical Perspective." Schenectady Museum, February 14 to April 4; traveled to Albany, Albany Institute of History and Art, May 1 to May 31.

Los Angeles, 1976
"Two Centuries of Black American Art." Los Angeles County Museum of Art, September 30 to November 21; traveled to Atlanta, High Museum of Art, January 8 to February 20.

Chicago, 1976
South Side Community Art Center. March.

St. Louis, 1977
"Currents of Expansion: Painting in the Midwest, 1820 to 1940." St. Louis Art Museum, February 18 to April 10.

Dallas, 1977
"Two Centuries of Black American Art." Museum of Fine Arts, March 30 to May 15; traveled to New York, Brooklyn Museum, June 25 to August 21.

New York, 1978
"New York/Chicago WPA and the Black Artist." Studio Museum in Harlem, November 13 to January 8; traveled to Chicago, Chicago Public Library Cultural Center, March 22 to April 23.

Huntsville, 1979
"Black Artists/South." Huntsville Museum of Art, April 1 to July 29.

Washington, D. C., 1980
National Conference of Artists. Corcoran Gallery of Art, March 14 to April 4.

Chicago, 1981
40th Anniversary Silent Auction. South Side Community Art Center, June 17.

Springfield, 1983
"After the Crash: New Deal Art in Illinois." Illinois State Museum, December 17 to September 6.

New York, 1984
"A Blossoming of New Promises: Art in the Spirit of the Harlem Rennaissance." Emily Love Gallery, Hofstra University.

Chicago, 1985
"Twentieth Annual Art Auction." South Side Community Center, May 26.

New York, 1985
"Collector's Choice: Treasures from the Schomburg Center." Schomburg Center for Research in Black Culture, February 1 to April 5.

Atlanta, 1985–86
"Afro-American Paintings and Prints from the Collection of Judge Irvin C. Mollison; A Gift to the Atlanta University Art Collections." Waddell Gallery, Atlanta University, December 15.

Los Angeles, 1987
"The Portrayal of the Black Musician in American Art." California Afro-American Museum.

Chicago, 1988
"The Collector's Art." Museum of Science and Industry.

Detroit, 1988
"Homage to Archibald J. Motley, Jr." Your
Heritage House, Incorporated, February to
March 10.

New York, 1988
"Three Masters: Eldzier Cortor, Hughie Lee-
Smith, Archibald J. Motley, Jr." Kenkeleba
Gallery, May 22 to July 17.

Washington, D. C. (Blues), 1989
"The Blues Aesthetic: Black Culture and
Modernism." Washington Project for the Arts,
September 14 to December 9; traveled to
Los Angeles, California Afro-American
Museum, January 12 to March 4; Durham,
Duke University Museum of Art, March 23 to
May 20; Houston, Blaffel Gallery, University of
Houston, June 8 to July 31; New York, Studio
Museum in Harlem, September 14 to
December 30.

Washington, D. C. (SITES), 1989
"African American Artists 1880–1987,
Selections from the Evans-Tibbs Collection."
Smithsonian Institution Traveling Exhibition
Service.

New York, 1989
"Afro-American Artists in Paris: 1919–1939."
The Bertha And Karl Leubsdorf Art Gallery,
Hunter College of the City University of New
York, November 8 to December 22.

Washington, D. C., 1990
"Facing History: Black Images in American Art
1710–1940." Corcoran Gallery of Art, January
13 to March 25; traveled to New York,
Brooklyn Museum, April 20 to June 25.

Newark, 1990
"Against the Odds: African American Artists
and the Harmon Foundation 1923–1943."
Newark Museum of Art, January 13 to
April 15.

BIBLIOGRAPHY OF WORKS CITED

Works listed below are cited in
abbreviated form.

AAA, 1932
Notable Paintings and Drawings (auct. cat.).
New York: American Art Association/
Anderson Galleries, Inc. December 14, 1932.

Aden, 1940
Aden, Alonzo J. "The Exhibit of Graphic Art."
In *Commemoration of the Seventy-Fifth
Anniversary of the Proclamation of the
Thirteenth Amendment to the Constitution of
the United States*. Washington, D.C.: Library
of Congress, 1940.

American Heritage, 1986
"Our 2nd Annual Winter Art Show."
American Heritage 38 (December 1986).

American Negro Artists, 1929
National Gallery of Art. *Catalogue of an
Exhibition of Paintings and Sculpture by
American Negro Artists* (exh. cat.).
Washington, D.C.: National Gallery of
Art/Smithsonian Institution, 1929.

American-Scandinavian Foundation, 1930
The American-Scandinavian Foundation.
Udstilling af Amerikansk Kunst (exh. cat.).
Copenhagen: Ny Carlsberg Glyptotek, 1930.

Anacostia, 1974
Anacostia Neighborhood Museum. *The
Barnett-Aden Collection* (exh. cat.).
Washington, D.C.: Smithsonian Institution
Press, 1974.

Art Institute, 1921
The Art Institute of Chicago. *Twenty-fifth
Annual Exhibition by Artists of Chicago and
Vicinity* (exh. cat.). Chicago: The Art Institute
of Chicago, 1921.

Art Institute, 1922
The Art Institute of Chicago. *Twenty-sixth
Annual Exhibition by Artists of Chicago and
Vicinity* (exh. cat.). Chicago: The Art Institute
of Chicago, 1922.

Art Institute, 1923
The Art Institute of Chicago. *Twenty-seventh
Annual Exhibition by Artists of Chicago and
Vicinity* (exh. cat.). Chicago: The Art Institute
of Chicago, 1923.

Art Institute, 1925
The Art Institute of Chicago. *Twenty-ninth
Annual Exhibition by Artists of Chicago and
Vicinity* (exh. cat.). Chicago: The Art Institute
of Chicago, 1925.

Art Institute, 1929
The Art Institute of Chicago. *Thirty-third
Annual Exhibition by Artists of Chicago and
Vicinity* (exh. cat.). Chicago: The Art Institute
of Chicago, 1929

Art Institute, 1930
Art Institute of Chicago. *Thirty-fourth Annual
Exhibition by Artists of Chicago and Vicinity*
(exh. cat.). Chicago: The Art Institute of
Chicago, 1930.

Art Institute, 1931
The Art Institute of Chicago. *Thirty-fifth
Annual Exhibition by Artists of Chicago and
Vicinity* (exh. cat.). Chicago: The Art Institute
of Chicago, 1931.

Art Institute, 1932
The Art Institute of Chicago. *Thirty-sixth
Annual Exhibition by Artists of Chicago and
Vicinity* (exh. cat.). Chicago: The Art Institute
of Chicago, 1932.

Art Institute, 1933
The Art Institute of Chicago. *Thirty-seventh
Annual Exhibition by Artists of Chicago and
Vicinity* (exh. cat.). Chicago: The Art Institute
of Chicago, 1933.

Art Institute, 1935
The Art Institute of Chicago. *Thirty-ninth
Annual Exhibition by Artists of Chicago and
Vicinity* (exh. cat.). Chicago: The Art Institute
of Chicago, 1935.

Atlanta University, 1943
Atlanta University. *Exhibition of Paintings by
Negro Artists of America* (exh. cat.). Atlanta:
Atlanta University, 1943.

Barnett, 1933
Barnett, Albert C. "Tanner and Motley Listed
in Fair Art Exhibit." *Defender* (Chicago),
September 2, 1933.

Barter, 1977
Barter, Judith A. and Lynn E. Springer. *Currents of Expansion: Paintings in the Midwest, 1820–1940* (exh. cat.). St. Louis: St. Louis Art Museum, 1977.

Bernard, 1989
Bernard, Catherine. *Afro-American Artists in Paris: 1919–1939.* New York: Hunter College, 1989.

Black Collegian, 1985
"The Art of the Harlem Renaissance: Turning Point in Black Consciousness." *Black Collegian* 15 (January/February 1985).

Black Dimensions in Art, 1976
Black Artists in Historical Perspective. New York: Black Dimensions in Art, 1976.

Brooklyn Museum, 1932
Brooklyn Museum. *Catalogue of the Summer Exhibition of Paintings, Sculpture, and Drawings* (exh. cat.). Brooklyn: Brooklyn Museum, 1932.

Campbell, 1987
Campbell, Mary Schmidt. *Harlem Renaissance Art of Black America* (exh. cat.). New York: Studio Museum, 1987.

Center Gallery, 1984
The Center Gallery of Bucknell University. *Since the Harlem Renaissance* (exh. cat.). Lewisburg: The Center Gallery of Bucknell University, 1984.

Century of Progress, 1934
The Art Institute of Chicago. *Catalogue of a Century of Progress Exhibition of Paintings and Sculpture* (exh. cat.). Chicago: The Art Institute of Chicago, 1934.

Chabrier, 1925
Comte Chabrier. "Expositions de l'Art Institute de Chicago, du No-Jury Exposition et du Cincinnati museum." *Revue du Vrai et du Beau,* 4 (February 1, 1925).

Chabrier and Serac, 1925
Comte Chabrier and G. Serac, "Expositions d'Amerique." *Revue du Vrai et du Beau* 4 (July 10, 1925).

Chicago Evening Post, 1932
"Art of East is Challenged by Mid-West." *Chicago Evening Post,* February 2, 1932.

Chicago Newspaper Guild, 1946
Inside Page One: Second Annual Yearbook. Chicago: Chicago Newspaper Guild, November 22, 1946.

City University of New York, 1967
The Evolution of Afro-American Artists: 1800–1950. New York: The City University of New York, 1967.

Corcoran Gallery, 1934
The Corcoran Gallery of Art. *National Exhibition of Art by the Public Works of Art Project* (exh. cat.). Washington, D.C.: The Corcoran Gallery of Art, 1934.

Dallas, 1936
Exhibition of Fine Arts Productions by American Negroes (exh. cat.). Dallas: Texas Centennial, 1936.

Davis Store, 1935
The Davis Store Galleries. *Catalog of the Salon des Refusés: Exhibition by Artists of Chicago and Vicinity* (exh. cat.). Chicago: The Davis Store Galleries, 1935.

Dover, 1960
Dover, Cedric. *American Negro Art.* New York: New York Graphic Society, 1960.

Driskell, 1975
Driskell, David. *Amistad II: Afro-American Art.* Nashville: Fisk University, 1975.

Driskell, 1976
Driskell, David. *Two Centuries of Black American Art* (exh. cat.). New York: Alfred A. Knopf/Los Angeles County Museum, 1976.

Dunkley, 1985
Dunkley, Tina. *Afro-American Paintings and Prints from the Collection of Judge Irvin C. Mollison* (exh. cat.). Atlanta: Clark Atlanta University, 1985.

Evansville Press, 1938
"Permanent Collection of 50 Paintings to be Displayed for Public in State Hospital Sunday and Monday." *The Evansville Press* (Evansville, Indiana), May 1938.

Evening Star, 1935
"Colored Artist Paintings Painting Murals." *The Evening Star* (Washington, D.C.), October 18, 1935.

Fauset, 1990
Fauset, Jessie Redmon. *Plum Bun: A Novel Without a Moral* (cover illustration). Boston: Beacon Press, 1990.

Fine, 1973
Fine, Elsa Honig. *The Afro-American Artist.* New York: Holt, Rinehart and Winston, Inc., 1973.

Forgey, 1980
Forgey, Benjamin. "Black Artists–Vivid Scenes and Urban Images." *The Washington Post,* April 2, 1980.

Gaither, 1975
Gaither, E. Barry. *Jubilee* (exh. cat.). Boston: Museum of Fine Arts and the Museum of the National Center of Afro-American Artists, 1975.

Ghent, 1968
Ghent, Henri. *Invisible Americans: Black Artists of the 1930s* (exh. cat.). New York: The Studio Museum, 1968.

Halpert, 1942
Halpert, Edith Gregor. *American Negro Art: 19th and 20th Centuries* (exh. cat.). New York: The Downtown Gallery, 1942.

Harmon Foundation, 1929
Exhibit of Fine Arts by American Negro Artists (exh. cat.). New York: The Harmon Foundation, 1929.

Herald and Examiner, 1929
"Negro Artist Wins Honors." *Herald and Examiner*. January 7, 1929.

Hudson, 1979
Hudson, Ralph N. *Black Artists/South* (exh. cat.). Huntsville, Alabama: Huntsville Museum of Art, 1979.

Hunter, 1988
Hunter, John. *Homage to Archibald John Motley, Jr.* Detroit: Your Heritage House, Incorporated, 1988.

Hyde Park Herald, 1933
"The Renaissance Society Column of Art Notes and Comments." *The Hyde Park Herald*, July 14, 1933.

IAFA, 1926
Illinois Academy of Fine Arts. *Catalogue of the First Exhibition by Members of the Illinois Academy of Fine Arts in the Galleries of the Illinois State Museum* (exh. cat.). Chicago: Illinois Academy of Fine Arts, 1926.

IAFA, 1929
Art Galleries of the Illinois State Museum. *Third Annual Exhibition by Members of the Illinois Academy of Fine Arts* (exh. cat.). Springfield: Art Galleries of the Illinois State Museum, 1929.

IAFA, 1931
Illinois Academy of Fine Arts. *Fifth Annual Art Exhibition by Members of the Illinois Academy of Fine Arts* (exh. cat.). Chicago: Illinois Academy of Fine Arts, 1931.

ISFA, 1926
All Illinois Society of the Fine Arts, Inc. *First Exhibition by Artists of Illinois, at the Galleries of Carson, Pirie, Scott and Company* (exh. cat.). Chicago: All Illinois Society of the Fine Arts, Inc., 1926.

IWAC, 1928
Illinois Women's Athletic Club. *Third Annual Exhibition by Members of the Illinois Academy of Fine Arts* (exh. cat.). Chicago: Illinois Women's Athletic Club, 1928.

Jacobson, 1933
Jacobson, Jacob Z., ed. *Art of Today: Chicago, 1933*. Chicago: L. Stein, 1933.

Jewell, 1928
Jewell, Edward Alden. "A Negro Artist Plumbs the Negro Soul." *The New York Times Magazine*, March 25, 1928.

Jewett, 1933
Jewett, Eleanor. "Show Works of A. J. Motley at Woman's Club." *Tribune* (Chicago), January 26, 1933.

Kofman, 1972
Kofman, Nadine. "Student Finds Neglected Black Artist Still Painting." *Centre Daily Times* (University Park), August 2, 1972.

Kramer, 1974
Kramer, Victor, ed. *Studies in the Literary Imagination* 7:2 (Fall 1974).

LeFalle-Collins, 1987
LeFalle-Collins, Lizzetta and Leonard Simon. *The Portrayal of the Black Musician in American Art* (exh. cat.). Los Angeles: California Afro-American Museum, 1987.

Locke, 1939
Locke, Alain. *Contemporary Negro Art* (exh. cat.). Baltimore: Baltimore Museum of Art, 1939.

Locke, 1940
Locke, Alain. *The Art of the American Negro 1851–1940* (exh. cat.). Chicago: Tanner Art Galleries/American Negro Exposition, 1940.

Locke, (We Too), 1940
Locke, Alain. *We Too Look at America* (exh. cat.). Chicago: South Side Community Art Center, May 1940.

Locke, 1945
Locke, Alain. *The Negro Artist Comes of Age: A National Survey of Contemporary American Artists* (exh. cat). Albany: Albany Institute of History and Art, 1945.

Madden, 1971
Madden, Betty I. *Paintings and Sculptors in Illinois 1820–1945* (exh. cat.). Springfield: Illinois Arts Council, 1971.

McElroy, 1989
McElroy, Guy C., Richard J. Powell, and Sharon Patton. *African American Artists 1880–1987: Selections from the Evans-Tibbs Collection*. Washington, D.C.: Smithsonian Institution, 1989.

McElroy, 1990
McElroy, Guy. *Facing History: The Black Image in American Art 1710–1940*. California: Bedford Publishers, 1990.

McKenna, 1983
McKenna, Maureen A. *After the Great Crash: New Deal Art in Illinois* (exh. cat.). Springfield: Illinois State Museum, 1983.

Mandel Brothers, 1935
Exhibition of Sketches Submitted for the Federal Mural Competition (exh. cat.). Chicago: Mandel Brothers, 1935.

Mavigliano, 1990
Mavigliano, George J. and Richard A. Lawson. *The Federal Art Project in Illinois 1935–1943*. Carbondale, IL: Southern Illinois University Press, 1990.

National Gallery, 1933
Association for the Study of Negro Life and History. *Exhibition of Works by Negro Artists at the National Gallery of Art/Smithsonian Institution* (exh. cat.). Washington, D.C.: Association for the Study of Negro Life and History, 1933.

National Urban League, 1978
Golden Opportunity (exh. cat.). New York: The National Urban League, 1978.

New Gallery, 1928
The New Gallery. *Exhibition of Paintings by Archibald John Motley, Jr.* (exh. cat.) New York: The New Gallery, 1928.

The New Yorker, **1928**
"The Art Galleries." *The New Yorker*, March 10, 1928, pp. 78-79.

Newark Museum, 1927
The Newark Museum. *Paintings and Water Colors by Living American Artists.* (exh. cat.) Newark: The Newark Museum, 1927.

No-Jury, 1926
Chicago No-Jury Society of Artists. *Fourth Exhibition of the Chicago No-Jury Society of Artists* (exh. cat.). Chicago: Chicago No-Jury Society of Artists, 1926.

No-Jury, 1927
Chicago No-Jury Society of Artists. *Fifth Exhibition of the Chicago No-Jury Society of Artists* (exh. cat.). Chicago: Chicago No-Jury Society of Artists, 1927.

Opportunity Magazine, **1928**
"Archibald John Motley, Jr." *Opportunity Magazine* (April, 1928).

Powell, 1989
Powell, Richard. *The Blues Aesthetic: Black Culture and Modernism* (exh.cat.). Washington, D.C.: Washington Projects for the Arts, 1989.

Price, 1980
Price, Ramon. "Five Artists: Four Works." In *DuSable Museum Artists Directory 1980–1981.* Chicago: DuSable Museum of African American History, 1980.

Reader's Digest, 1978
"Black Art in America," *Reader's Digest* (June 1978).

Renaissance Society, 1930
Exhibition of Paintings Selected from the Annual Exhibition of Paintings by Artists of Chicago and Vicinity (exh. cat.). Chicago: The Renaissance Society and the University of Chicago, 1930.

Reynolds, 1990
Reynolds, Gary A. and Beryl J. Wright. *Against the Odds: African-American Artists and the Harmon Foundation, 1923–1943* (exh. cat.). Newark: The Newark Museum of Art, 1990.

Rich, 1938
Rich, Daniel Catton. *Art for the Public by Chicago Artists. Works Progress Administration Federal Art Projects* (exh. cat.). Chicago: The Art Institute of Chicago, 1938.

Roberts, 1937
Roberts, Mary F., ed. *Dance International 1900–1937* (exh. cat.). New York: Dance International Committee, 1937.

Robinson, 1987
Robinson, Jontyle Theresa. "Archibald John Motley, Jr.: Pioneer Artist of the Urban Scene." In *American Visions: Afro-American Art–1986*, edited by Carroll Greene, Jr. Washington, D.C.: Visions Foundation, Inc., 1987.

Robinson, 1988
Robinson, Jontyle Theresa. "The Art of Archibald John Motley, Jr.: A Notable Anniversary for a Pioneer." In *Three Masters: Eldzier Cortor, Hughie Lee-Smith, Archibald John Motley, Jr.* (exh. cat.). New York: Kenkeleba Gallery, 1988.

South Side Community Art Center, 1940
South Side Community Art Center. *Paintings by Negro Artists of the Illinois Art Project, Works Progress Administration* (exh. cat.). Chicago: South Side Community Art Center, 1940.

South Side Community Art Center, 1981
South Side Community Art Center. *40th Anniversary: Silent Auction.* Chicago: The South Side Community Art Center, 1981.

Studio Gallery, 1933
The Studio Gallery. *Exhibition by Chicago Artists.* Chicago: Studio Gallery, 1933.

Teilbet, 1970
Teilbet, Jehaone, ed. *Dimensions of Black.* (exh. cat.) La Jolla Museum of Art, 1970.

Tibbs, 1983
Tibbs, Thurlow. *Surrealism and the Afro-American Artist* (exh. cat.). Washington, D.C.: The Evans-Tibbs Collection, 1983.

Toledo, 1934
Toledo Museum of Art. *Catalogue of the Twenty-first Annual Exhibition of Selected Paintings by Contemporary American Artists.* Toledo: Toledo Museum of Art, 1934.

Tribune (Catalogue) 1953
"Catalogue of the Twenty-first Annual Exhibition of Selected Paintings by Chicago Sunday Tribune," *Tribune* (Chicago), October 25, 1953.

Tribune, 1953
"Negro Artists Exhibit at Public Library." *Tribune* (Chicago), October 25, 1953.

Tribune, 1935
"Eight Chicago Artists Win Competition for Postoffice Murals." *Tribune* (Chicago), July 16, 1935.

Viva, **1976**
"The Tattler." *Viva* 4 (November 1976).

Wallace, 1986
Wallace, Carol et al. *Dance: A Very Social History*. New York: The Metropolitan Museum of Art and Rizzoli International Publications, 1986.

Watson, 1936
Watson, Forbes. *Painting and Sculpture for Federal Buildings*. Treasury Department Art Projects (exh. cat.). Washington, D.C.: Corcoran Gallery of Art, 1936.

Whitney Museum, 1933
Paintings and Prints by Chicago Artists (exh. cat.). New York: The Whitney Museum of American Art, 1933.

Woodall, 1977
Woodall, Elaine D. "Archibald J. Motley, Jr.: American Artist of the Afro-American People 1891–1928." Master's thesis. Pennsylvania State University, 1977.

Woodall, 1979
Woodall, Elaine D. "Looking Backward: Archibald J. Motley and the Art Institute of Chicago." *Chicago History* 8 (Spring 1979): 53–55

INDEX

Illustrations are indicated by italicized numbers, unless text on and illustration of the subject are on the same page.

For works by artists other than Archibald J. Motley, Jr., the artist's name is indicated in parentheses after the title of the work.